Caroline Tisdall,
poet, photographer and film-maker, was born
in 1945. She graduated from the Courtauld Institute
of Art, London, taught Art History at the University of
Reading and was art critic of *The Guardian* (London)
from 1970 to 1981. Her other publications include *Joseph
Beuys Coyote* (1976), *Joseph Beuys* (1979), *Beirut: Front Line
Story* (with Selim Nassib, 1983), *Witches' Point* (with Paul
van Vlissingen, 1987) and *Grist to the Mill – Selected Writings
1970-1995*. Angelo Bozzolla (born 1938) is an artist, writer
and theatrical designer who has lived and worked
in Italy, the USA and Britain.

WORLD OF ART

This famous series
provides the widest available
range of illustrated books on art in all its aspects.
If you would like to receive a complete list
of titles in print please write to:
THAMES & HUDSON
181A High Holborn, London WC1V 7QX
In the United States please write to:
THAMES & HUDSON INC.
500 Fifth Avenue, New York, New York 10110

Printed in Singapore

Caroline Tisdall *Angelo Bozzolla*

FUTURISM

169 illustrations, 20 in color

 THAMES & HUDSON

For David

© 1977 Thames & Hudson Ltd, London

Published in the United States of America in 1985 by
Thames & Hudson Inc., 500 Fifth Avenue,
New York, New York 10110

thamesandhudsonusa.com

Reprinted 2000

ISBN 0-500-20159-5

Printed and bound in Singapore by C.S. Graphics

Contents

55e Année — 3e Série — N° 51

Gaston CALMETTE
Directeur-Gérant

RÉDACTION — ADMINISTRATION
26, rue Drouot, Paris (9e Arr¹)

POUR LA PUBLICITÉ
s'adresser, de, rue Drouot
à l'heure de réclame
Chez MM. LAGRANGE, CERF & Cⁱᵉ
8, place de la Bourse

LE FIGARO

« Louf par ceux-ci, blâmé par ceux-là, me moquant des sots, bravant les méchants, je me hâte de rire de tout... de peur d'être obligé d'en pleurer. » (BEAUMARCHAIS.)

H. DE VILLEMESSANT
Fondateur

RÉDACTION — ADMINISTRATION
26, rue Drouot, Paris (9e Arr¹)

ABONNEMENTS

Le Futurisme

M. Marinetti, le jeune poète italien et français au talent remarquable et fougueux, que ses retentissantes manifestations ont fait connaître dans tous les pays latins, vient d'un prélude d'enthousiastes disciples, vient de fonder l'École du « Futurisme » dont les théories dépassent en hardiesse toutes celles des écoles antérieures ou contemporaines. Le *Figaro* qui a déjà servi de tribune à plusieurs d'entre elles, et des plus importantes, offre aujourd'hui à ses lecteurs la synthèse des... à titre documentaire.

[...]

Manifeste du Futurisme

1. Nous voulons chanter l'amour du danger, l'habitude de l'énergie et de la témérité.

2. Les éléments essentiels de notre poésie seront le courage, l'audace et la révolte.

3. La littérature ayant jusqu'ici magnifié l'immobilité pensive, l'extase et le sommeil, nous voulons exalter le mouvement agressif, l'insomnie fiévreuse, le pas gymnastique, le saut périlleux, la gifle et le coup de poing.

4. Nous déclarons que la splendeur du monde s'est enrichie d'une beauté nouvelle : la beauté de la vitesse. Une automobile de course avec son coffre orné de gros tuyaux, tels des serpents à l'haleine explosive... une automobile rugissante, qui a l'air de courir sur de la mitraille, est plus belle que la *Victoire de Samothrace*.

5. Nous voulons chanter l'homme qui tient le volant, dont la tige idéale traverse la terre, lancée elle-même sur le circuit de son orbite.

6. Il faut que le poète se dépense avec chaleur, éclat et prodigalité, pour augmenter la ferveur enthousiaste des éléments primordiaux.

7. Il n'y a plus de beauté que dans la lutte. Pas de chef-d'œuvre sans un caractère agressif. La poésie doit être un assaut violent contre les forces inconnues, pour les sommer de se coucher devant l'homme.

8. Nous sommes sur le promontoire extrême des siècles !... À quoi bon regarder derrière nous, du moment qu'il nous faut défoncer les vantaux mystérieux de l'impossible ? Le Temps et l'Espace sont morts hier. Nous vivons déjà dans l'absolu, puisque nous avons déjà créé l'éternelle vitesse omniprésente.

9. Nous voulons glorifier la guerre, — seule hygiène du monde, — le militarisme, le patriotisme, le geste destructeur des anarchistes, les belles Idées qui tuent, et le mépris de la femme.

10. Nous voulons démolir les musées, les bibliothèques, combattre le moralisme, le féminisme et toutes les lâchetés opportunistes et utilitaires.

11. Nous chanterons les grandes foules agitées par le travail, le plaisir ou la révolte ; [...]

F.-T. Marinetti

LA VIE DE PARIS

« Le Roi » à l'Élysée... Palace

Il y eut avant-hier soir dans tous les théâtres de Paris, à l'heure où généralement on soigne les dernières chandelles et où les artistes remplacent en hâte par leurs nobles vêtements familiers les somptueux et éclatants oripeaux professionnels, un insolite et tout à fait surprenant brouhaha !

[...]

Un Monsieur de l'Orchestre.

Échos

La Température

Encore une très belle journée, hier, à Paris. Le ciel est de la plus grande pureté, et le soleil n'épanouissait pas malgré l'invincible du thermomètre, à vrai dire. [...]

La température se relève notablement sur toute la France. [...]

Départements, le matin, au-dessus de zéro : ... à Nice, 12°, à Biarritz et à Bordeaux, 7° ; à Ouessant, 7°, à Brest, 6° ; à Perpignan, 5° ; à Cette, 4° ; à Toulouse et à Agen, 3° ; à Rochefort et à Limoges, 2° ; à Nantes, au Mans et à Lyon, 1° ; à Angers et à Charleville, 3° ; à Nancy et à Besançon, 0° à Belfort.

Monte-Carlo : — Température : à midi la plus haute, 17° ; à midi, 14° ; temps beau.

New-York Herald :
À New-York : Temps pluvieux. Température : à midi, 13° ; à trois heures, hier soir, 9°. Vent d'Est.
À Londres : Temps beau. Température : à midi.

Les Courses

Aujourd'hui, à ... heures, Courses à Vincennes. — Gagnants du *Figaro* :

Prix Michelet : Privale ; Fringante.
Prix de Maisons : Fada ; Bourgogne.
Prix Leda : Farnèse ; Frégoli.
Prix de Maisons-Laffitte : Eleusis ; Éclaireur.
Prix de Plaisance : Bord Leyburn ; Élisabeth.
Prix de la Varenne : Élysée ; Étendard.

À Travers Paris

Le roi des Bulgares a chargé M. Stan... ministre de Bulgarie à Paris, de déposer en son nom une couronne sur le cercueil du marquis Costa de Beauregard et d'offrir ses condoléances à la famille du défunt.

[...]

Nouvelles à la Main

Les crédits de la marine.
— On assure que M. Caillaux et M. Picard ne s'entendent guère. Il y a chou.
— Il y a même abordage.

[...]

Le Masque de Fer.

Le complot Caillaux

M. Caillaux fomente un petit complot (tout petit) contre ses collègues du ministère, et en particulier contre le président du Conseil auquel il voudrait bien succéder.

[...]

The means of Futurism

'We will sing of great crowds excited by work, by pleasure, and by riot; we will sing of the multicoloured polyphonic tides of revolution in the modern capitals; we will sing of the vibrant nightly fervour of arsenals and shipyards blazing with violent electric moons; greedy railway stations that devour smoke-plumed serpents; factories hung from clouds by the crooked lines of their smoke; bridges that stride the rivers like giant gymnasts, flashing in the sun with the glitter of knives; adventurous steamers that sniff the horizon; deep-chested locomotives whose wheels paw the tracks like the hooves of enormous steel horses bridled by tubing; and the sleek flight of planes whose propellers chatter in the wind like banners and seem to cheer like an enthusiastic crowd.'

Filippo Tommaso Marinetti (1876–1944),
'The Founding and Manifesto of Futurism', 20
February 1909.

Italian Futurism was the first cultural movement of the twentieth century to aim directly and deliberately at a mass audience. To do so it made use of every available means and medium, and invented others beside. It was a hectic herald of the recurrent concern in the art of our times to equate art and life, an equation which still remains unresolved. But in the heady years which led up to and into the First World War the small group of writers, artists and musicians who called themselves the Italian Futurists set out to do more than that. Their aim and their claim was to transform the mentality of an anachronistic society. Marinetti and his friends were determined to prepare Italy for what seemed to be the great adventure of modern times: 'What we want to do is to break down the mysterious doors of the Impossible.'

The determination to reach as wide an audience as possible is the key to Futurism. It characterizes both the movement's most daring and stimulating experimentation and its most infuriating excesses of bombast. Above all, it explains why Marinetti, as leader of the movement, put such tremendous energy into expanding the boundaries of what could be termed 'culture' beyond all recognition. This meant not just the revitalizing of the traditional arts of painting, sculpture, poetry, music and architecture, but the invention of a new dimension of language flexible enough to express the range of experience open to man in the dawning century of speed, mobility and unprecedented scientific advance.

The face of the world as it had been known for centuries was changing daily. Einstein and Planck had opened up completely new ways of perceiving it. Morse, Bell (or rather Meucci) and Edison had invented extraordinary new means of communication, undreamt-of languages linking man to man invisibly across the globe, and these were already in constant and daily use. How could the arts, heralds of change, drag dully on in the gloom of academic nudes and wistful odes, using nothing but the old languages unchanged for centuries? In the age of light how could culture hide its brilliance in the murk of the garret? And how, in the age of transatlantic

7

1 Front page of *Le Figaro*, 20 February 1909

communication, could the poet still mumble sad lines to himself?

Marinetti was among the first to see that vast changes in man's mentality were imminent, and he was certainly the first to set his 'Man Multiplied by the Motor' in a world that sounds very much like the Global Village of the 1960s. The clarity and excitement of this vision of a transformed world is laid out in his extraordinary manifesto of 1913, 'Destruction of Syntax — Imagination without Strings — Words-in-Freedom':

'Futurism is grounded in the complete renewal of human sensibility brought about by the great discoveries of science. Those people who today make use of the telegraph, the telephone, the phonograph, the train, the bicycle, the motorcycle, the automobile, the ocean liner, the dirigible, the aeroplane, the cinema, the great newspaper (synthesis of a day in the world's life), do not yet realize that these various means of communication, transportation and information have a decisive influence on their psyches.

'An ordinary man can in a day's time travel by train from a little dead town of empty squares, where the sun, the dust and the wind amuse themselves in silence, to a great capital city bristling with lights, gestures and street cries. By reading a newspaper the inhabitant of a mountain village can tremble each day with anxiety, following insurrection in China, the London and New York suffragettes, Doctor Carrel, and the heroic dog-sleds of the polar explorers. The timid, sedentary inhabitant of any provincial town can indulge in the intoxication of danger by going to the movies and watching a great hunt in the Congo. He can admire Japanese athletes, Negro boxers, tireless American eccentrics, the most elegant Parisian women, by paying a franc to go to the variety theatre. Then back in his bourgeois bed, he can enjoy the distant, expensive voice of a Caruso or a Burzio.'

The Futurists turned their backs on the sheltered life of the cultured intellectual. They ridiculed both the servile respect paid to men of fossilized learning and the rejection of society implicit in traditional bohemian withdrawal. Instead, like the Dadaists and Russian Constructivists later, they opted for the public arena and demanded instant reaction. Whether this reaction was favourable or not was of secondary importance, and this is something to be borne in mind when any historical appraisal of Futurism is attempted. The essential thing was to involve a public that was no longer rendered passive and submissive. 'We place the spectator in the centre of the picture', the Futurist painters declared in their manifesto, and the expectation was that the spectator would not just stand there but hit back.

This transformation of the relationship between the artist in all fields of activity and the spectator in all walks of life is central to Futurism and dovetails with the aim to reach a mass audience. This programme was essentially Marinetti's, for although the members of the group affiliated themselves eagerly, it was always he who propelled the movement along, constantly expanding its scope, seeking new recruits and fresh adversaries. It was not for nothing that he was called 'the Caffeine of Europe'. Marinetti was a man of his time. He was an agitator, like Alfred Jarry, and an entrepreneur, like Guillaume Apollinaire. But more than this: fifty years before Marshall MacLuhan he had perfectly understood that, in the expanded world of twentieth-century communications, the medium is the message; that, whatever you have to say, how you say it is as important as what you say.

That is why the tangible evidence that remains to us of Futurist activity, the paintings, sculpture, fragments of music, playscripts and stage directions, poems and tracts, should be seen in the context of how they were presented. Under Marinetti's auspices, the presentation of culture was for the first time handled as if it were a political campaign, which indeed it was later to become. The means he used to launch his movement were those of the modern presidential election campaign: newspapers, saturation advertising, theatres and stadiums, whistle-stop tours, a stream of propaganda for his members and of abuse for their detractors, a blaze of publicity whenever a Futurist was lucky enough to be put on trial, and instant documentation of all these events.

To back up the effectiveness of the publicity machines that already existed, Marinetti invented his own. There was the ceaseless production of every possible kind of manifesto, ranging from 'The Painting of Sounds, Noises and Smells' to 'The Praise of Prostitution', and these were sent out to all the world. There were the editions of books from his own publishing house, endlessly printed and tirelessly distributed. There was the transformation of the cultural newspaper *Lacerba* into the official organ of the Futurist movement and a powerful political weapon, selling most of its edition to the workers of Milan and Turin. The effect of all this was that in the Italy of that time there was no one who had not heard of Futurism. And even now the reaction of an old Italian on hearing of a painter who is young or modern or both is likely to be, 'Ah, a Futurist '

The birth of Futurism was in itself a stroke of advertising genius. 'The Founding and Manifesto of Futurism' appeared in full on the front page of *Le Figaro*, in the edition of 20 February 1909. At one blow

Marinetti secured both massive scandal and bemused respect from the Italian press. He had managed to place his bombshell on the front page of the most revered paper of Europe. Had it appeared in some provincial Italian newspaper, it could have been dismissed as a random, eccentric outburst. But this attack on the glorious Italian past came from the pages of the most influential newspaper of the capital of the cultured world: Paris. And in Paris they had read that Italy was to be delivered from 'its smelly gangrene of professors, archaeologists, ciceroni and antiquarians', all of whom were dismissed and ridiculed as 'passéists'. The Italy of the future spelled out in *Le Figaro* meant youth, speed, the beauty of the motorcar and the aeroplane. In Paris they had heard that 'Art can be nothing but violence, cruelty and injustice.' The effect was everything that Marinetti had expected. The 'we' of the manifesto had in fact suggested a group that did not exist. The publication of the manifesto in *Le Figaro* was meant to attract the allegiance of daring initiates from every field. Among the first to join were the painters Umberto Boccioni (1882–1916), Carlo Carrà (1881–1966), Luigi Russolo (1885–1947), Giacomo Balla (1871–1958) and Gino Severini (1883–1966). The Futurist group had sprung ready-formed from a full-page advertisement, a novel way of finding kindred spirits.

This was typical of Marinetti's skill as a manipulator of the media. He was an expert with newspapers: the coverage that he secured for Futurism both in Italy and abroad was amazing, and not all of it was bought with the fortune he lavished on the movement. During one of the visits to London, for instance, Marinetti presented himself to the editor of a London newspaper claiming to be a war reporter fresh

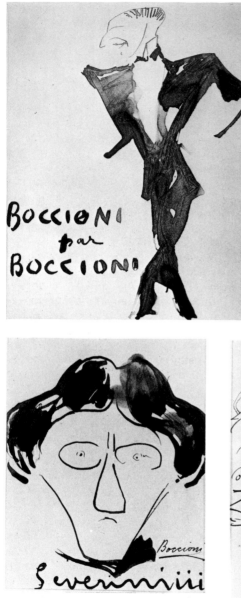

2 Boccioni *Self-Caricature* 1912

3 Boccioni *Carlo Carrà* 1912

4 Boccioni *Gino Severini* 1912

5 Boccioni *Luigi Russolo* 1912

from the Turkish front. An article was duly commissioned. Half way through, the action suddenly switched from the Turkish wars to the Futurists' activities in London.

This skill was later extended into the pages of *Lacerba* under the direction of the Florentine writer Giovanni Papini and the painter-critic Ardengo Soffici. Through the pages of *Lacerba*, Marinetti's Futurism showed its paces, demonstrating the scope of its involvement through the range of its manifestos. It also proved that a fortnightly newspaper could carry the most complicated and advanced philosophical writing, illustrations in the most outrageously modern manner, attacks of the most outspoken violence on all that was sacred, and still sell above all to the workers. During 1915 *l acerba*, its pages often blacked out with the censor's ink, shows the transformation of Futurism into a highly political movement *Lacerba* and Futurism advocated intervention in the First World War on the side, as they saw it, of the workers of France and against the passéist pedantry of Austria and Germany.

Marinetti was a poet, nourished, he was proud to think, at the breast of a Sudanese wetnurse, and heir to a fortune amassed allegedly in the brothels of Alexandria, Egypt, where he was born. Marinetti's first language had been the French of the disquieting Symbolist climate, and it was as a missionary bringing Symbolist poetry to Italy that he had first made his mark in the country to which he returned with all the fervour of an exile. The magazine *Poesia*, which he founded in 1905, was his main outlet until the launching of Futurism four years later, and the constant publishing of as many books as possible by himself and other Futurists was to be a central part of his Futurist programme. This too was used as an elaborate form of prestigious publicity. All the evidence indicates that very few copies were actually sold. Most of the editions were out of print before they could reach the shops; for days on end Marinetti dedicated copies which his secretary dispatched to half the world from the famous Casa Rossa in Milan.

It was not only his own books that were so liberally distributed. The Futurist writer and poet Aldo Palazzeschi records that a book of his published in 1909 was almost entirely given away and that even he failed to secure a copy. Marinetti's preface to this volume of poetry consisted of seventy-five pages of advertisements for the Futurist movement, with not a mention of the poems that followed!

The manifesto form was an ideal extension of the publicity machine, and Marinetti's use of it was an important precedent for the artists of later movements for whom the theoretical or public statement was an integral part of the strategy of reaching an audience. The manifesto has been used consistently by those movements and groups who have attempted to widen the scope of art, from the Dadaists, Russian Constructivists and Surrealists to the Fluxus movement in the 1960s. It is no coincidence that while art historians in the 1960s were examining Futurist painting and sculpture with renewed interest, the artists of Fluxus were rediscovering the forgotten range of innovations embarked on by the Futurists. One of the most stimulating Futurist manifestos, Luigi Russolo's 'The Art of Noises', was, for instance, translated by the Fluxus artist Robert Filliou and published with pride by the Great Bear Press.

The manifestos of Futurism were intended to provide clear and dynamic proof that the movement was invading every branch of life, cultural, social and political. Marinetti tirelessly persuaded each new

initiate to lay out his programme in the most colourful and inflammatory language possible, and many manifestos, notably Antonio Sant'Elia's 'Manifesto of Futurist Architecture', bear the signs of elaboration by Marinetti himself. Often, and perhaps under pressure from Marinetti, the manifesto was produced before any tangible evidence existed of the innovation it announced. Russolo's description of noises as the new dimension of music was described in 'The Art of Noises' before the machines that were to produce this concert of noise were constructed. The daring of the manifesto often went far beyond the results that followed. Carrà's 'Painting of Sounds, Noises and Smells' of 1913, for example, describes a dazzling range of acoustic effects in Futurist painting while claiming that they had already been partly achieved in works like his own *Funeral of the Anarchist Galli* and *Jolts of a Taxicab*, or by Boccioni in *States of Mind* and *Forces of a Street*, and Russolo's *Revolt* or Severini's *Pan-Pan*. With the best will in the world it is hard to find in these paintings either the environment-force described by Carrà, or much justification for his claim that they represent total painting. 'The Founding and Manifesto' glorified the idea of possible or impossible experimentation, rather than analysing what had actually been achieved, and Marinetti's exploration of the development of the senses in his 'Manifesto of Tactilism' (1921) is another example of this.

The function of the manifesto was to create excitement and polemic, and it was an ideal medium for that; it was cheap and quick to produce, could be run off in vast editions, distributed on the streets and sent out by post so that reverberations were felt from Japan to the United States. It gave the impression that the Futurist movement was a huge organization encompassing all the disciplines. And to reinforce the idea of Futurism spreading throughout the world, there were manifestos written by foreign contributors: Valentine de Saint-Point's 'Futurist Manifesto of Lust', Apollinaire's 'Anti-Futurist Manifesto' and C.R.W. Nevinson's 'Vital English Art'.

But the written word in the form of books, newspapers and manifestos was not enough. Marinetti knew that to be effective he must reach all levels of society, including Italy's high proportion of illiterates. Propaganda on the streets was one way to deal with this, and an early rumpus in Venice was typical of the riot-raising potential of activities that were bound to cause both immediate aggravation and subsequent repercussions. One Sunday morning Marinetti and his friends climbed up to the top of the campanile of St Mark's with a trumpet and a loudspeaker. As the congregation poured out of Mass, they were greeted with three blasts of the trumpet and a stream of abuse for the churchy, passéist stink of Venice, together with a blast of publicity for the Futurists.

The most effective and characteristic manifestation of all was the invention of the Futurist Evening (*serata futurista*). This was a combination of theatre, concert, political assembly, discussion and riot. The theatres of cities up and down Italy were the regular venues for these events, since Marinetti realized that the theatre was Italy's most popular form of entertainment and a far more effective way of reaching the masses than the bookshops and news kiosks. Once a Futurist Evening had been announced in a city it was awaited as an event to be experienced at all costs. The initiates of whatever city it was would meet Marinetti and his friends at the station and carry them in triumph to their hotel. The police were always on the alert for trouble

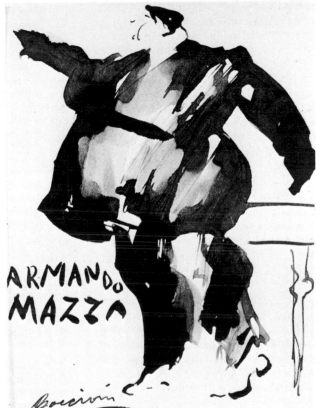

6 Boccioni
Armando Mazza 1912

for hours before the Evening began, and
the theatre was usually heavily surrounded
by reinforcements, thus creating the de-
sired tone of tension. The theatre was
always packed an hour before the perfor-
mance was due to begin, with insults and
tomatoes already flying.

The Evening invariably began with
Marinetti and his friends, protected from
attack by the massive weight of the poet
Armando Mazza, hurling insults at the host
city and its illustrious men. The police
rarely moved to protect the Futurists from
their audiences. In fact, in Bologna on one
occasion it seemed that the police too had
joined the three thousand who attacked

the eleven Futurists. If the Evening con-
tinued after that it might include a showing
of Futurist paintings, the declamation of
manifestos, the groaning and scraping of
Russolo's Noise Intoners, gems of Futurist
Variety Theatre, and more mutual insults.
Marinetti was a master at picking up signs
of aggression and using them to his own
advantage. At one Evening, a distin-
guished lawyer in the audience whistled
non-stop derision until Marinetti turned on
him: 'There's a crack in your empty head
and the air whistles through it.'

Ideally the Evening would break up in a
riot that would spread through the streets
and bars of the city, to be followed by

scandalized articles in the next day's press, and maybe even a prosecution. Marinetti gained enormous publicity from the three trials for obscenity that followed the publication in 1910 of his novel *Mafarka futurista*, the offending item being Mafarka's eleven-metre-long penis which he wrapped round himself when he slept. Marinetti was acquitted at the first trial, given a two-and-a-half-month suspended sentence at the second, and had the same suspended sentence confirmed at the third. This experience was turned to advantage whenever a charge emerged out of a Futurist Evening. In 1914, for example, Luigi Russolo was brought to trial following a concert in the Teatro del Verme in Milan. The concert of eighteen Noise Intoners had been officially vetoed on the grounds that it would certainly create a public disturbance. But the veto had been withdrawn when two members of Parliament and the respectable musician Umberto Giordano appealed on Russolo's behalf. Sure enough it all ended with Russolo coming to blows with a prominent Catholic newspaper editor. He was given a suspended sentence.

The foreign tours through the cities of Europe were an elaborate extension of the Futurist Evening. They had a dual function. They demonstrated above all that living culture could participate in the speed and mobility of the modern world. And the publicity incurred by the group in foreign capitals as far-flung as London and Moscow gave them added prestige back in Italy. When the 'Exhibition of Futurist Painters' toured Europe in 1912, a whole range of supporting activities accompanied it: discussions, press conferences, concerts and encounters with rival or sympathetic groups. For foreigners Italy was still the land of museums, with a glorious culture safely buried in the past.

As Georges Bataille patronizingly wrote to Marinetti: 'To our foreign eyes the greatest fascination of Italy is that it is so retarded.'

The conquest of Paris, the capital of art and the stamping ground of Cubism, would have been Marinetti's ultimate triumph. His advice to the Futurist musician and composer Francesco Balilla Pratella was typical of his strategy for gaining attention: 'To conquer Paris and appear in the eyes of Europe as an absolute innovator, the most advanced of all musicians, I advise you with all my heart to set to work determined to be the most daring, most advanced, most unexpected and most eccentric emanation of all that has been done in music to date, I advise you to make a real nuisance of yourself, and not to stop until all around you have declared you to be mad, incomprehensible, grotesque, etc.' This enthusiasm for self-advertisement affected the painters too. Once their paintings had been amply advertised in the pages of the Parisian newspapers, they themselves publicized their exhibition at the Galerie Boétie. Boccioni rushed up and down showing newspaper clippings to the passers-by, and Carrà could scarcely take his eyes off his own name up in electric lights. Back at home, the Roman Futurist painter Giacomo Balla had exhibited his paintings in an electric light factory, and had even been moved to call his daughters Elica and Luce (Propeller and Light), the names they bear to this day.

This was the framework of presentation that Marinetti had created for the movement. He urged his group to behave as if the Futurist City already existed, as if the Futurist Reconstruction of the Universe were already under way, as if the great mental transformation had already taken place. The artists joined in wholeheartedly and kept up with the hectic pace

for a number of years. But the question was always there: how long could any artist sustain this type of behaviour in the public arena? Most of those Futurists who did not die in the First World War returned to the secluded life of the studio. It was probably only Marinetti who saw the movement as a form of total revolution. It was certainly only he who could greet the Russian Revolution and the Agit-trains of Constructivism, with the recognition that 'Every nation had or still has, its own form of passéism to overturn. We are not Bolsheviks because we have our own revolution to make.' And only Marinetti could so cunningly have turned the entire Russian Revolution and the achievements of the Constructivists to his own advantage, though the Russians insisted that they were not Futurists. 'I am delighted to learn that the Russian Futurists are all Bolsheviks and that for a while Futurism was the official Russian art. On May Day of last year the Russian cities were decorated with Futurist paintings. Lenin's trains were decorated on the outside with coloured dynamic forms very like those of Boccioni, Balla and Russolo. This does honour to Lenin and cheers us like one of our own victories.' And yet by then it was with Fascism that Futurism was most closely associated.

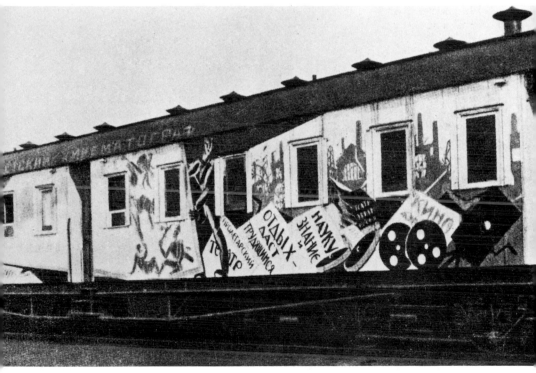

7 Agit-Train 1919

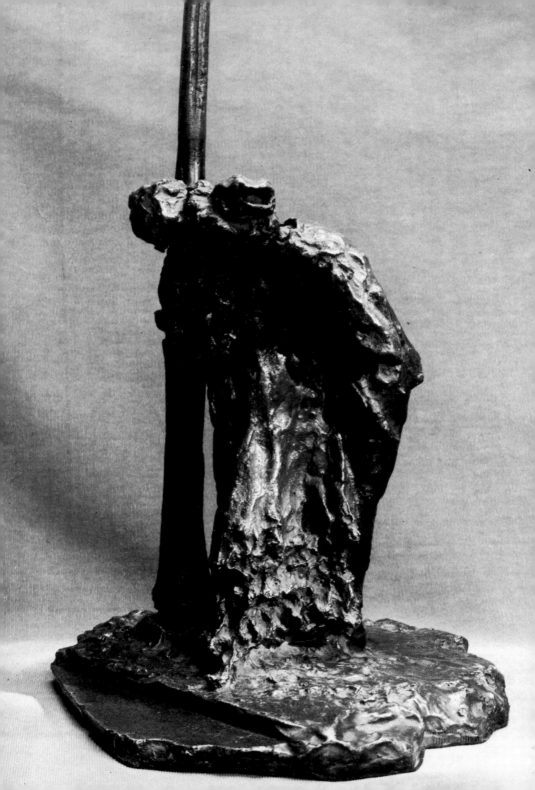

The roots of Futurism

'What do the victims matter, if the gesture be beautiful?'

Laurent Tailhade.

'A change in values – that means a change in the creators of values He who has to be a creator always has to destroy '

Friedrich Nietzsche.

Since its appearance in 1909, the strident and wilful violence of 'The Founding and Manifesto' has been the litmus test of Futurism. When it appeared it served its purpose in generating outraged reaction. A generation later the climate of real violence in the world made it repellent to intellectuals intent on what Jean Cocteau called 'the return to order' – the calm, idyllic and classicizing art of the 1920s. In the face of the Fascism of the 1930s a theorist of the left like Walter Benjamin inevitably overlooked the radical aspects of Futurism that led to Marinetti's split with Mussolini in 1920, and equated Futurism and Fascism as part and parcel of the same tendency:

'"Fiat ars – pereat mundus" says Fascism and, as Marinetti admits, expects war to provide the artistic gratification of a sense of perception that has been changed by technology. This is evidently the consummation of "L'art pour l'art". Mankind, which in Homer's time was an object of contemplation for the Olympic gods, now is one for itself. Its self-alienation has reached such a degree that it can experience its own destruction as an aesthetic pleasure of the first order. That is the

situation of politics which Fascism is rendering aesthetic. Communism responds by politicizing art.' (From 'The Work of Art in the Age of Mechanical Reproduction').

Benjamin's formulation became the orthodox attitude towards Futurism. With hindsight it is possible to see that neither violence nor the aestheticization of politics was restricted to Futurism, and Futurism was never the official art of Fascism. Cultural violence and aggressive attacks on prevailing values, both cultural and moral, were part and parcel not only of Futurism, but also of Dada, pre-revolutionary Russian art, and, later, Surrealism, and continue to play a part in any form of art that refuses to accept the limitation of its role to polite decoration. We can deplore both the machine ethic of Futurism and the fact that Futurist street battles were a direct precedent of Fascist punitive tactics, while remembering that the decisive ideological rift between the two movements came in 1919 when Marinetti's idealist and radical demands proved too much for Mussolini's pragmatist strategy of conciliation with Church and monarchy.

The roots of Futurism are a tangled web of turn-of-the-century political, cultural and philosophical currents that come to light, unacknowledged, in 'The Founding and Manifesto' Few, if any, of the ideas in it are totally original. Violence, war, anarchy, nationalism, the cult of the superman, glorification of urban life, of technology

8 Rosso *Kiss under the Lamp Post* 1882

and of speed, together with hatred of the past and scorn of academic values, had all been voiced before. What was new was the way in which they were all brought together and synthesized into one inflammatory cultural document ripe for distribution.

Violence of course was uppermost: 'We intend to sing the love of danger, the habit of energy and fearlessness. . . . Courage, audacity and revolt will be the essential elements of our poetry . . . There is no more beauty except in strife. No work without an aggressive character can be a masterpiece. Poetry must be conceived as a violent attack on unknown forces, to reduce and prostrate them before man.'

Love of violence and professed belief in the virtue of destruction were the hallmarks of the French Symbolist literary circles which had been the main formative influence on the young Marinetti. Writers from J.K. Huysmans to Stéphane Mallarmé and Paul Valéry expressed their hatred of the mean, vulgar and money-grubbing life of the modern bourgeois through their elevation of the extraordinary, the gloriously immoral and the adventurous. In the last decade of the nineteenth century events caught up with literature in a series of daring raids and exploits that brought anarchy and Symbolism even closer together. The 'destructive gesture of the anarchist' advocated by Marinetti in 1909 had found its real-life expression in the bombs of Emile Henry, Auguste Vaillant and Ravachol (which gave the French language a new verb beloved of Symbolists, *ravacholer*), in the exploits and bank raids of the Bonnot and Marius Jacob gangs, and in a wave of outrages and assassinations that swept the capital. The poets' reactions were calculated to shock. Octave Mirbeau saw in Ravachol's explosions 'the roll of thunder preceding the joy of sun and peaceful skies'. Anarchist reviews and newspapers, the most famous of which was *Les Temps nouveaux*, published sympathetic writings by Valéry, Mallarmé, Saint-Pol Roux, Emile Verhaeren, Paul Adam and Laurent Tailhade, who was infamous for the phrase at the head of this chapter.

The writings of Pierre-Joseph Proudhon, Mikhail Bakunin, Friedrich Nietzsche and Georges Sorel informed this cultural anarchism. Most influential of all was Sorel's elevation of violence to a political doctrine. He had come to the conclusion that class struggle contributed to the vigour and health of society, and that only violence could produce the 'extreme moments', the moments of true freedom when 'we make an effort to create a new man within ourselves'. Such ideas, pursued at length in Sorel's *Reflections on Violence*, found their cultural expression in a manifesto of 1907 (two years before 'The Founding and Manifesto of Futurism') published by the Parisian group, the Compagnons de l'Action d'Art, in which violence was advocated as the means to preserve the dignity of art, under the slogan 'Long live violence against all that makes life ugly!'

What attracted a restless generation to the theories of Sorel was the seductive equation of violence and freedom. Second only to his influence on the Symbolist climate of Marinetti's Parisian youth was that of Nietzsche. Both were later to be the subjects of essays by the young Socialist schoolmaster, and erstwhile anarchist, Benito Mussolini, whose study of Nietzsche was published in the Florentine magazine *La Voce* in 1911 (see p. 165). Mussolini's interpretation of the philosophy of Nietzsche was symptomatic of the process of oversimplification and distortion to which his work has been

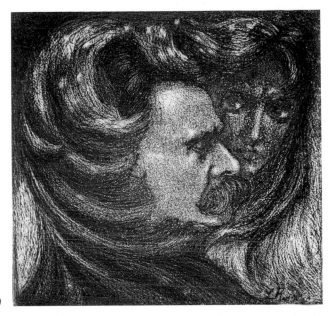

9 Russolo *Nietzsche* 1909

subjected. In this interpretation Nietz-
schean ideas of the aesthetic superman,
his advocacy of a war of opinions, his
rejection of the market place and his
misanthropy were taken out of context to
serve the interpreter's own ends. 'To
understand Nietzsche', Mussolini wrote,
'we must envisage a new race of "free
spirits", strengthened in war, in solitude, in
great danger . . . spirits endowed with a
kind of sublime perversity, spirits which
will liberate us from the love of our
neighbour.'

The shrugging off of neighbourly love
emerges in that contradictory marriage of
anarchy and nationalism which charac-
terizes this period, and which re-emerges
so stridently in 'The Founding and Mani-
festo'. Eleven years later, in 'Futurist
Democracy' of 1919, Marinetti com-
mented on the effect of this association.

'One of the sentences of the first
manifesto, . . . glorifying at the same time
patriotism and the destructive gesture of
the libertarian, seemed madness or simply
joking to political mentalities. Everyone
found it absurd or ridiculous that the
libertarian idea went hand in hand with
that of the Fatherland for the first time. . . .
How come the idea, "destructive gesture
of the libertarian", was not accompanied
by its inseparable friend, anti-patriotism?
Enormous shock for those brains, so-
called political, nourished on com-
monplaces and bookish ideologies, ab-
solutely unable to understand life, race,
crowds, individuals. But their shock was
even greater when, during that glorious
May of 1915, they again saw the strange
couple walking the streets of Milan and
Rome: Destructive Gesture of the Liber-
tarians and Patriotism, with the new names
of Mussolini, Corridoni, Corradini, Gari-
baldi, Marinetti, to the cry of "War on
Revolution" . . . We today separate the
idea of the Fatherland from that of
reactionary, clerical Monarchy. We unite
the idea of Fatherland with that of daring

Progress and of anti-police revolutionary democracy.'

It was on just these points, of course, that Marinetti and Mussolini were to fall out.

Marinetti would have been loath to admit it, but this turbulent nationalism had its precedents too. In Italy it had already been processed into a justification for Italian imperialism by 1900, when Giovanni Pascoli's oration 'Una Sacra' made the African wars respectable by presenting them as 'patriotic socialism' — the shifting of class struggle from internal to foreign politics, from classes to nations, so that the fight was between rich nations and poor ones. Much the same kind of reasoning, coupled with hatred of the past, lay behind the Futurists' later 'Interventionist' campaign for Italy's entry into the First World War, presented as Italy and France against the old tyrants of Europe, Germany and Austria.

Politicians were not alone in seeing the twin policies of nationalism and imperialism as a means of galvanizing the Italian people into acting as a nation rather than as separate states. Italy had been united as a country only since 1861, and regional allegiance, or provincialism, in culture as in politics, still came before the sense of 'Italianness'. The most vocal and energetic exponent of Italian nationalism in culture before Marinetti was Gabriele D'Annunzio, the prolific writer and man of action who prefigured Marinetti in appropriating Nietzschean ideas of grandeur and the superman to become what the sculptor Medardo Rosso called *il Presidente della Casa Io* (President of Maison Ego). The lifelong rivalry between Marinetti and D'Annunzio certainly had something to do with the larger-than-life egos of both men, but it must have been particularly irksome to Marinetti that

through his poetry and plays D'Annunzio had already expressed many of the themes that seemed so innovatory in 'The Founding and Manifesto'.

With a facility for catching on to the latest cultural currents and moods that was in contrast to the heaviness of his style, D'Annunzio had as early as 1892 sung the praises of the machinery of modern warfare in his 'naval ode', 'To a Torpedo Boat on the Adriatic'. Both D'Annunzio and Marinetti had a thematic precedent in the elegiac Symbolist verse of the Belgian poet Emile Verhaeren, whose *Villes tentaculaires* included themes of factories, stock exchanges, revolts and the future.

By the turn of the century D'Annunzio had expanded his repertoire to include political tragedy. *Glory* of 1899 tells the story of a revolt led by a young hero, Ruggero Flamma, supported by armed peasants ready for confrontation with the army. A year later D'Annunzio stood as a Socialist candidate in Florence and was defeated. However, in an interview given to the correspondent of *Le Temps* at this time his true political affinities emerge: 'You believe I am a Socialist? I am and remain an individualist to the last, a ferocious individualist. I like to go for a moment into the lions' den, but I was pushed there by disgust for the other parties. Socialism in Italy is an absurdity. Among us there is no possible action other than destruction. All that now exists is nothing, scum, death opposed to life. First of all one must defile everything. One day I will go out into the streets.'

Much of the same anti-Socialist sentiment is expressed in Marinetti's ironic dedication of his own satirical tragedy *Roi Bombance* (1905) to the leaders of Italian Socialism: 'To the great cooks of Universal Happiness — Filippo Turati — Enrico Ferri — Arturo Labriola.'

In 1903, D'Annunzio's highly coloured poem 'Laus vitae' ('Praise of Life') celebrated the confrontations between striking workers and charging cavalry that were a frequent event in those years of social upheaval. The poem was couched in an epic style and romantic tone that would be unacceptable to Marinetti a few years later, but the theme found a clear echo in 'The Founding and Manifesto': 'We will sing of the multicoloured polyphonic tides of revolution in the modern capitals. . . .' And to top it all, in 1910 D'Annunzio was among the first to see the poetic possibilities of the aeroplane in 'Perhaps So, Perhaps Not'. But, most important as a precedent for the Futurist espousal of war was D'Annunzio's excited reaction to the prospect of war in Africa. It was typical of the poet that this should emerge as a confusion of populism and imperialism with the glory of ancient Rome that was to be a keynote of D'Annunzio's later poetry and a foretaste of the official Fascist penchant for the re-creation of the style and architecture of the Roman Empire. The 'Augural Song for the Chosen Nation' is a hymn to the Italian campaign in Africa:

'So you will yet behold the Latin sea
 covered
with massacres in your war . . . Italy, Italy
sacred to the new dawn
with the plough and the prow.'

So close did the paths of the two poets move that in 1906 they both produced equally obnoxious superman heroes in works inspired by the 'African passion'. Corrado Brando, the expeditionary adventurer in D'Annunzio's tragedy *More than Love*, lives and kills for glory in the service of imperialism, his slogan being, 'If this be a crime, I wish all my virtues to kneel before my crime.' Mafarka the Futurist, hero of Marinetti's novel, is even more bumptious in his pretensions. Born, of course, without the aid of woman, Mafarka in Africa swashbuckles his way through every variation of exotic and erotic experience armed with the mighty penis that was to be the subject of Marinetti's trial for obscenity in 1910 (see p. 93); he exits only when he has compelled his slaves to build him 'a gigantic invincible bird' – a sailplane – on which to set off for even greater adventures.

Such extravagant manifestations of intransigent aggression in literature bore fruit a few years later. When the Libyan War was declared in 1911, a massive press campaign and popular feeling won over not only the Socialist party and the government headed by Giovanni Giolitti but also the revolutionary syndicalists who were now prepared to maintain that colonialism and syndicalism could go hand in hand. While D'Annunzio greeted this as the vindication of Latin-Italic history, the 'martial eagle' and the 'Libyan Sibyl', Marinetti saw in it the 'great Futurist hour' and urged the government to 'become Futurist, to enlarge all national ambitions, disdaining the stupid accusations of piracy and proclaiming the birth of Panitalianism'. Reality is sometimes even sillier than literature.

Underlying the Futurist emphasis on the will to change was the philosophy of Henri Bergson (1859–1941). Bergsonian ideas of *élan vital*, universal flux, dynamism, and the importance of intuition, coloured the general theoretical tone of Futurism, while his theories of perception were to find something approaching visual interpretation in Futurist paintings (see p. 32). In Bergson, Marinetti recognized an anti-determinist philosopher proposing a future formed not by the unchangeable forces of the past, but by the action of men in the here and now: a voluntarist philo-

sophy as expressed in *Creative Evolution* (1907). Added to this was Bergson's belief in the universality of art and the sheer vitality of creativity, made all the more relevant by his exploration of the relationships between mind and body, material and memory, time and movement, and the fact that all of these were considered in the light of contemporary scientific knowledge.

Italian painting of the second half of the nineteenth century had also reflected the course of social and political events, though in a much less overt and aggressive way than literature. Among the painters, too, the romantic spirit of the Risorgimento found its expression in realism and rebellion both against traditional academic standards of beauty and against the cultural domination of France. Italian critics were to continue to despise the home product and ignore the achievements of Italian artists, but the painters themselves proved that Italian art could be more than just a feeble imitation of French Realism, Impressionism or Post-Impressionism. The Futurists, grudging in their recognition of literary precedents, were glad to hail Italian artists like the painters Giovanni Segantini, Gaetano Previati and Giuseppe Pellizza da Volpedo, and the sculptor Medardo Rosso, as their predecessors, because they were Italian and because they had all been victims of critical Francophile snobbery.

What was new in Futurism was the will to establish an Italian national art. Groups and movements of the nineteenth century had been firmly centred in one city or another— Naples, Florence, Rome or Milan — and their character had been local rather than national or international. While Futurism was certainly a product of the industrialized and urban north, Marinetti's

internationalism brought a new dimension of experience and a firmer sense of identity to artists trapped between the achievements of the ever-present Renaissance and a shaky knowledge of contemporary developments abroad.

One of the first signs of a move away from soapy imitations of Canova's neoclassicism emerged in Naples, in the open-air painting of the Posillipo School, so called after a town near Naples. The major figure was the Dutch painter Antonio Sminck van Pitloo (1790–1837) who defied the murk of the academies and took to the country, letting air and sunlight into landscape painting. Pitloo's liberating influence bore fruit in Florence with the emergence of the first locatable 'movement' in Italian art: the Macchiaioli. Its activities spanned a thirty-year period from the 1840s to the 1870s, a time when intellectuals and artists from all over Italy were drawn to Florence because its climate and laws were more liberal than those elsewhere. Connected to the Macchiaioli were veterans of Garibaldi's campaign of 1848 and, later, those who had taken part in the independence campaigns of the 1860s. Florence offered cultural contact with the outside world through direct and indirect contact with the painters of the Barbizon School, through Edgar Degas's visits to the city, and through the writings of Proudhon and Champfleury. The Demidoff collection, which included works by Delacroix, Decamps and Greuze, was accessible to the painters.

The ideals of the Macchiaioli were Truth, Reality and Nature, and their intention was to liberate art from academic artificiality by capturing 'impressions received from reality'. Popular subjects and impressions of modern life were what concerned the major Macchiaiolo painters, Telemaco

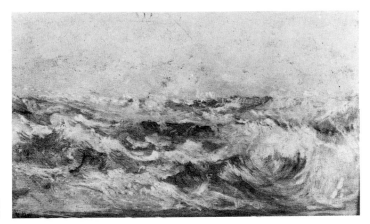

10 Fattori
Stormy Sea

Signorini (1835 – 1901), Giovanni Fattori (1825–1908) and Silvestro Lega (1826–95). As Signorini wrote in 1863, the aim of the group was the creation of an art that would be 'a page of our times, a reflection of our sentiments and of our customs'. Polemical writings on art by Signorini and others gave the Macchiaioli group the trenchant vocality that makes it a forerunner of Futurism. Another radical writer and artist, Adriano Cecioni, emphasized that new art could develop in Italy only if there was a complete break with the past: 'The Macchiaiolo painter must have neither affection for nor sympathy with the past. . . . The divorce between the modern and the old must be absolute, the disregard of history must be complete.'

The term Macchiaioli comes from *macchia* meaning mark or spot. In his autobiography, Fattori disarmingly described how the painters lighted on this technique when a friend 'showed us a painting which inspired us to see a black pig against a white wall. There's the spot.' The aim was not to dissolve figures, objects or landscapes in a shimmer of light and colour as in Impressionism, but to suggest boldly simplified form through the contrasted use of colours and chiaroscuro – 'impressions received from reality in clear Southern light', fresh, quick, bold and usually on a small scale. Signorini preferred casual scenes of town life, taking Florence or Edinburgh as they were and featuring, in *Leith* of 1880, one of the first painterly treatments of that bold new art of advertising. Signorini was considered a naturalist, while Fattori, Lega and Giuseppe Abbati (1836–68) were the 'reformists', and concentrated more on the contrasts caused by light and colour. Both Fattori and Lega had used soldiers and anti-Austrian themes as subject matter, and Abbati was the boldest of all in his dabs of form-giving colour. Fattori's favourite scenes were of work in the fields, while Lega was attracted to the ordinary life of the liberal bourgeois of Florence depicted in a style that retained more use of line than usual in the group.

In their youthful optimism the Macchiaioli had imagined that the unification of Italy in 1861 would bring a better deal for Italian artists and more serious treatment from critics and collectors. The Italian Exhibition held in Florence in that year

23

11 Signorini *Leith* 1880

Italian blend of symbolism and broken line and colour that the Futurists, and in particular the young Boccioni, took their inspiration.

Segantini was a pantheist and a socialist, a painter who believed that the artist should be educated not in the academies but in the streets and fields. In true Symbolist fashion he declared that the artist should live as an aesthete, abandoning family and wealth to devote himself to the cult of beauty, and that 'the thoughts of the artist must no longer turn to the past, but forge ahead to the future which he preconceives'. Mystical mountains and skies brought him closer to the German Romantic Caspar David Friedrich than any other Italian artist. He evolved his Divisionist technique of 'precise and richly coloured strokes' to capture a more faithful and reverent record of the light, the air and the truth of nature.

Initially Boccioni certainly owed almost everything to Previati, stylistically as well as in terms of Symbolist subject matter. Although he was to discard Previati's religious feeling, he retained more than a trace of his symbolism to the end, and his penchant for the monumental figure of his mother could well have been a leftover from Previati's favourite theme of maternity. Previati's most famous work, *Fall of the Angels*, extravagantly combines the two apparently contradictory sides of his nature. A colossal cascade of angels reminiscent of Rodin's *Gates of Hell*, silhouetted against the brilliant rays of the sun, brings together Previati the mystical illustrator of the *Divine Comedy* and Previati the rationalist, author of books on the science of colour and light, the technicalities of painting, and the physiological phenomena of Divisionism.

Previati's symbolically loaded anti-realism was to have a great effect on the

seemed to herald a new era that never came. Gradually the artists left for Paris, or stayed to meet the same lack of comprehension as before, expressed most poignantly in Fattori's late work: storm-tossed seas and wind-tormented trees.

Italian critics were just as uncomprehending of the next generation: the Divisionists, notably Giovanni Segantini (1858–99), Gaetano Previati (1852–1920) and Giuseppe Pellizza da Volpedo (1868–1907). Though their work was once again interpreted as second-best to the Parisian Post-Impressionist product, they differed radically in style and intention. 'Divisionism', in the hands of the French painters Georges Seurat and Paul Signac, meant the representation of colour and light through dots of pure colour which mixed optically, i.e. on the viewer's retina. Segantini's naturalist spiritualism, Previati's symbolism and Pellizza's social consciousness had ultimately little to do with Signac's theories. It was from their

24

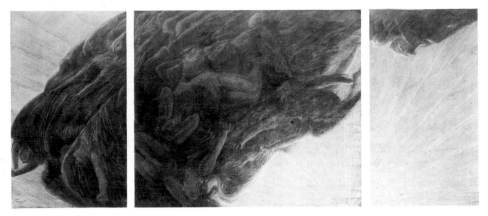

12 Previati *Fall of the Angels*

early work of the Futurist painters. So too was the almost cult-like worship of light and sun suggested by the intensity of the *Fall of the Angels*. The theme recurs in an extraordinary painting by another artist admired and defended by the Futurists. Pellizza da Volpedo's *Sun* of 1904 is a study of iridescent light, an equivalent in painting to a photograph taken looking into the sun. Composition is drastically simplified to the contrast of light and dark zones so that the shimmering beams of the sun obliterate the foreground rather than illuminate it. While *Sun* was painted in strictly Divisionist technique, Pellizza's most influential canvas, much admired by the Futurists for its social theme, was the huge *Fourth Estate* of 1896–1901, in which the treatment is closer to Impressionism, and the compositional focus centres on a powerful grouping of massed and organized workers: the new Italy.

The 'Technical Manifesto of Futurist Painting' ends with a clear statement: 'We conclude that painting cannot exist today without Divisionism.' It was from the vocabulary of Segantini, Previati and Pellizza that the young Futurists were to

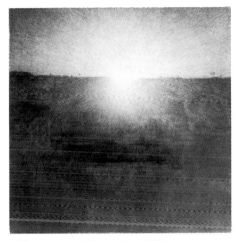

13 Pellizza da Volpedo *Sun* 1904

build up their repertoire of themes and techniques. The Divisionist style was well in evidence in their work for some time after the publication of 'The Founding and Manifesto' in 1909 and their own 'Technical Manifesto of Futurist Painting' in 1910.

Divisionist themes of city life, working life, intimist interiors and the study of light were the natural choice for a generation born, with the exception of the older Balla,

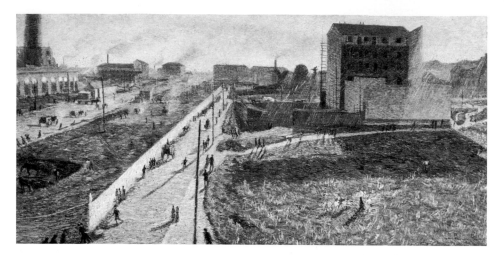

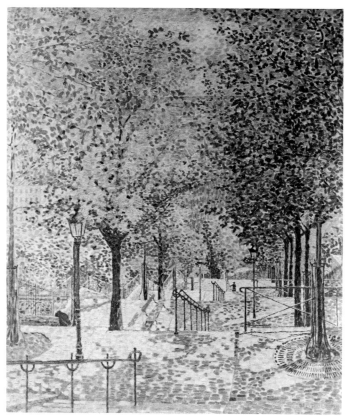

14 Boccioni
*Factories at Porta
Romana* 1908

15 Severini
Spring in Montmartre
1908

in the early 1880s. Boccioni, still searching for a personal style and approach, was the only one who had been strongly attracted to the loaded symbolism of Previati, and this mostly in his graphic work (*Crowd Surrounding Equestrian Monument* and *Ex-libris*, both of 1908). Boccioni painted the *Suburbs of Milan: Factories at Porta Romana* of 1908 in strictly Divisionist style; Carrà was seduced by the nocturnal lights of Piazza Beccaria into transforming the suns of Pellizza and Previati into glittering impressions of artificial light and city life. Severini in Paris applied a cheerful Post-Impressionism, with none of the drama of Boccioni and Carrà, to carefree scenes like the 1908 *Boulevard* (its Métro sign hinting at the future) and the Divisionist *Spring in Montmartre*. Perhaps the most significant individual development was Balla's extraordinary marriage of Divisionist touch, realist approach and social concern in large-scale canvases like *Work* and *Bankrupt* of 1902 [52–3].

The 'Manifesto of the Futurist Painters', published on 11 February 1910, adds another name to the list of Italian artists overlooked and neglected by the critics, that of the sculptor Medardo Rosso: 'Ask these priests of a veritable religious cult, these guardians of old aesthetic laws, where we can go and see the works of Giovanni Segantini today. Ask them why the officials of the commission have never heard of the existence of Gaetano Previati. Ask them where they can see Medardo Rosso's sculpture. . . .'

Two years later, when Boccioni turned his interest to sculpture, his 'Technical Manifesto of Futurist Sculpture', published on 11 April 1912, described 'the genius of Medardo Rosso, an Italian, the only great modern sculptor who has tried to open up a whole new field of sculpture by his representation in plastic art of the influences of the environment and the atmospheric links which bind it to his subject'.

Medardo Rosso (1858–1928) had been an outstanding victim of Italian neglect, and, discouraged, had virtually stopped work in 1907. Born in Turin, he spent most of his relatively few working years in Paris, where he met Soffici in 1904. During his lifetime and after, his extraordinary breakthrough in sculpture was blindly underrated as simply a sculptural form of Impressionism, or as a small-scale shadow of Rodin. Soffici and the Futurists were the first to recognize, in 1909–10, the significance of his attempt to break down the solidity of sculpture, not just through Impressionistic play of light on the surface, increased by the wax coating he evolved to enhance the fluidity of his forms, but also by expressing both the interdependence of figures and surroundings, and the unity of space, light and air. A small group of works like *Kiss under the Lamp Post* (1882) [8], *Impressions of an Omnibus* (1883–84) and *Conversation in a Garden* (1893) show how he evolved a unique genre of sculpture in which fleeting gestures and psychological moods were caught with the perceptiveness and wit of the city-dweller turning for inspiration to the life around him on the streets.

In a letter to a friend, Edmond Claris – a rare statement by an eccentric character not given to talking about himself or his work – Rosso wrote:

'In nature there are no limits, and there cannot be in a work of art. It should capture the atmosphere that surrounds the figures, the colour that animates it, the perspective that fixes it in position. When I do a portrait I cannot limit myself to the lines of the head since this head belongs to a body and exists in an environment that influences it: it is part of a whole that I cannot suppress.'

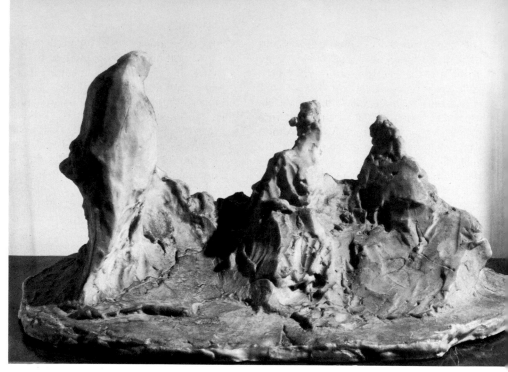

16 Rosso *Conversation in a Garden* 1893

The relationship between such perception and the 'dynamic interpenetration' described by the Futurist painters in their 'Technical Manifesto' is clear: 'To paint a human figure you must not paint it – you must render the whole of its surrounding atmosphere. . . . Our bodies penetrate the sofas on which we sit, and the sofas penetrate our bodies.'

Marinetti's group of Milanese Futurists were not the only intellectuals to defend Italian art in general and grotesquely underrated personalities like Medardo Rosso in particular. For several years magazines and scholarly yet polemical journals had provided a platform for trenchant attacks on the stagnant state of official Italian culture. The most sustained

and impressive of these had come from Florence, through the pages of the two magazines sponsored by Giuseppe Prezzolini (1882–?) and Giovanni Papini (1881–1956) – the self-styled 'villains of philosophy' who introduced themselves to their public as pagans, idealists and individualists. *Leonardo*, the first of these magazines, was published from January 1903 to August 1907. During these years it faithfully mirrored the ambivalent position of its editors and contributors. In the name of creative freedom, idealist philosophy was flaunted in the face of the prevailing positivism of Italian culture. Here there was in fact a similarity with the thinking of their rival in philosophy, and *bête noire*, Benedetto Croce, whose writings on aesthetics, although showing affinities

with the *élan vital* of Bergson, were in general too 'Hegelian', too idealist (old style), and too officially academic, for the younger generation.

In the pages of *Leonardo* the mysticism of Prezzolini and Papini found its place with the provincial nationalism of Adolfo De Carolis, attacks on and defence of the aesthetic of Art Nouveau, and enthusiasm for Symbolist literature and painting. In 1907 they were joined by the young painter and writer Ardengo Soffici (1879–1964). Soffici had lived in Paris since 1904, and had an intimate knowledge of the latest developments in French painting. His accounts of Cubism were to be the most stimulating and lucid writings on the movement to appear in Italy, while his own painting, Futurist though the titles may have been (e.g. *Lines and Volumes of a Person*, 1912; *Decomposition of Plastic Planes*, 1913), was a closely observed personal rendering of the Cubist aesthetic.

Fifteen months after the demise of *Leonardo* it was replaced by *La Voce*, which attempted to put into practice Prezzolini's tale of a young man possessed by a mysterious voice which urges him on to a campaign of moral purification. In the first issue the ultimatum was delivered in an article entitled 'Innovation and Junk': 'Old age and rubbish must not have an everlasting domain. We must make room for the young.'

The limitations of *Leonardo* had yielded to a breadth of approach that covered social, political, moral and cultural issues. The aim was nothing less than 'an integral education of man', and Croce was now back in favour as 'the poet of philosophy'. While the emphasis was firmly 'Nationalists no, but Italians yes', some of the most significant articles were Soffici's on French developments, though he sprang to the attack in 1909 when the Venice Biennale once more failed to honour Medardo Rosso. In 1911 another contributor was Benito Mussolini, still a socialist, writing on the linguistic struggle in the Austrian-ruled Trentino. Gradually, however, a split developed in *La Voce* between Prezzolini, who was increasingly concerned with political and social practicalities, and Papini and Soffici whose commitment was to poetry and art. This was eventually to result in their departure from *La Voce* at the end of 1912 to found *Lacerba*. This 'act of liberation', as Papini and Soffici called it, belongs to a later chapter (p. 166). Although the group in Florence did become to some extent the victims of what Papini called the 'provincial narrow-mindedness' of that city, and lacked the outrageously iconoclastic internationalism of Marinetti, their activities as expressed through the pages of *La Voce* were essential yeast to the fermentation of Futurism.

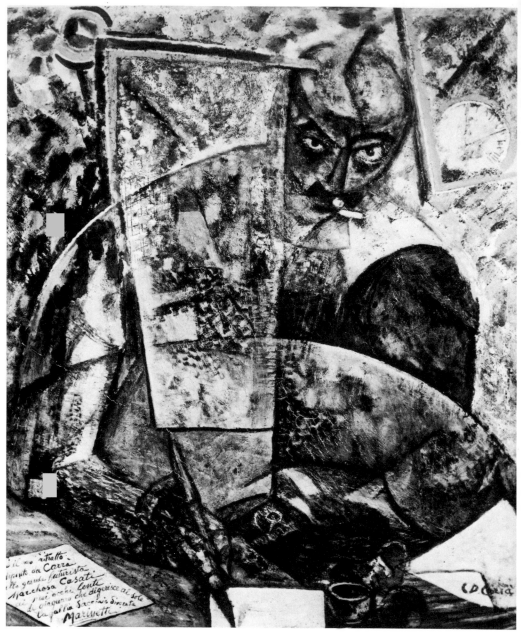

17 Carrà *Portrait of the Poet Marinetti* 1911

Painting and Sculpture up to 1913

'We wish to re-enter into life. Science of today, disowning its past, responds to the natural needs of our time. In the same way art, disowning in turn its past, must respond to the intellectual needs of our time.'
'Technical Manifesto of Futurist Painting',
11 April 1910.

The 'Manifesto of Futurist Painters' was published as a leaflet by Marinetti's magazine, *Poesia*, on 11 February 1910. A few weeks later, on 18 March, it was declaimed from the stage of the Teatro Chiarella in Turin. The audience, so the Futurists claim, numbered three thousand: 'artists, men of letters, students and others. . . . It was a violent and cynical cry which displayed our sense of rebellion, our deep-rooted disgust, our haughty contempt for vulgarity, for academic and pedantic mediocrity, for the fanatical worship of all that is old and worm-eaten.'

This manifesto was a rallying cry, not a solemn statement of artistic intent and procedure. It was a classical example of Futurist theory preceding Futurist practice and gave little idea of what Futurist painting could or would look like, which was just as well since the signatories were still painting in the manner they were soon to discard as being in itself 'passéist'. It was written in grandiose and powerful terms that suggested a thriving and extensive movement.

In fact, although the manifesto was signed by five painters, only three took an active part in drawing it up. Carlo Carrà recalled that he, Umberto Boccioni and Luigi Russolo worked at it throughout the day and were joined in the evening by Marinetti, whose intoxicated rhetoric is evident in the style of the writing. It was then sent to Gino Severini in Paris, possibly in the hope that he would be able to find more signatories there. In a similar way the commitment of Giacomo Balla (1871–1958) in Rome was sought, since he, as an older painter and teacher of Boccioni and Severini, already commanded considerable respect. Although he did sign, he was not to take an active part in the movement until 1912. 'Two other painters who were to have put their names to it, Romolo Romani (1885–1916) and Aroldo Bonzagni (1887–1918), hastily withdrew when they realized how rumbustious Futurist life was to be, though Romani should have known, since of the seven he alone had been associated with Marinetti's *Poesia*.

The manifesto was addressed to the 'Young Artists of Italy', and attacked once more everything that was old, academic, venerated, plagiarized, fossilized and commercial. Translated into the context of painting this meant down with 'the classicism of Rome, the neurasthenic cultivation of hermaphrodite archaism which they rave about in Florence, the pedestrian, half-blind handiwork of '48 which they still buy in Milan, the work of pensioned-off government clerks which they think the world of in Turin; the hotchpotch of encrusted rubbish of a

group of alchemists which they worship in Venice'.

It meant away with the self-interested critics – 'those complacent pimps' – along with ignorant professors and gouty academics. They had reduced Italian art to the 'ignominy of prostitution' while ignoring the genuine talents of the three artists admired by the Futurist painters: Segantini, Previati and Rosso.

There was little hint of what would replace this dismal state of affairs, apart from the promises of an art that would look for its inspiration to the 'miracles of contemporary life', the 'world which will be continuously and splendidly transformed by Victorious Science', Marinetti's dream-world of trains, planes, submarines and great cities inhabited by the 'feverish figures of the bon viveur, the cocotte, the apache and the absinthe drinker'. The themes and subjects of the past were to be abandoned, along with the tyranny of 'harmony and good taste'. Originality, innovation and the joyful welcoming of the smear of 'madness' were to take their place.

The vagueness of these threats and promises was remedied two months later in the 'Technical Manifesto of Futurist Painting', published, again by *Poesia*, on 11 April 1910. The key to their painting was to be the concept of 'universal dynamism' hinted at in Marinetti's initial manifesto. This was perhaps the single most prevalent preoccupation of their time, bringing together the philosophical legacy of Nietzsche and Bergson, the intuitive approach of the Symbolists, and contemporary scientific explorations of the relationship between mind and matter. Now the Futurist painters set themselves an ambitious task. Neither analysis of movement, nor the capturing in visual form of a single movement, would satisfy them.

This would merely repeat what had already been achieved in the chronophotography of E. J. Marey and Eadweard Muybridge, or in cinematography. They wanted nothing less than the visual expression of the essence: 'For us the gesture will no longer be an arrested moment of universal dynamism: it will clearly be the dynamic sensation itself made eternal. . . . Universal dynamism must be rendered as dynamic sensation.'

Science had brought new vision and new perception. There could, at least for ten years, be no more static nudes, 'as tedious as adultery in literature', and no more crusts of bitumen. The world could now be perceived as a flux of movement and interpenetration in which to paint a single object in static isolation from everything around it was to deny both knowledge of the persistence of the image on the retina and the revelations of the X-ray. Universal dynamism was the principle that drew together all objects in time and space. As Bergson had asked, 'Does not the fiction of an isolated object imply an absurdity, since this object borrows its physical properties from the relations which it maintains with all the others, and owes each of its determinations, and consequently its very existence, to the place which it occupies in the universe as a whole?' It followed, for Bergson, that 'any division of matter into independent bodies with determined outlines is artificial'. Such thoughts and the challenge of finding a form for them were to concern each of the Futurists in different ways, but as long as they shared common interests this was the central one. It gave them a means of dealing with the contemporary phenomena of speed, the machine and the dynamism of city life, since all these could be seen as extensions of the principle of universal dynamism.

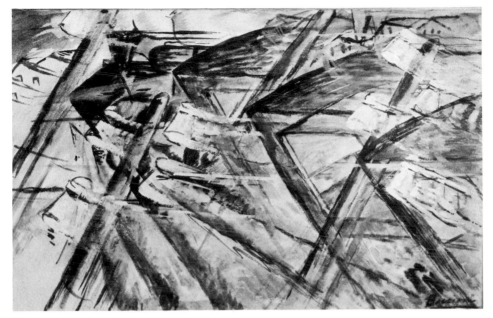

18 Boccioni *Train in Motion* 1911

The core of the 'Technical Manifesto of Futurist Painting' is a sequence of thumbnail verbal sketches illustrating this principle, a list that reads like an index of the paintings that were to appear in the next two years:

'All things move, all things run, all things are rapidly changing. A profile is never motionless before our eyes, but it constantly appears and disappears. On account of the persistency of an image on the retina moving objects constantly multiply themselves; their form changes, like rapid vibrations, in their mad career. Thus a running horse has not four legs, but twenty, and their movements are triangular.

'All is conventional in art. Nothing is absolute in painting. What was truth for the painters of yesterday is but a falsehood today. We declare, for instance, that a portrait must not be like a sitter, and that the painter carries within himself the landscapes which he would fix upon his canvas.

'To paint a human figure you must not paint it; you must render the whole of its surrounding atmosphere.

'Space no longer exists: the street pavement, soaked by rain beneath the glare of electric lamps, becomes immensely deep and gapes to the very centre of the earth. Thousands of miles divide us from the Sun; yet the house in front of us fits into the solar disc.

'Who can still believe the opacity of bodies, since our sharpened and multiplied sensitivity has already penetrated the obscure manifestations of the medium? Why should we forget in our creations the doubled power of our sight, capable of giving results analogous to those of the X-rays? . . .

'The sixteen people around you in a rolling motor bus are in turn and at the

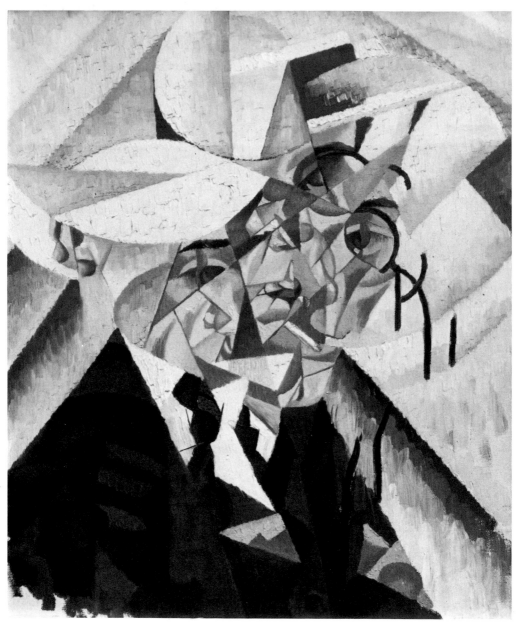

19 Severini *Self-portrait* 1912

20 Balla
Flight of Swifts 1913

same time one, ten, four, three; they are motionless and they change places; they come and go, bound into the street, are suddenly swallowed up by the sunshine, then come back and sit before you, like persistent symbols of universal vibration.

'How often have we seen upon the cheek of the person with whom we are talking the horse which passes at the end of the street?

'Our bodies penetrate the sofas upon which we sit, and the sofas penetrate our bodies. The motor bus rushes into the house it passes, and in their turn the houses throw themselves upon the motor bus and are blended with it.'

Embedded in this catechism are the precedents of Futurism: Medardo Rosso's figures jolting and lurching on a bus are there with the sun rays of Previati. From these simple formulations each painter was to take the aspect that most concerned him. For Balla it was above all the simply optical phenomena — the dazzle of fractured colour cast by a *Street Lamp*, the network of traces left by a *Girl Running on a Balcony*, the motions of a *Flight of Swifts* or the fractured spectrum of *Mercury Passing the Sun as Seen through a Telescope*. Carrà took the physicality of movement and fused it into dynamism of the city, as in *Jolting Cab*, *What the Tramcar Said to Me*, or the rush of figures in *Leaving the Theatre*. Boccioni probed deepest into the philosophy of universal dynamism, with Bergson as his mentor. There in the manifesto is the formulation of interpenetration that informed the way in which *The Street Enters the House*, how ripples of *Laughter* rise and ripple through the air like physical waves, and why a sculpture of a head must include the window through which it is seen and then the house too. Russolo's interpretations were less subtle, literal illustrations of both the manifesto and Bergson: heavy-handed demonstrations of why a head becomes *One-Three Heads* or how memory superimposes images as in *Memories of a Night*.

New techniques obviously had to be evolved. Not only movement and dynamism were to be captured. Perception of

35

colour too was heightened for the Futurists, just as it had been for the Fauves: 'How is it possible to see the human face as pink? . . . The human face is yellow, red, green, blue, violet.' But when they came to describing their chosen method it was clear little had changed since Previati and Segantini: 'We conclude that painting cannot exist today without Divisionism . . . Divisionism for the modern painter must be an *innate complementariness*, which we declare to be essential and necessary.'

Divisionism was indeed the common style that united the painters, a curiously 'passéist' position, to use their own terminology. But their work was also a curious mixture of Impressionist approach and Symbolist imagery. Boccioni acknowledged the debt to Impressionism in his book *Futurist Painting and Sculpture* of 1914, asserting that, like every other modern movement in painting then, 'our manifesto was founded on Impressionism'. Although Carrà and Boccioni must have seen Impressionism at first-hand in Paris, Futurist admiration seems to have been influenced by articles published in *La Voce* in 1909 by Ardengo Soffici: 'The movements of a figure must not stop with its contour. . . . The intensity of the play of values and the protrusions of lines of the work should impel it into space, spreading out into infinity the way an electric wave emitted by a well-constructed machine flies out to rejoin the eternal force of the universe.'

Even more startling than the Milanese painters' lack of original thought was their apparent ignorance of that revolution in painting beyond the Alps: Cubism. This

21 Russolo, Carrà, Marinetti, Boccioni and Severini in Paris 1912

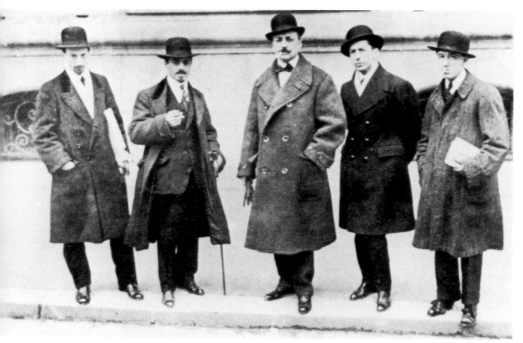

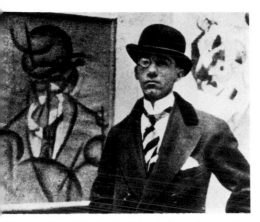

22 Severini in front of his paintings in London 1913

was not remedied until October 1911, well after Soffici had written about the Cubists in *La Voce*. Marinetti had planned to hold a major exhibition of Futurist work in Paris that autumn, but Severini, on returning to Milan, was horrified to find his fellow Futurists lagging far behind the stylistic innovations of Paris, and understandably alarmed at the derisive response such ignorance would cause in Paris. At Marinetti's expense, Boccioni, Carra and Russolo set off in November to see for themselves 'where things stood in art', as Carrà put it. What they saw sent them into a flurry of activity in preparation for their Paris début three months later. Boccioni set to work, in his own words, 'like a madman', and he, Carrà and Russolo each incorporated elements of Cubism into new works.

Although Futurism had been widely and wildly reported abroad from the day of the appearance of 'The Founding and Manifesto' in *Le Figaro* in 1909, this was the first international airing for Futurist painting. After three weeks in the plush surroundings of the Bernheim-Jeune Gallery in Paris, it went on to the Sackville Gallery in London, and then, with the help of Herwarth Walden, director of *Der Sturm*, to Berlin, Amsterdam, Zürich, Vienna and Budapest. Although Balla was listed in the catalogue for the Bernheim-Jeune exhibition as showing one work, there is no record of his having in fact taken part. But for the other four painters this was their chance to show their paces, to demonstrate that the ambitious promises of the 'Technical Manifesto' had borne fruit and that they could measure up to the most advanced art in Europe. Failure abroad, after all their derisive comments on the servile provincialism of Italian art, would have meant certain disgrace back home.

Each painter presented a group of works selected to show both his own achievement and the range of Futurism to best effect. The accompanying catalogue for the Sackville Gallery contained specially written comments on each of the paintings, together with 'The Founding and Manifesto', an updated version of the 'Manifesto of Futurist Painters' (presented as a note from 'The Exhibitors to the Public' incorporating their latest theories), and the 'Technical Manifesto', now confusingly called 'Manifesto of the Futurist Painters'. There were thirty-five works on show, not thirty-four as is usually stated (a trap for art historians lay in the numbering: the insertion of painting 26a, Russolo's *Portrait of the Artist*, added on to the apparent total). Although most of them were painted in 1910–12, the roots and origins of each painter are still visible and distinct; so too are reactions to the formulations of the 'Technical Manifesto', and the greater or lesser influence exerted by Cubism.

What they had in common was a gradual passage from Divisionism to a style and technique informed by the advanced

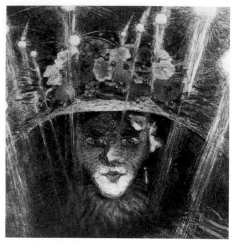

23 Boccioni *Modern Idol* 1911

24 Boccioni *Mourning* 1910

painterly practice of Paris. This set off a series of contradictions in attitude. Early Futurist painting, under the especial influence of Balla, had paid more than lip-service to social themes, presented both in terms of the tensions, disruptions and riots of a time of social upheaval, and in quieter studies of the actual material of the spreading cities. In the Cubist aesthetic attitude there was no place for this: the object itself was the arena of action. Nor was there scope for the elaborate psychological interests of Boccioni. Anxious to win the approval of Paris, they rushed into Cubism, and in so doing discarded much that, though still tentative and raw, was original and rich in possibilities.

Boccioni was the keenest to cut a bold and up-to-date figure in Paris. He pre-

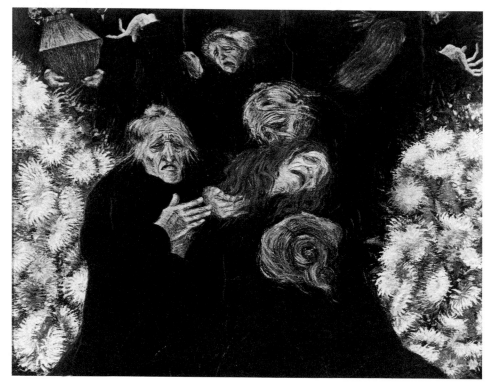

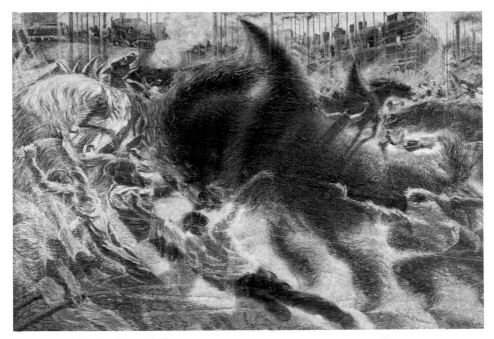

25 Boccioni *The City Rises* 1910

sented almost exclusively new works, some of which can scarcely have dried in time for the show. In spite of the Cubist-informed sophistication and philosophical references of the *States of Mind*, his Symbolist roots and Divisionist technique were still evident in *Modern Idol*, *The Laugh*, and *The City Rises Modern Idol* was certainly the ugliest image he ever painted. Described in the Sackville catalogue simply as 'Light effects upon the face of a woman', it exemplifies the darker side of his dual vision of woman. He was caught between the chaste image expressed in his early intimist portraits of his beloved mother and sister and a perverse fascination with the wan hags of Art Nouveau, who haunt his *Mourning* of 1910, and with the she-monsters of Symbolism and shady night-life, now

updated in the lurid brassiness of *Modern Idol*. Here, as in the 'Technical Manifesto', the human face is 'yellow, red, green, blue, violet'.

The City Rises, the last of Boccioni's major city subjects, was his attempt at a great synthesis of labour, light and movement. The theme goes back to the influence of Balla, with whom he had studied for a short time in Rome, an influence that was all the stronger since Boccioni, unlike Carrà, had no academic training. Balla's *Work*, *Bankrupt* and *The Workman's Day* of 1902–04 [52–4] were startlingly original attempts to make still-life close-ups of the fabric of a man-made environment the subject of painting, together with faithful reproduction of both natural and artificial light. Back in the suburbs of Milan in 1909, Boccioni

26 Boccioni
Riot in the Galleria 1910

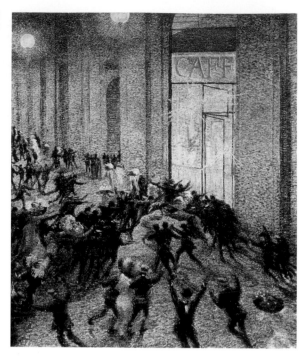

27 Boccioni *Raid* 1911

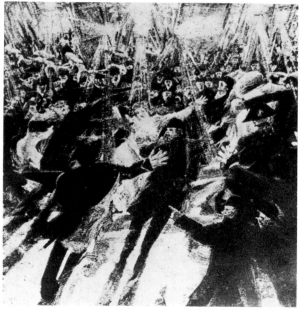

applied these lessons to the expanding factory scenes outside the Porta Romana, substituting broken Divisionist brush-strokes for Balla's realism. *The City Rises* is compositionally much bolder than these simple cityscapes, though the Divisionist touch is still there. The great horse looming in the foreground is a strangely anachronistic symbol of physical effort, power and industrialized labour.

In 1910–11 Boccioni painted three canvases round the theme of riots and confrontation between police and demonstrators. The first, *Riot in the Galleria* of 1910, was patently Divisionist, a flurry of shadow figures rushing off in the middle ground of the canvas against a backdrop of bright and dazzling café lights. As in *Raid* and *Riot* of the following year, the lights and the rush of figures moving inwards are the devices for the manifesto claim to 'place the spectator in the centre of the picture'. But in *Raid* the theory of 'lines of force', an additional device for linking up objects, is already in evidence, here still in its crude stages as solidified light streaming from background to foreground. As the

catalogue note from Exhibitors to the Public explained:

'If we paint the phases of a riot, the crowd bustling with upraised fists and the noisy onslaught of cavalry are translated upon the canvas as sheaves of lines corresponding to all the conflicting forces, following the general law of violence of the picture. These force-lines must encircle and involve the spectator so that he will in a manner be forced to struggle himself with the persons in the picture.'

After this, Boccioni turned away from social themes to subjects selected as vehicles for his painterly theories. *Laughter* of 1911 finds him in Severini's world of 'the exciting new psychology of night-life', now fused with Bergson's *Treatise on Laughter* and theories of the superimposed images of memory. Bergson describes the mechanism of laughter as 'a rationally structured system suddenly translated into a whirling machine'. In *Laughter* only the head of *Modern Idol*'s sister escapes the whirling machine. She rises intact from the network of light rays that interconnect objects and space, background and fore-

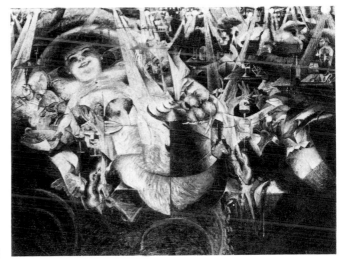

28 Boccioni *Laughter* 1911

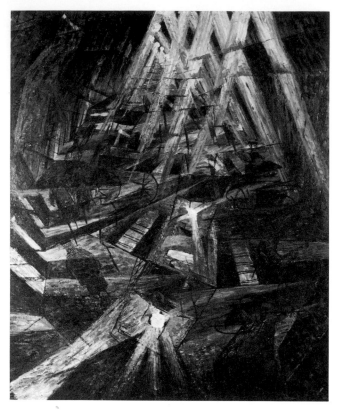

29 Boccioni
The Forces of the Street 1911

ground. Boccioni's descriptive catalogue note is at pains to make this sound Cubist, Bergsonian and scientific at the same time: 'The personages are studied from all sides, and both the objects at the front and the back are to be seen, all these being present in the painter's memory, so that the principle of the Roentgen rays is applied to the picture.'

Boccioni included three works which took these 'Roentgen rays' (or X-rays) a stage further. *The Forces of the Street, The Street Enters the House* and *Simultaneous Visions*, all of 1911, put into practice the Futurist principles of interpenetration and spatial disruption described in the 'Technical Manifesto': 'Space no longer exists: the street pavement, soaked by rain beneath the glare of electric lamps, becomes immensely deep and gapes to the very centre of the earth.' *The Forces of the Street* expressed this threatening nightmare with solidified light and the heavily Expressionist diagonal rays that Russolo was to make even more reminiscent of 'the anguish which one experiences in the modern city'. At the other end of Boccioni's stylistic spectrum was *The Street Enters the House*, closer to Severini's lighter touch and bright kaleidoscope of colour. A woman leans over the balcony and on her copious back appears a tiny horse, a cameo Pegasus illustrating the perceptual superimposition

42

described in the 'Technical Manifesto': 'How often have we seen upon the cheek of the person with whom we are talking the horse which passes at the end of the street.' (Can it be a pun that the horse now appears on the buttock cheek of the woman?)

Where *The Forces of the Street* was generalized and abstracted, Boccioni's aim in *The Street Enters the House* was to make all the elements from foreground to background, from balcony rails to the distant construction workers and the houses beyond them, perfectly legible, so that the viewer is confronted by the scene as if the canvas itself were the window. As the catalogue explained: 'The dominating sensation is that which one would experience on opening a window: all life, and the noises of the street rush in at the same time as the movement and the reality of the objects outside. The painter does not limit himself to what he sees in the square frame of the window as would a mere photographer, but he also reproduces what he would see by looking out on every side from the balcony.'

The centrepiece of his contribution to the 1912 exhibition was a group of three paintings called *States of Mind: The Farewells, Those Who Stay* and *Those Who Go*. The notion of 'states of mind', like 'universal dynamism', reached Boccioni by way of Bergson's *Matter and Memory*, and was another shared theme among the Futurist painters and many others of their generation. It was Boccioni, however, who studied it closest. In *Futurist Painting and Sculpture* of 1914 he wrote: 'The principle of pictorial emotion is in itself a state of mind. It is the organization of the plastic elements of reality interpreted through the emotiveness of their dynamism, not the transcription of images

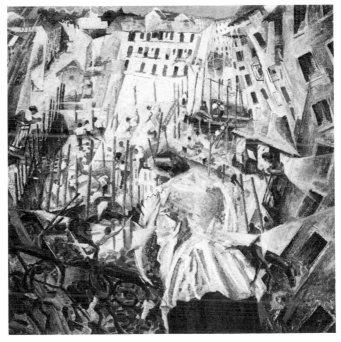

30 Boccioni
*The Street Enters
the House* 1911

reflecting literary or philosophical ideas. It is the lyrical relativity of the movements of material, expressed through forms.' The theme itself had been tackled a few years before by Charles Cottet (1863–1924); and Boccioni might well have seen his huge triptych *In the Land of the Sea* in Padua.

Boccioni's *States of Mind* were an ambitious attempt to shake off dependence on descriptive reality and to capture the essence of emotion by forcing 'colours and forms . . . to express themselves'. He painted two versions, the first in the early summer of 1911 and the second in the late autumn after his experience of Cubism. This second version was the one shown at the Bernheim-Jeune, and showed most clearly his fusion of Cubist grid and structure with the emotive directional lines of Futurist 'states of mind' painting.

The scene is a railway station as the train pulls out. The subject is the various emotions of departure. The centrepiece on which the other two depend is *The Farewells*. In the first version this is a chaos of gaseous matter painted in bold expressionist swirls. In the second the spiralling movement is still there, but is now faceted into Cubist planes. The locomotive has become visible, both from the side and face on, distinguished by boldly stencilled numbers—the hallmark of Cubist order. There is a nod of recognition to Robert Delaunay's Orphism, and in particular to his *Eiffel Tower*, in the disc-shaped clouds and iron pylon. The catalogue note added a musical reference: 'In the midst of the confusion of departure, the mingled concrete and abstract sensations are translated into force-lines and rhythms in quasi-musical harmony: mark the undulating lines and the chords made up of the combinations of figures and objects.'

The use of directional lines to represent emotion, limply characterized by Signac in 1899 as horizontal for calm, ascending for joy and descending for sadness, is even more pronounced in the flanking paintings. The excitement of *Those Who Go* is expressed with dynamic horizontal and oblique lines. In the second version the original expressionistic heads, a direct hark back to Boccioni's earlier *Mourning*, have become stylish Cubist caricatures. The dark and sombre green-black tone of both versions suggests a night journey, and on the horizon are flashes of the landscapes the train has crossed. *Those Who Stay* wade sadly through a forest of pale-green perpendiculars eloquently described as indicating 'their depressed condition and their infinite sadness dragging everything down towards the earth. The mathematically spiritualized silhouettes render the distressing melancholy of the souls of those who are left behind.'

Carrà showed eleven paintings. These showed even more clearly than Boccioni's his passage from passéist treatment and subject matter, through works that put into practice the rhythms and interpenetrations of the 'Technical Manifesto', to those painted or adapted to incorporate experience of Cubism in the months before the 1912 exhibition. Cubism at this time was a way of tightening up his composition and welding Cubist planes on to his own sharp powers of observation. Although it was to become increasingly important for him over the next few years, he was less of an obsequious convert than Boccioni.

The reasons for this can be found in Carrà's temperament and background. He was less ambitious than Boccioni, in terms both of reputation and of the aims of his painting. While Boccioni was largely self-

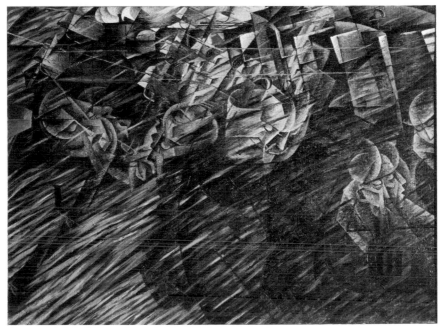

31 Boccioni *States of Mind: Those Who Go* 1911

32 Boccioni *States of Mind: Those Who Stay* 1911

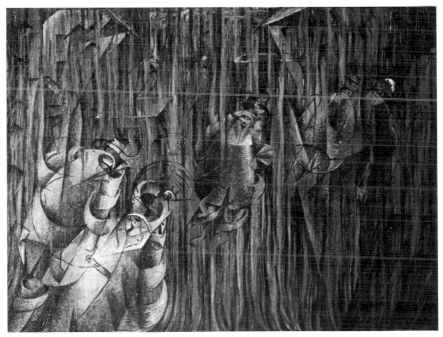

taught, Carrà had the confidence of formal training at the Brera Academy in Milan, completed in 1909. This, and his earlier experience as a mural decorator from 1895 onwards, gave him a feel for the craft of painting, for surface and texture, which remained consistent through the Futurist, Cubist and Metaphysical stages of his work. His wanderings through the capitals of Europe at the turn of the century and his spell as a decorator at the 1900 World Fair in Paris had at least given him the chance of seeing the work of an earlier generation; there was probably something in his claim that it was he who opened Boccioni's eyes to the Impressionists.

Carrà had been secretary to the Famiglia Artistica, once-radical meeting-place and exhibition space in Milan. In this capacity he had acquired quite a reputation for reviving the 'ardent and polemical tone' that it had had in earlier days. Carrà's cover for the 1909 annual exhibition catalogue of the Famiglia Artistica, however, shows a lugubrious Symbolist group of figures, and suggests that he, like Boccioni, was still groping around in the range of available styles when 'The Founding and Manifesto of Futurism' was written. This catalogue cover and a notably passéist portrait of his father (1903) are among the few works that have survived Carrà's destruction of his early output, which appears to have been distinguished by experimentation with *plein air* painting and 'sober humanitarian subject matter', certainly influenced by the anarchist thinking of the circles Carrà had frequented in Italy and abroad.

Carrà's selection of city themes was less intense and less Symbolist than Boccioni's. What interested him was the phenomena of urban life, the sensations that could be caught and interpreted in painting. A series of city scenes, including the *Nocturne in Piazza Beccaria* painted in 1909, continue Previati's Divisionist interest in light, reflections and shadows in a way similar to Balla's but with the refined and subtle colour range that was typical of Carrà. This was not in the 1912 Bernheim-Jeune exhibition, but works like *Leaving the Theatre* of 1910–11, and *The Jolting of a Cab* of 1911, show how he adapted such observations to a Futurist attitude by selecting details of city life and focusing on them. These works echo the principle of *unanimisme* formulated by the anarchist writer Jules Romains in his book *La Vie unanime* of 1909: the idea of collective experience, and in particular of the city as a shared existence. With this in mind a visual form had to be found for the manifesto slogan 'all things move'. The rush of scurrying figures broken down in bold Divisionist strokes suggests distintegration through light and colour while moving towards the device of 'placing the spectator in the centre of the picture' that Carrà was to attempt on a more ambitious scale in *The Funeral of the Anarchist Galli*.

Futurist perception of the life of inanimate matter — 'the suffering of a street lamp' mentioned in the manifesto — found a light-hearted and anecdotal echo in *The Jolting of a Cab*. Carrà's catalogue notes were indicatively simpler than Boccioni's. This painting is described as 'the double impression produced by sudden jolts of an old cab upon those inside it and those outside'. A stage later comes *What the Tramcar Said to Me* of 1911. The tightening-up process that Carrà had applied to *The Jolting of a Cab* after seeing Cubist composition is taken further in this attempt to capture 'the synchronous emotions of a passenger in a tramcar and of the spectator outside', although the anecdotal theme and the literal description of the outline of the streetcar retain a slightly naïve charm.

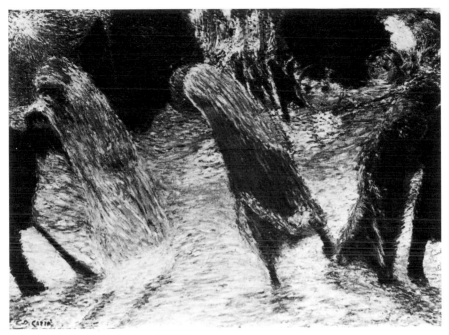

33 Carrà *Leaving the Theatre* 1910 11

34 Carrà *Women Swimmers* 1910

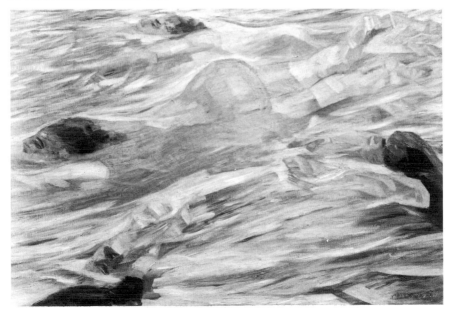

Synthesis was the theme of Carrà's much-altered *Portrait of the Poet Marinetti* of 1911: 'a synthesis of all the impressions produced by the Chief of the Futurist Movement'. Here the 'battles of planes' and 'contest of lines', added to the quizzical stare of the poet flashing those famous whites of his eyes commented on all over Europe, gives the spectator the uneasy feeling that neither the poet's pen nor the painter's brush is vehicle enough for the energy of a man of action. Carrà's aim was to transform the portrait by replacing a description of the sitter with the sensation of his character and personality. With *Women Swimmers* (1910) he attempted to do the same for the 'sensation of swimming' that had been described by the Futurist poet Libero Altomare, transforming it into the 'state of mind' of swimming in one of the oddest Futurist works of this time.

The Funeral of the Anarchist Galli (1911) was Carrà's most dramatic, ambitious and successful contribution to the exhibition. This huge canvas was also a manifesto piece and must have come close to what Marinetti had envisaged Futurist painting could be. It was not until the Interventionist period at the beginning of the First World War that specific events were to become the prime subject of Futurist painting; this was a perplexing failure to face the challenge of current events. Until then the 'multicoloured, polyphonic tides of revolution in the modern capitals' remained vague and generalized, restricted to romantic excitement in much the same way as their vision of the machine or 'victorious science'. *The Funeral of the Anarchist Galli* is an exception, but remained unique even in Carrà's work. He had, it is true, painted a kind of companion piece, *The Martyrs of Belfiore*, but this Risorgimento theme was strictly in the historical romantic tradition, and he had destroyed it by 1912.

Carrà had been present in 1904 at the funeral of one Galli, who had been killed in a demonstration. The police ordered that the funeral be held not in the cemetery but in the square in front of it, and closed off the streets. The anarchists resisted, and Carrà witnessed the ensuing battle. Carrà set out to recapture the excitement and emotion of the 'revolutionary proletariat', as he called it in the catalogue, using it as a parable of the death of the individual vindicated in the regenerative force of the masses, a theme culled from general anarchist belief, and more specifically from the *unanimisme* of Romains. Carrà pulled out all the stops, accentuating the gaping foreground composition to 'place the spectator in the centre of the picture', right in the middle of the action. The lances and the flutter of banners are direct references to Italian tradition — the battle scenes of Paolo Uccello — with the Futurist addition of multiple lines indicating their paths of movement. The violent red tone of the painting and its menacing play of light and shadow must have made an impressive contrast with the moody muted greens of Boccioni's *States of Mind*. Like these, *The Funeral of the Anarchist Galli* had been altered in the months preceding the Paris show: the upper part of the canvas was overpainted, transforming the atmosphere into a threatening bank of tactile Cubist planes, certainly much less convincing in terms of Cubism than Boccioni's incorporation of the vocabulary of planes, facets and multiple viewpoints into *The Farewells*. But then Carrà's intention at this stage was not to arrange a perfect marriage of styles. The strength of *The Funeral of the Anarchist Galli* comes from the intensity of the artist's feeling for the subject matter, and it was this, the strongest aspect of

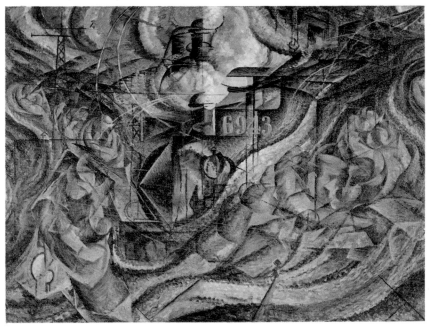

35 Boccioni *States of Mind: The Farewells* 1911

36 Carrà *The Funeral of the Anarchist Galli* 1911

Futurism, that the poet Guillaume Apollinaire, defender of Cubism, was to attack (see p. 58).

Carrà's tribute to the 'greedy railway stations that devour smoke-plumed serpents' ('The Founding and Manifesto') was more matter-of-fact than Boccioni's *States of Mind. Milan Station*, also painted in 1911, was perhaps his last painting free of Cubist influence. It makes an interesting contrast with Delaunay's *Eiffel Tower*, painted a year earlier. In Carrà's painting the spiral form and massive material nature of the iron structure spreads out and up to enclose the composition as if in a great metallic clamp. Delaunay's *Eiffel Tower* has little to do with the challenge of scale or structure. Iron is neither seen nor felt, and the skyward striding of 'giant gymnasts', the language of iron, could equally well be a pile of bricks.

Severini's eight canvases were certainly the most consistent in the 1912 show, which was not surprising since his years in Paris meant that he was not subjected to sudden revelation or hasty assimilation. He had

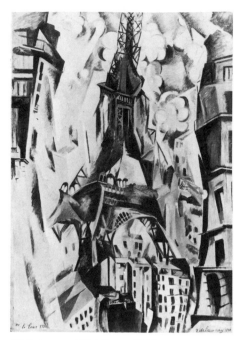

38 Delaunay *Eiffel Tower* 1911

37 Carrà *Milan Station* 1911

been embarrassed by his Parisian friends eager thirst for news of Futurist exploits after Apollinaire had reported in the *Mercure de France* on the first 'Battle of Florence', the fisticuffs that were inflicted by the Milanese group on the Florentines after Soffici's uncomplimentary review in 1911 (see p. 167). Severini saw 'those jousts' as ammunition to hostile critics.

As he said, it was in Paris that Severini was born 'intellectually and spiritually'. The Symbolists, and then Manet and the Impressionists, had been his mentors, although it was probably Balla's influence that aroused his interest in Divisionism, which found form in his *Spring in Montmartre* of 1909 [15]. There are traces in his autobiography which suggest that he too might have been a rebel had he not become accustomed to polite café society.

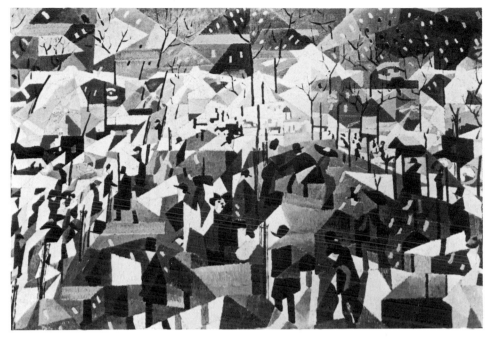

39 Severini *The Boulevard* 1909

In 1898 he had been barred from all Italian schools for some unspecified offence. When he arrived in Paris in 1906, his passion was for flying. Yet his subject matter was neither rebellious nor particularly machine-minded Café scenes, boulevards and dancers were his themes, with none of the psychological or social intensity that sometimes surfaced in Boccioni or Carrà He too, of course, shared the interest in Romains's *unanimisme*. *The Boulevard* of 1909, shown at the Bernheim-Jeune, could be an illustration of Romains's 'these are no longer movements, they are rhythms'. Colour is still applied in a Divisionist way, and movement skilfully implied through the use of the shifting viewpoint which Picasso and Braque had introduced into painting as part of the Cubist vocabulary from 1910

onwards. As the catalogue said: 'Light and shadow cut up the bustle of the boulevard into geometric shapes.' The composition was based on ingenious arrangements of triangles, with now and again a recognizable figurative detail.

In keeping with the blandness of his themes, Severini's touch had none of the ferocity of the other Futurist painters: his affinity was increasingly with Cubism. From the Divisionist dabs of *Spring in Montmartre* he moved on to bolder compositions based on flat shifting foreground planes, as in the *Milliner* of 1910, and to a range of gradated colour that was certainly more subtle and sensitive than the red-greens and heavy tones of the Milanese painters. Themes like the *Milliner* or the *Black Cat* of 1911 could, it is true, have come from the shady crannies of the

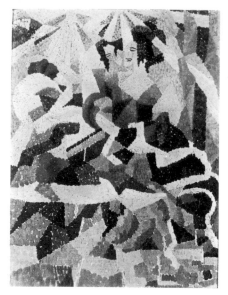

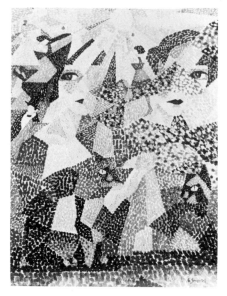

40 Severini *Milliner* 1910

41 Severini *The Obsessive Dancer* 1911

42 Severini *Black Cat* 1911

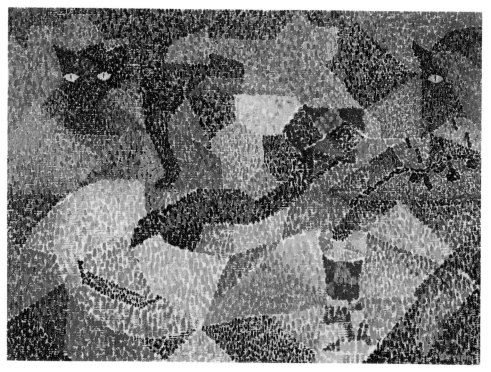

Symbolist mind, but Severini's milliner is brought out into the open, and all that is left of Poe's macabre cat are the tell-tale haunting eyes, transformed into a painterly device for transfixing the spectator.

The eyes of a cat and a dancer become the anchor points in Severini's next exercise in shifting planes. *The Obsessive Dancer* of 1911 is described as 'The sum total of impressions, past and present, near and distant, small or exaggerated, of THE DANCER, according to the various states of mind of the painter who has studied her at many periods of his life.' This study was extended to a series of increasingly complex and virtuoso *Dancers*, Severini's favourite vehicle for capturing the disintegrating effect of electric light, as in the dynamic sensation of the *Yellow Dancers* of 1911, which brought him closest to Delaunay's prismatic colour, or in the kaleidoscopic facets of their environment.

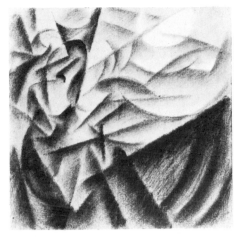

43 Severini *Dancer* 1914

44 Severini *Nord-Sud* 1912

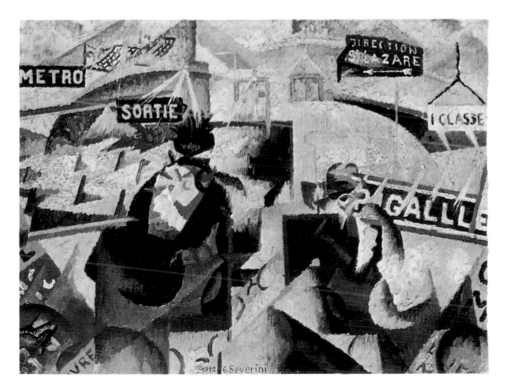

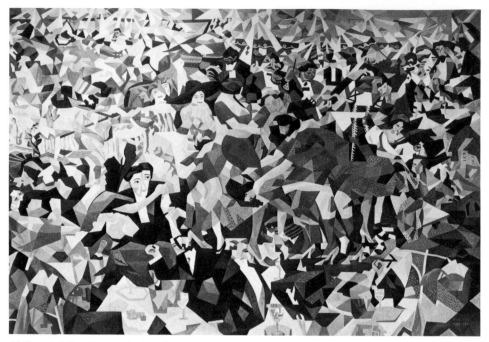

45 Severini *Pan-Pan at the Monico*

Pan-Pan at the Monico was the most ambitious of these studies of dancers: a Parisian Futurism inhabited by the 'champagne-sodden crowd, the perverse dance of the professionals, the clashing of colours and laughter at the famous night tavern at Montmartre'. His interest in light, colour and geometric shape was leading him steadily through abstracted figuration towards an abstract painting of prismatic light in a parallel course to Balla's studies of iridescent colour of 1912. Futurists prided themselves on innovation and the creation of new languages, but it should be remembered that they shared a general climate of experimentation. Pioneers of abstract painting like Frank Kupka and Wassily Kandinsky had already made their independent breakthroughs into abstraction in 1909. In their investigations of movement, too, the Futurists were not unique: by 1911 Marcel Duchamp was already exploring a sophisticated union of the phenomenon of movement and the immobile surface of a canvas on which it is portrayed, in his *Nude Descending a Staircase*.

Among his paintings Severini included only one that illustrated his Futurist researches into simultaneity and the perceptual tricks played by memory. *Memories of a Journey* of 1910–11 looks more naïve and clumsy than the polished *Dancers*, but comes closest to the ambitious Futurist programme explored by Boccioni and Russolo. It records 'the sensations of the artist's journey from his

birthplace to Paris, the proportions and values being rendered in accordance with the emotion and mentality of the painter'. The well of Severini's home town, Cortona, jostles with the Alps and the Arc de Triomphe in an indeterminate style that was to be resolved into Cubist order in later Métro scenes of 1912 like *Nord-Sud*.

Russolo's six canvases were an illustration of the points of the manifesto, literal to the point of caricature. They were the most over-dramatic and the most naïve works on show. Among the painters he was the eager dilettante, but in terms of ideas his philosophical knowledge and inventiveness was probably a stimulus to

46 Duchamp *Nude Descending a Staircase* 1911

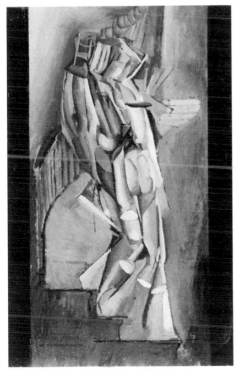

them all. He turned his hand to poetry, painting, philosophy, and, most consistently, music. In this he was the prototype of what the Futurist should be, forging links between the arts and applying Futurist principles in more than one field. His name disappeared completely from histories of Futurism until the late 1960s, partly because accounts that concentrated on Futurist art to the exclusion of other fields could not cope with this fairly incompetent painter whose interest came to an abrupt halt once he had embarked on his 'Art of Noises' (see p. 114). It was only in the 1960s that a generation tracing the roots of contemporary *avant-garde* experiment in music could hail him as a forgotten precursor of John Cage and Edgardo Varese.

Russolo came from a musical family, and became intrigued with art largely through his visits to the Brera Academy in Milan when Carrà was a student there. His technical knowledge was mostly picked up while helping on the restorations of Leonardo at Santa Maria delle Grazie, also in Milan. His earliest known works were a series of etchings of 1909, shown at the Famiglia Artistica, and including a profile portrait of the mentor of the day, Nietzsche. The style, complete with the swirling tresses of the philosopher's *alter ego*, was heavily derived from Previati [9]. This was characteristic of Russolo's literary approach. Whatever style he adopted, whether Divisionist brushstroke, Symbolist swirl, or Futurist lines of force, he laid it on thickly, making up in panache and gusto for what he lacked in subtlety and skill.

The centrepiece of his contribution to the 1912 exhibition was *Rebellion*, a subject corresponding to Carrà's *Funeral of the Anarchist Galli*. The compositional division of the canvas is the literal description

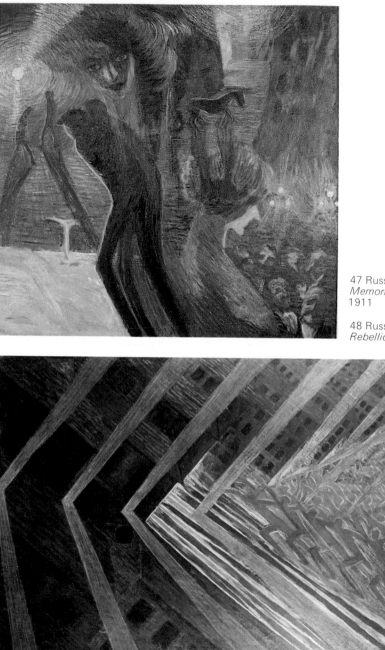

47 Russolo
Memories of a Night
1911

48 Russolo
Rebellion 1911–12

of 'the collision of two forces, that of the revolutionary element made up of enthusiasm and red lyricism against the force of inertia and reactionary resistance to tradition'. The advance of the great wedge of the masses armed with solidified Futurist lines of force makes the houses cave in 'just as a boxer is bent double by receiving a blow'.

Previati's swirling line was still there in the cascading tresses of *Tina's Hair*, another 'study of light effects upon the female face', while *One-Three Heads* was a faithful translation of the manifesto formulation 'On account of the persistency of an image upon the retina, moving objects constantly multiply themselves', a point which had already been made with more subtlety in Duchamp's first version of the *Nude Descending a Staircase* of 1911. Russolo's most ambitious attempt to illustrate Bergson's principle of psychic duration was *Memories of a Night* of 1911, completed about the same time as Severini's *Memories of a Journey*. In a bold square format, Russolo crammed together hints and echoes of the full Futurist range, failing, however, to lift them above the level of illustration. The familiar 'horse which passes at the end of the street' is there, together with the sinister stare of Boccioni's *Modern Idol*, the lamplight of Carrà and Balla and the dawning sun of Previati. For his railway contribution, Russolo froze the lines of force of a train at full speed into the 'ridge of light'.

By this time he was moving away from painting to concentrate on the development of his own machines, the Noise Intoners, which gave more scope to his inventive spirit than his clumsy attempt to capture the spiralling surge of sound in his vast painting *Music* of 1911–12.

<center>★ ★ ★</center>

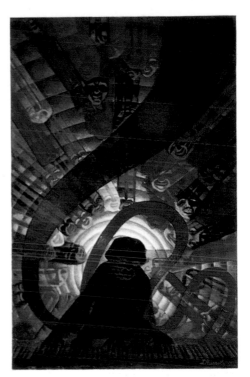

49 Russolo *Music* 1911–12

With a campaigner like Marinetti the Futurist Exhibition was bound to attract an enormous amount of attention. Carrà was overwhelmed to find *The Funeral of the Anarchist Galli* on the cover of a magazine in the city where twelve years previously, as a humble decorator, he had felt himself to be among the 'rejected'; and Boccioni rushed up to girls in the street to show them his name in the newspapers of the day. The reactions of Apollinaire, the most articulate and witty voice of the *avant-garde*, were of course a test for them all. After the painters' visit to Paris in November 1911 he had written a condescending piece in *Mercure de France*, paying less attention to their ideas than to the comfor-

table 'English' cut of their clothes and Severini's eccentric habit of wearing different coloured socks (on that occasion Apollinaire reported the right foot was clad in raspberry and the left in bottle-green). He had recognized Boccioni as the 'theoretician of the school', and, although he had not seen their work, he surmised that their intentions were 'above all to express sentiments, almost states of mind (that's an expression used by M. Boccioni himself), and to express them as strongly as possible'. He found, however, that Boccioni's description of the *States of Mind* painting on which he was working was 'above all sentimental and puerile'.

After the Bernheim-Jeune exhibition Apollinaire's attitude was still tinged with the cynicism of Paris. In his review in *Le Petit Bleu* of 9 February 1912, he ambiguously hailed the painting of states of mind as 'the most dangerous painting imaginable'. He informed his readers that the Futurists wished to reproduce movement, admitting that this was legitimate research, but one that had already been resolved by French painters 'as far as this was possible'. In accord with the canons of Parisian art he attacked them for their lack of 'plastic concern' and the importance they gave to 'subject'. 'The Futurists', he wrote, 'have until now had more philosophical and literary ideas than plastic ones.' In a backhanded final compliment he concluded: 'They will teach our young painters to have more daring, for without daring the Futurists would never have shown such imperfect paintings.'

It was from such critical comments as these that the habit of regarding Futurism as the inferior cousin of Cubism arose, encouraged partly by the Futurists' concern to conquer Paris and also by the inclusion in the Bernheim-Jeune and Sackville Gallery catalogues of conciliatory moves towards the order of Cubism. While the tyranny of words like 'harmony' and 'good taste' had been attacked in the 'Technical Manifesto' as convenient means of demolishing the work of spirited geniuses like Goya, Rembrandt and Rodin, the catalogue introduced the notion of harmony, albeit 'new harmony', as an answer to Cubism. They were trying to shrug off the label of 'primitives of a new sensibility' of which they should by rights have been proud.

When the exhibition moved to London in March 1912 it was a gift for the press and a fruitful source of ideas for the rebellious young painter and writer Wyndham Lewis (1884–1957). 'Nightmare exhibition at the Sackville Gallery,' shouted the *Pall Mall Gazette*, though its critic P. G. Konody had to admit that the Futurist painters were 'not only sincere but endowed with overabundant imagination'. The *Bystander* featured a cartoon showing the Houses of Parliament thrown into dynamic disruption by 'a Futurist Eye'. The *Daily Express* called it 'The New Terror', and the *Morning Post* (according to the painter Walter Sickert) refused to allow its critics to review a show that was in itself 'an immorality and must not be chronicled'. In an art community that ranged from the most fossilized academicism that Marinetti could have found anywhere to the incipient rumbles of rebellion that were to come from Wyndham Lewis and his Vorticist friends, reactions to the Futurist invasion were understandably mixed. For the young artists who were to become Vorticists and associates of the Rebel Art Centre the liveliness of Futurist behaviour and Futurist art came as an eye-opener, although rivalries were later to develop since the Vorticists, and in particular Wyndham Lewis, were as unwilling to be taken for tamer cousins of Futurism as the

Futurists were to be considered inadequate Cubists. But some indication of the controversy can be gathered from David Bomberg's angry allegations that Lewis had 'stolen' and 'adapted the figures of Boccioni'.

If the English art establishment, soon to be lampooned by its own rebels, had *not* been horrified, the Futurist Exhibition could only have been a failure in Marinetti's eyes. He was not disappointed. Sir Philip Burne-Jones was 'outraged by these 'ludicrous productions' which to his mind were 'outside the place of art altogether and in no way concerned with it'. He and the banker Max Rothschild had a public exchange of angry letters, Rothschild maintaining that 'when there bursts forth from one mansion a song of youth and originality, even though harsh and discordant, it should be received not with howls of fury but with reasonable attention and criticism.' He put his money where his mouth was by buying several works, and when the exhibition went on to Der Sturm in Berlin a Dr Borchardt bought twenty-four more.

While in London Marinetti gave interviews galore to an insatiable press. He flattered the *Evening News* by announcing 'Why, London is a Futurist city.' Its flashing lights, its advertisement-plastered buses and, above all, its Underground had given him a novel experience: 'I got what I wanted: not enjoyment, but a totally new idea of motion, of speed.' At the same time he castigated English painters for failing to grasp the wonder of their marvellous city: 'Your painters live on a nostalgic feeling, longing for a past that is beyond recall, imagining they live in the pastoral age.' In a lecture at the Bernstein Hall on 19 March 1912 he congratulated England on 'her brutality and arrogance', as well as on her material success, but upbraided her for

being 'a nation of sycophants and snobs enslaved by old, worm-eaten traditions, social conventions and romanticism'. *The Times* reported that on the receiving-end of this 'impassioned torrent of words . . . some of the audience begged for mercy', and concluded that the 'anarchical extravagance of the Futurists must deprive their movement of the sympathy of all reasonable men'.

But it was not the sympathy of reasonable men that interested Marinetti. With '350 articles' as proof of the impact the exhibition had made in Paris, London, Berlin, Brussels, The Hague, Amsterdam and Munich, and with 11,000 francs worth of sales, he felt the tour had been 'a colossal success'. A group of Italian artists with demonstrably shared interests had succeeded in making their mark outside Italy. Encouraged, financed, and to some extent cajoled by him, they had produced over the space of two years a body of work in which most of the major themes of Futurism found more or less convincing visual expression. If they shared a naïvety in the face of the machine, and a lack of grasp of the social implications of a world in a state of change, then he was not the one to criticize them.

It was after the hectic months of the touring exhibition that the Futurist painters began to work more independently of each other. The absence of collective manifestos at this time is indicative of the way in which each painter was beginning to work out his own direction, although all were to rally to the Interventionist cause in 1914 (see p 174).

Carrà's interest became increasingly analytical, and, as far as the idea of Futurist dynamism was concerned, he was already leaving the fold by 1913. In spite of their titles, paintings of 1912 like *The Galleria in*

Milan and *Centrifugal Forces* were basically static works. His friendship with Soffici and the experience of Cubism had made him take stock of his ideas. He was to move through Cubism in much the same way as through Futurism, relying on instinct more than theory. Severini's themes were already clearly defined within an increasingly abstract treatment of dancers and light, while Russolo, although continuing to paint movement with ever-heavier abstracted lines of force, was devoting most of his time to the Noise Intoners.

50 Carrà *The Galleria in Milan* 1912

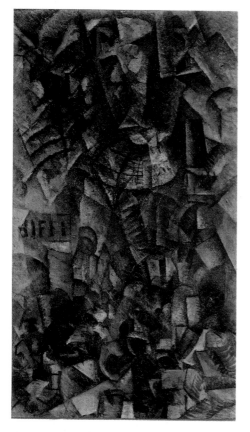

It was exactly at this stage that Balla began to play an active part in Futurism, exhibiting for the first time with the other painters at the Teatro Costanzi in Rome in February 1913. Until then he had taken little or no part in their activities, although among the older generation he alone had encouraged Boccioni and Severini, and although he had set an example with his innovatory treatment of social themes. The support he had given by putting his name to their manifestos had been important for all of them. There were several reasons for his reticence. To begin with he was in Rome, not Milan, and he had a family to keep. Even though he was established, his association with Futurism probably lost him much of his clientele. A letter of 1910, from Boccioni to Severini, reported that 'Balla sells nothing and is obliged to give lessons and is almost starving'. A year later he was reduced to submitting an academic portrait of the Mayor of Rome to the World Fair in Rome, presumably in an attempt to win back a measure of official approval.

This is all the stranger since in that year, with preparations for the Bernheim-Jeune exhibition afoot, it must have seemed that Futurist painting was on the brink of international recognition. Even odder, and still unexplained, was Balla's absence from that exhibition. Even *Street Lamp* (*Suffering of a Street Lamp*) of 1909, the only work listed in the catalogue, was not in fact shown. It could be that the other painters were so engrossed with the development of innovatory technical devices to bring them up to date with Cubism, that they felt Balla to be lacking in overt Futurist intent. Later he too was to adapt 'lines of force' and 'paths of movement' to his interest in light and motion, but the early stages of his work could quite easily have formed the basis of a completely different Futurist approach. The social themes of *Work* and

51 Balla *Street Lamp* 1909

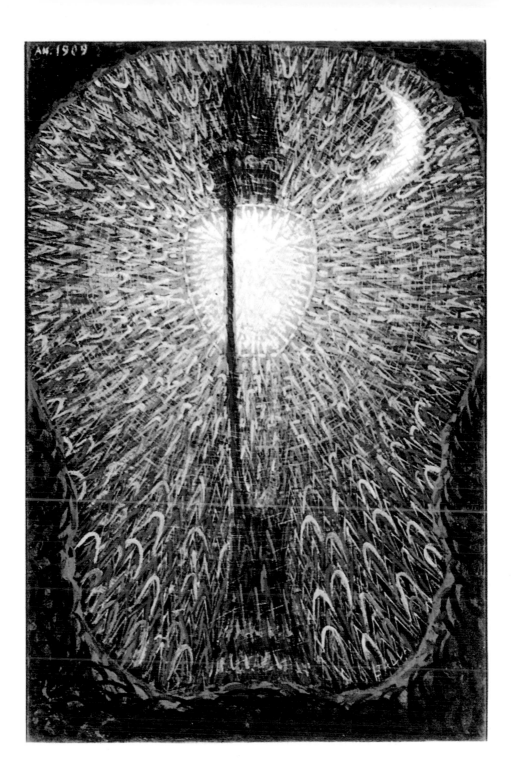

Bankrupt of 1902 in which the emotiveness of Segantini and Pellizza da Volpedo were developed into a personal yet objective approach, are clear enough. But there is much more to them than that. Both show an intense interest in the physical structure of urban life, right down to bricks and mortar and the effort that goes into raising them. In *Bankrupt* Balla combined realism with innovatory compositional daring, derived partly from the bold angles and surface detail of photography *Bankrupt* was like a life-size chunk of city brought into the gallery space, designed to rest on the floor to emphasize the effect of a section of street complete with pavement and the graffiti that built up on a bankrupt's door. In *Work*, the same bold composition and surface detail are carried a stage further through close attention to effects of light.

While photography had influenced the daring angles of these early paintings, cinematic sequences of changing light and passing time seem to have played a part in the conception of *The Workman's Day* of 1904. Three different panels express the changing light and shadow of different times of day. The viewpoint shifts, the workers come and go, dwarfed by the scaffolded shell of yet another rising building. The day moves on from dawn in the scaffolding of the top left panel, to bright midday in the bottom left, with the crouching figures of workers eating in the blazing sun, and ends with the large panel on the right in which the shadowy workers disappear into the deeper shadows of the darkening city. The treatment is mildly realist throughout, yet the effect of changing light and passing time is as powerful as later complicated Futurist devices to illustrate such syntheses.

Boccioni criticized Balla in a letter to Severini of 1907, stating that 'his universe does not throb'. *Waving Goodbye*, c. 1908, could almost have been an answer to this. Again the compositional angle is photographic: a stairwell seen from above, down which waving figures move into the spiral of the repeated pattern of stairs and banisters. The downward movement of the women, the upward direction of their waves and the implied sound of their voices echoing round the stairwell are again an intimation of the principles of Futurism, achieved not through technical and stylistic innovation but by adaptation of Balla's own vocabulary to a new range of expression.

52 Balla in front of *Bankrupt* [109] c. 1929

This was still true of Balla's early Futurist works. In terms of subject the *Street Lamp* of 1909 which failed to turn up in Paris could be interpreted as a visual equivalent of the declaration in the 'Technical Manifesto of Futurist Painting' that, 'The suffering of man is of the same interest to us as the suffering of an electric lamp, which, with spasmodic starts, shrieks out the most heartrending expressions of colour.' Balla had found his inspiration in one of the first electric street lamps installed in Rome, a subject which, as he put it, was 'called by all inartistic and painted by me for the first time'. Needle-

53 Balla *Work* 1902

54 Balla *The Workman's Day* 1904

sharp hairpins of brightly coloured light dart out from the lamp, throwing into shade the pale sickle of the moon that had already been threatened in Marinetti's manifesto 'Let's Kill the Moonlight' of the same year. *Street Lamp* was probably painted in a flash of enthusiasm to greet the new movement. After that came the hard years described in Boccioni's letter, and it was not until 1912 that Balla returned to Futurist themes with *Leash in Motion* and *Rhythms of a Bow*. Both are studies of movement, with none of the philosophical and emotional complications of Carrà and Boccioni. It was the physical phenomena of light and movement that intrigued Balla, and the challenge of combining them with the bold compositional angles and skilful brushwork of his own style. *Leash in Motion* is a light-hearted study of a diminutive dachshund trotting along in a flurry of scampering legs and wagging tail next to the feminine swirls of his mistress's skirts and dainty boots, and comes close to being a kitsch symbol for the Futurist principle of paths of movement. *Rhythms of a Bow* may have been painted as part of a decorative scheme for a room in the house

56 Galli *Vibrations* from *Novissima* 1904 [cf. 57]

of one of his private pupils, a Frau Löwenstein in Düsseldorf where he spent some time in 1912, a foretaste of the furniture and room designs he was to do after the war. This would explain the curious triangular shape of the frame of the painting, although the triangle for Balla was also a synthetic symbol of movement. The violinist's hand is featured 'moving in different positions and inserted into the landscape of the continuously active bow' as he described it: movement expressed by a muted chiaroscuro play of tones.

In 1912, the study of colour harmony and light rays, laid out in geometric prisms and repeated series of dovetailed tones, brought Balla to a pioneering abstract stage. The *Iridescent Interpenetrations* preceded Severini's abstract studies of prismatic light and colour by two years, and put Balla in the forefront of abstract experimentation along with Kupka. Some were small watercolour sketches on paper, others fully worked up three-foot-wide oils on canvas, though these too could have been intended as studies for paintings like *Rhythms of a Bow*. They may

55 Balla *Leash in Motion* 1912

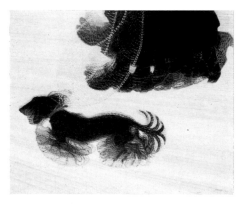

57 Balla *Rhythms of a Bow* 1912

58 Balla *Iridescent Interpenetration No. 1* 1912

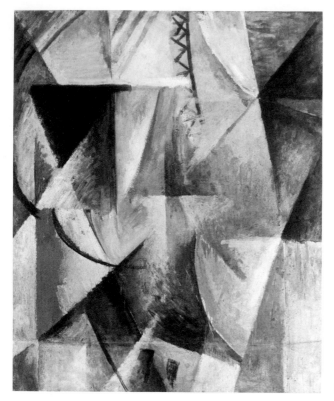

possibly have been partly inspired by Delaunay's *Window* series, which was certainly known in Düsseldorf. In a letter home enclosing a small example, Balla wrote: 'First enjoy a little bit of iridescence ... it is the result of an infinite number of trials and experiments and the pleasure it gives was finally found in its simplicity. The study which went into this will bring about changes in my work, and the rainbow will be capable – through my observation of reality – of possessing and giving an infinity of colour sensations, etc etc. ...'

Back in Rome later in 1912, Balla took a step backward to take a step forward. He embarked on a renewed study of motion. The first result, *Girl Running on a Balcony*, was little more than a clumsy body placed around the lines of motion located in Marey's pioneering chronophotographic analysis of the trajectories of running figures, and a contemporary line drawing of the same theme is even closer to Marey's white lines on black. Through the next year he was to develop a much more fluid and original expression for his passion for light and flight. In 1913 the essence of speed for Balla was to be found, not in the machines celebrated by Milanese Futurists, but in the southern rhythms of *Flights of Swifts* [20]. In early versions of the theme his interest was in the swifts themselves and the sequential stages of their bodies in motion across experimentally decorative backgrounds. But gradually the paths of their

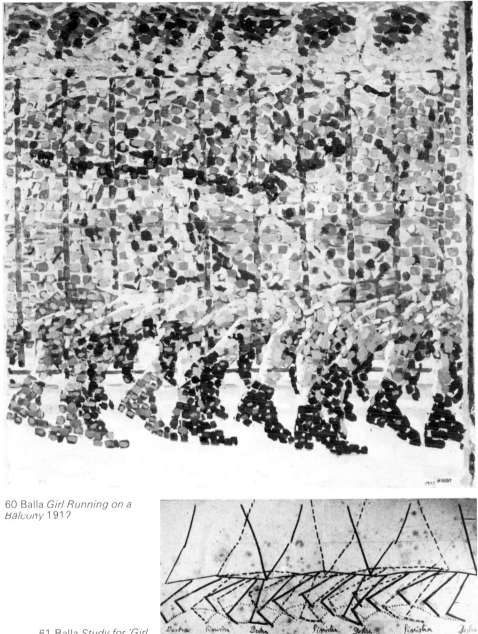

60 Balla *Girl Running on a Balcony* 1912

61 Balla *Study for 'Girl Running on a Balcony'* 1912

movements took over, tracing complex webs of flight across the whole canvas. Balla's late involvement with the technical mechanics of the other painters now stood him in good stead. With *Paths of Movement ÷ Dynamic Sequences* he was able to fuse the most challenging aspects of their researches on to his own development. It was only after this that he turned to more mechanical forms of speed, passing first through the bold abstract planes of works like *Abstract Speed*, based on the stark repetition of luminous discs and dark solid lines of force. When he painted *Speeding Automobile*, 1913, he did not need, like Russolo, to fall back on heavy hints of the vehicle's shape: it was synthesized in the paths of its passage. His interest in scientific optical equipment had

been suggested in another painting of the Düsseldorf stay in 1912. *Window in Düsseldorf* featured a pair of realistically painted binoculars placed prominently in the foreground, suggesting the means by which the spectator could penetrate the hazy expanse of the Rhine beyond the window.

Balla's treatment of spatial atmosphere became more sophisticated and cosmic through the studies of abstract speed, until with *Densities of the Atmosphere* he was aiming at a concept of space that, as he said, 'has more to do with the voices of the infinite than with our own'. *Mercury Passing the Sun as Seen through a Telescope* [161], which was painted in the excitement of an eclipse of the sun in November 1914, extended the earthly field

62 Balla *Abstract Speed* 1913

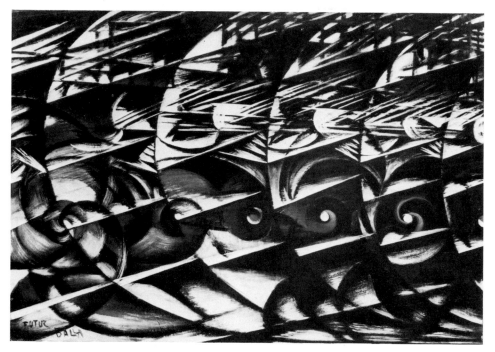

63 Balla *Window in Düsseldorf* 1912

of vision suggested by the binoculars into the prismatic swirl of space, and was the culmination of his 'scientific' optical interest.

It was in 1912–13 that Balla threw in his lot completely with the Futurist movement. As he later recalled, 'Friends took him aside imploring him to return to the right course, predicting a disastrous end. Little by little acquaintances vanished, the same thing happened to his income, and the public labelled him MAD, BUFFOON. At home, his mother begged the Madonna for help, his wife was in despair, his children perplexed . . . but without further ado he put all his passéist works up for auction, writing on a sign between two black crosses: FOR SALE – THE WORKS OF THE LATE BALLA.'

After this his inventiveness flourished. From 1913 to the end of the war he experimented with sculpture constructions, manifestos, Words-in-freedom compositions, Futurist Evenings and Synthetic Theatre, even aspiring (in tandem with Fortunato Depero, a later and younger adherent) to 'The Futurist Reconstruction of the Universe' (see p. 195).

His painted studies of the paths of movement and the forms of trajectories put Balla in a good position for another pioneering experiment, this time in ab-

64 Balla
Design for 'Line of
Speed and Vortex' 1913

stract sculpture. In 1914–15 he did a number of watercolour designs for sculptures which, had they been realized then instead of posthumously in 1968, would have been as revolutionary as Vladimir Tatlin's *Corner Reliefs* (1915). With titles like *Line of Speed and Vortex*, *Line of Speed and Noise Form*, or *Vortex and Volume Form*, these were to be simple lines in three-dimensional space, painted red or blue according to direction and function. These designs were reproduced in the leaflet 'Futurist Reconstruction of the Universe' in March 1915, along with the *Plastic Complexes* described on p. 195. Apart from these, Balla's main contribution to a form of sculpture that could be called abstracted rather than abstract was *Boccioni's Fist*, the demonically energetic synthesis of the lines of force of Boccioni's body landing a punch, carried out in red-painted cardboard in 1915, and adopted, as a line drawing, by Marinetti as the symbol of the Futurist movement.

There was certainly a paradox in Balla's work. He was the most naturally inventive of the Futurist painters, coming up with radical concepts of abstract colour painting and sculpture that were far ahead of their time. At the same time he was the one who pursued optical analysis the furthest, certainly rivalling in paint what Bragaglia was doing in photography (see p. 138). Yet he was remarkably spendthrift with his ideas. This may be a sign of strength in a Futurist, but it remains perplexing in a painter.

The most consistent body of Futurist sculpture was made by Boccioni between 1911 and 1914. Unlike Balla, whose approach was basically intuitive, Boccioni set about it armed with theory. Yet it was a theory which emphasized intuition above all: Bergson's concept of intuition as an essential part of creativity. This had already become a complicated theoretical exercise by the time Boccioni came to translate Bergson's 'simple act' into 'intuitive gestures'. In fact the most 'intuitive gesture' to be found in Futurism was indeed in the field of sculpture, in Francesco Cangiullo's *Philosopher*: a head of wet clay slapped into shape with proto-Dadaist blows in front of the spectator's eyes. The kind of intuition that Boccioni was to pursue in

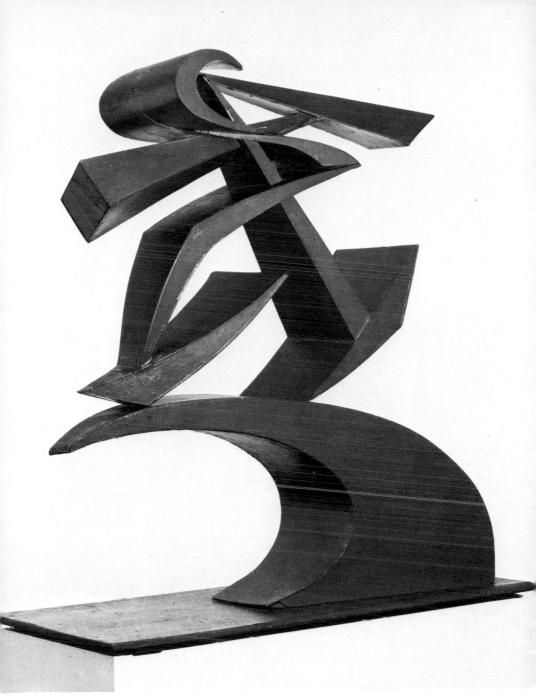

65 Balla *Boccioni's Fist* 1915

sculpture had less to do with spontaneity than with what he called the 'terrible tension in the artist', akin to André Breton's 'convulsive beauty'. According to Bergson, life itself is grasped through intuition. Life for Bergson, and for the Futurists too, was an indivisible whole; in the last analysis, mind = matter. This whole was the *Materia* that was the title of several paintings by Boccioni. Now in sculpture he wished to take this a stage further, and depict matter in terms of movement and duration: 'Instead of breaking up reality into individual natural elements, we want to render *life* as *matter*, revealing in it its quality as movement.'

Boccioni's written attempts to free his art from accusations of plagiarism of Cubism — including the statement that 'Picasso extracts dead elements from the object with which he will never succeed in making a living thing' — help to clarify the reasons for his sally into sculpture. Attempts at three-dimensional Cubism like Picasso's *Head* of 1909 did not really make sense. Cubist dissection had little meaning when reassembled in three dimensions, as Boccioni must have realized when he saw the work of Picasso and Alexandre Archipenko in Paris. Futurist lines of force and interpenetration of planes, on the other hand, could perhaps be applied still further in sculpture than in painting, with the added advantage that the contact with 'matter' would be even more direct. And then it was part and parcel of those years of experiment that painters should explore the boundaries of their field. In the space of a few crucial years, Picasso, Tatlin, Alexandre Archipenko, Henri Matisse, Kurt Schwitters, Hans Arp and others were to take what Tatlin called 'the culture of materials' beyond traditional canvas and paint, and Boccioni's sculpture belongs as much to this context as to the climate

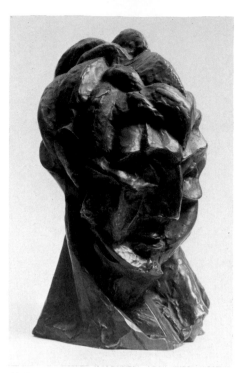

66 Picasso *Head* 1909

of Futurist experiment of which Balla was part.

Boccioni's period of sculptural activity was short but intense, reaching a peak in 1913–14, a time when he also produced sixty paintings and drawings, his book *Futurist Painting and Sculpture* (featuring twenty-two illustrations of his own work and six only of each of the other painters), and numerous articles. Of a probable total of thirteen sculptures only four survive: *Antigrazioso* of 1912, *The Development of a Bottle in Space* and the *Unique Forms of Continuity in Space*, both of 1913, and his last one, *Horse + Rider + Houses* of 1914. The others, it seems, were destroyed after a memorial exhibition of his work which was held in Milan after his death in 1916.

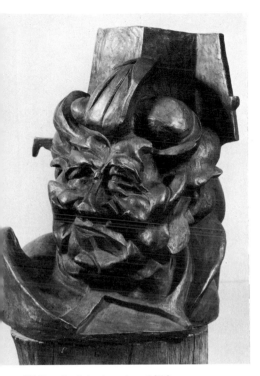

67 Boccioni *Antigrazioso* 1912

The principles of Boccioni's sculpture were expressed in his 'Technical Manifesto of Futurist Sculpture' (1912) in a more radical form than he was in fact able to achieve. The date of this manifesto, published by *Poesia*, is given as April 1912. (This, like Boccioni's dating of several of his sculptures, is doubtful. In the months before April he had been so busy with the exhibition at Bernheim-Jeune and the Sackville Gallery that it seems unlikely that he could have produced the manifesto then. In a letter from Paris to his friend Vico Baer of 15 March 1912 he wrote: 'In these days sculpture obsesses me. I think I have seen the way to a complete renovation of this mummified art', words reminiscent of Baudelaire's condemnation of 'this Carib art'. He could hardly have had time to get the manifesto written and printed back in Milan during that following month. And strange too is his omission of any reference to the manifesto in a letter to Carrà of 12 April. Boccioni's manifesto quotes Marinettian phrases like 'Words-in-freedom' and 'Imagination without Strings' that did not appear until May 1912 in Marinetti's 'Technical Manifesto of Futurist Literature'. All in all, it seems most likely that it was not actually published until August 1912, and that two sculptures, *Fusion of Head and Window*, and *Head + House + Light*, mentioned by Boccioni in *Futurist Painting and Sculpture* as being of 1911 were in fact of 1912.)

In 'Technical Manifesto of Futurist Sculpture' Boccioni analysed the work of

68 Boccioni *Abstract Voids and Solids of a Head* 1912

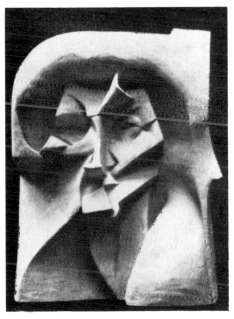

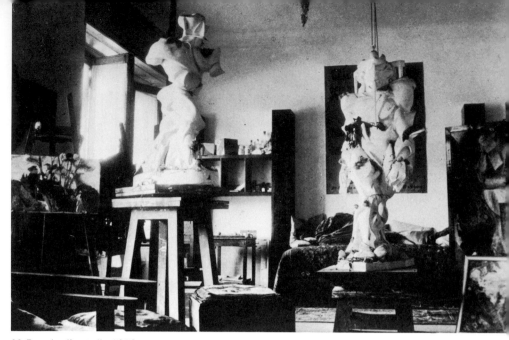

69 Boccioni's studio 1913

the four sculptors he considered significant. Three of these he found to be lacking in originality: Constantin Meunier was in the shadow of the Greeks, Emile Antoine Bourdelle in that of the Gothic spirit, and Auguste Rodin was under the influence of the Italian Renaissance. Only Medardo Rosso was singled out for work that was 'revolutionary, modern, profound and necessarily contained. In his sculpture there are no heroes and no symbols, but the planes of the forehead of a woman or a child which betray a hint of spatial liberation, will have far greater importance in the history of the spirit than that with which he has been credited in our times'. But the perceptions of Rosso were limited by Impressionism to 'high and low relief. . . . This shows that he still conceived the figure as a world unto itself with a traditional foundation and descriptive intentions.'

This was a crude analysis of Rosso's achievement in which Boccioni, to strengthen his own argument, seems to have confused Rosso's aim, that of seizing everyday reality and fugitive light, with Impressionism. In his own search for epic and heroic movement Boccioni also overlooked the antenna-like sensitivity with which Rosso captured the movement of air and light.

The most outspoken section of Boccioni's manifesto attacked the 'monstrous anachronism' of sculpture. The academic concept of the nude had much to answer for: 'An art that must take all the clothes off a man or a woman in order to produce any emotive effect is a dead art.' For Boccioni the essence of sculpture lay not in 'reproducing the external aspects of contemporary life', but in 'the vision and conception of the lines and masses which form the internal arabesque. . . . We must

74

take the object which we wish to create and begin with its central core. In this way we shall uncover new laws and new forms which link it invisibly to an EXTERNAL PLASTIC INFINITY and an INTERNAL PLASTIC INFINITY. This new plastic art will be a translation, in plaster, bronze, glass, wood or any other material, of those atmospheric planes which bind and intersect things.' This concept of the essence of sculpture was grandly called by Boccioni 'Physical Transcendentalism', and shows again how the experimental climate of the times formed a link between artists who were seeking a new expression of the reality beneath the surface. The results were to be very different, but in the basic premises there are parallels, notably with Naum Gabo's 'Realist Manifesto', Moscow 1920.

The most celebrated section of the manifesto was an advance formulation for a later international generation's experiments with materials: 'Destroy the literary and traditional "dignity" of marble and bronze statues. Refuse to accept the exclusive nature of a single material in the construction of a sculptural whole. Insist

10 Balla *Coloured Plastic Complex* 1914–15

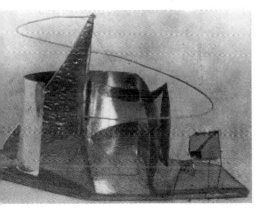

that even twenty different types of material can be used in a single work of art in order to achieve plastic movement. To mention a few examples: glass, wood, iron, cement, hair, leather, cloth, mirrors, electric lights, etc.'

Balla and Depero were to come closer to putting this list into practice, with the *Complexes* of 1915, than Boccioni ever did. His prescription for the inclusion of such materials sounded more like a foretaste of their work than his own: 'transparent planes, glass, strips of metal sheeting, wire, street lamps or house lights may all indicate planes — the shapes, tones and semi-tones of a new reality'. Although Boccioni's first sculpture, the ungainly *Fusion of Head and Window*, and his last, *Dynamic Construction of a Gallop: Horse + Rider + Houses*, did include more than one material, traditional plaster was the medium he used consistently. Three of the surviving sculptures probably escaped destruction because they were cast in passéist and durable bronze. His subjects too were limited to reinterpretations of traditional things: the head, the figure, the still-life bottle, rather than the invention of new or abstract themes.

Fusion of Head and Window was an extraordinarily inelegant attempt to fuse together elements of art and reality. A real window frame, complete with metal catch and triangles of glass, crowned the sculptured head with its braided chignon of apparently real hair in an almost literal parody of the Futurist principle of interpenetrating planes, emphasized still further by the diminutive house that flanked the head. Most of the studies for *Fusion of Head and Window* are dated 1912, and feature the solidified rays of light passing over the head that had already appeared in the drawing *Counterlight* of 1910 and in the painted rays of

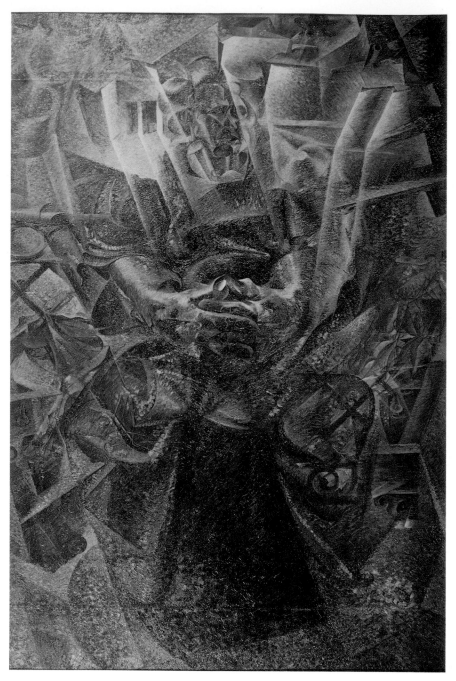

71 Boccioni *Materia* 1912

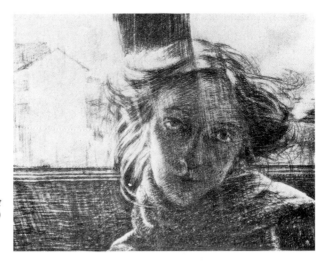

72 Boccioni *Counterlight*
1910

73 Boccioni *Fusion of Head
and Window* 1912

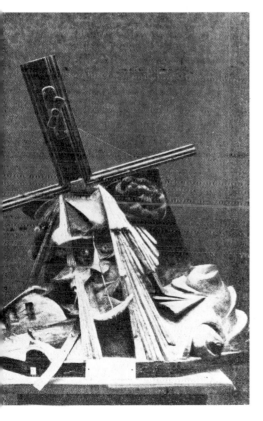

Simultaneous Visions of 1911. This was an unconvincingly self-conscious start, but the next pieces, *Head + House + Light*, found Boccioni more at ease working in plaster and limiting material experiment to details like the iron balcony railings. The scale of this—as of several other sculptures – was impressive. It was basically a life-scale bust of his mother, shown in her familiar position, hands on lap, as in paintings like *Materia*, and in the *Horizontal Construction*, also of 1912. In fact its conception and composition were less radically different from his painterly approach than the bold words of the manifesto would lead one to expect. The figure is massively central, and the elements of house and light, though suggesting that the perception of the figure must continue beyond her physical limits, do little to lessen the frontal composition that Boccioni criticized in others.

Head + House + Light was among the eleven 'plastic ensembles' that Boccioni showed in the Galerie Boétie in Paris in June–July 1913, and the other ten were certainly done in the twelve months before

that. On show too were twenty-two drawings accompanied by short statements of intent:

'I want to render the fusion of a head with its environment.

'I want to render the prolongation of objects in space.

'I want to model light and the atmosphere.

'I want to transfix the human form in movement.

'I want to synthesize the unique forms of continuity in space.'

The exhibition opened on 21 June 1913, and the next day Boccioni delivered a lecture, helped by Severini. Language difficulties made this a somewhat confused occasion, by all accounts, and Severini recalled that at one point an exasperated Boccioni exclaimed: 'It's not words I lack, but ideas!' He was, however, able to express his ideas both in a

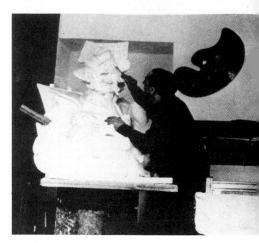

75 Boccioni working on *Head + House + Light* 1912

presentation for the exhibition and in an account of the lecture in *Futurist Painting and Sculpture*: 'My intention was to decompose the unity of material into many materials, each of which, because of its natural diversity, would characterize diversity of weight and molecular volume. Through this a dynamic element would be achieved.'

There was little trace of such sophisticated concepts in the works on show. Most of them related much more closely to the simpler formulations that accompanied the drawings. *Antigrazioso* of 1912 was the 'fusion of a head with its environment' that he had already attempted on a more ambitious scale with *Head + House + Light*. Once more it was the ever-present head of his mother, this time presented in what must have been designed as an answer to the 'dead elements' of Picasso's 1909 *Head*. The relationship of the head to the environment, detailed and explicit in *Head + House + Light*, was reduced to schematic blocks in the abstracted relief of

74 Boccioni *Table + Bottle + Block of Houses* 1912

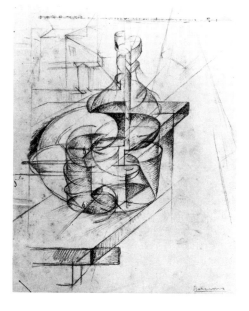

78

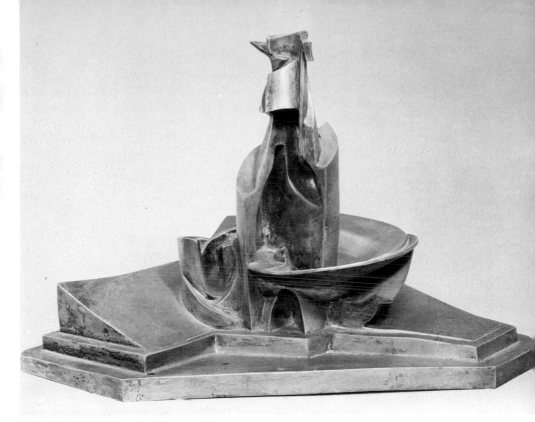

76 Boccioni *Development of a Bottle in Space* 1912–13

Abstract Voids and Solids of a Head, which was virtually a Cubist sculpture. Neither of these had the dynamism of his treatment of that unlikely subject: a bottle.

The *Development of a Bottle in Space* (1912–13) was Boccioni's first successful sculpture in the round, and he did three versions of it. The spiralling form of a bottle expanding into space had already been suggested in the foreground of the painting *Simultaneous Visions* of 1911, and by putting it into three dimensions Boccioni achieved an effect that was both lyrical and truly architectonic. It was similar, for instance, to the forms of other architects like Erich Mendelsohn, but also reminiscent of

the spiralling forms of Art Nouveau. As Salvador Dali once jokingly said, Boccioni would have been one of the few artists who could have completed Antoni Gaudí's fantastic church of the Sagrada Familia, in Barcelona. As indicated in the manifesto, it was not only the form of the object that was to continue in space, but also the so-called 'inanimate forces': 'because there is an energy at work inside it'. Like Carrà, Boccioni was tackling the problem of absolute and relative motion, and both chose to do it with the most paradoxical vehicle, in Futurist terms: the still-life.

Explaining his theory of sculptural movement, Boccioni distinguished between the static body that is studied and

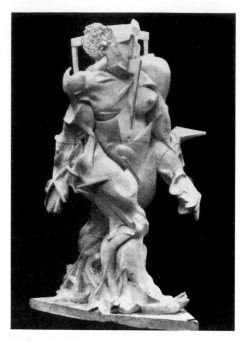

77 Boccioni *Synthesis of Human Dynamism* 1912

Three striding figures heralded *Unique Forms of Continuity in Space*, moving steadily away from the heritage of Rodin's *St John* and *Walking Man* to the evolution of an alarmingly energetic Futurist Man. Through the life-size *Synthesis of Human Dynamism* of 1912, then *Speeding Muscles* and *Spiral Expansion of Speeding Muscles*, both of 1913, Boccioni gradually stripped the figure of its burden of environmental encumbrances, surface detail and baroque cascades of muscle, to reveal a form in which movement was synthesized, as opposed to the sequential depiction of movement in the earlier studies. In the catalogue to the Galerie Boétie exhibition Boccioni wrote: 'The force form, with its centrifugal direction,

78 Rodin *Walking Man* 1877

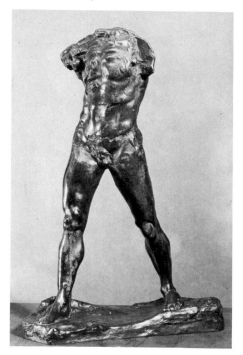

then rendered as moving, and his concept of a body that is actually in a state of movement: 'a living reality'. Here, as with Balla, there are significant parallels with the 'photodynamic' researches of Anton Giulio Bragaglia (see p. 138), though Boccioni was anxious to dissociate his work from that of a 'mere photographer'. Bragaglia's 'Manifesto of Futurist Photodynamism', dated 1911, but probably of 1913, contained the following statement: 'To render a body in movement, I do not portray the trajectory, that is, the passage from one state of rest to another state of rest, but attempt instead to capture the form that expresses its continuity in space.' That was almost word for word the title of the culmination of Boccioni's sculptural activity: the *Unique Forms of Continuity in Space* of 1913.

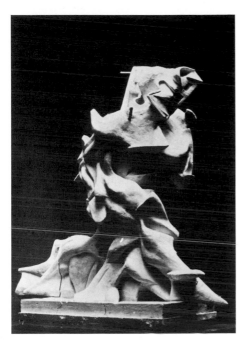

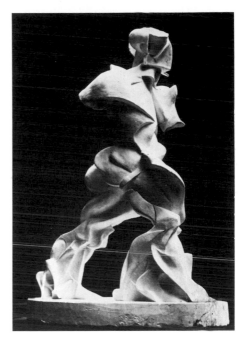

79 Boccioni
Speeding Muscles 1913

80 Boccioni
Spiral Expansion of Speeding Muscles 1913

represents the potential of the real living form. . . . The spectator ideally should construct the continuity (simultaneity) evoked by the force form, the equivalent of the expansive power of the body.'

More than any other image of Futurist art *Unique Forms of Continuity in Space* embodies the aggressive energy of the statement: 'We are the primitives of a new sensibility.' Human features made way for a synthesis of every kind of machine the Futurists ever depicted, his chest swelled out into the shape of the 'non-human model' envisaged by Marinetti in 'War, Sole Hygiene of the World': 'endowed with unexpected organs adapted to the exigencies of unexpected shocks . . . a prow-like development of the breast-bone which will increase in size as the future man becomes a better flier'. And, as if in

flight, the thigh and calf muscles of this monstrous mechanized mannikin, all the more alarming for being half life-size, are pushed back as if by the pressure of air as it cuts through space.

Here again it is worth remembering that while the Futurists were the most aggressively self-styled 'primitives of a new sensibility', they were by no means unique in their search for the languages that could express this sensibility. This is particularly clear in the sculpture that was being created all over Europe. Picasso's presentation of objects from life, like the real spoon in his painted sculpture *Absinthe Glass* of 1914, was symptomatic of a move into the materials of everyday life that was to be elaborated in one way or another by many sculptors. Vladimir Tatlin in Russia evolved his 'culture of materials' and his

corner reliefs of 1915 that were both painting and sculpture. Marcel Duchamp compounded the problem by introducing his *Ready Mades*, also in 1914: objects like a bottle rack or a urinal removed from their 'real life' normal context and placed in the context of art. With a very different reality in mind, Constantin Brancusi was searching for a new language of pure form in which all surface detail was stripped away to reveal 'the essence'. Boccioni's brief years of sculptural experiment belong essentially to the spirit of the adventurous object, and so do the multi-material collages of another Futurist experimenter—Enrico Prampolini (1892–1956). He claimed that these too dated from 1914; they were as delicate and playful as their title, *Béguinages*: a foretaste of the Dada object.

After *Unique Forms*, Boccioni returned to painting, breaking off only once to construct his last sculpture. *Horse + Rider + Houses* of 1914 could not have been more of a contrast. It was delicate, sensitive and experimental, constructed of cardboard, wood and metal, highlighted with bold coloured brushstrokes. He had not stopped painting throughout his sculpting period, but *Unique Forms of Continuity in Space* probably represented the end of a process of solidification. The same process was evident in the treatment of figures and landscape in his paintings. It was certainly not a simple return to Cézanne, but a reconstruction of the challenge of Cézanne, an alternative to the development pursued by the Cubists, and one perhaps that had first to be attempted in sculpture.

After the exhibition at the Galerie Boétie, Boccioni's paintings became increasingly analytical and compact in composition. Social themes, crowd scenes and epic subjects disappeared, to be replaced with the closest a Futurist could come to Cubist intimacy. In *Speeding Muscles* and *Dynamism of a Cyclist* external atmosphere made way for an enclosed laboratory study of microcosms of movement. The more enclosed this study became, the more abstract the result, until, in spite of titles like *Plastic Forms of a Horse* or *Dynamism of a Football Player*, the works of 1913 and early 1914 parallel the abstraction of Severini's *Spherical Expansion of Centri-*

81 Boccioni
Dynamism of a Cyclist 1913

82 Boccioni
Unique Forms of Continuity in Space 1913

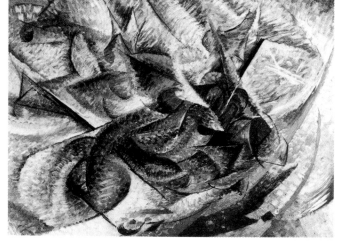

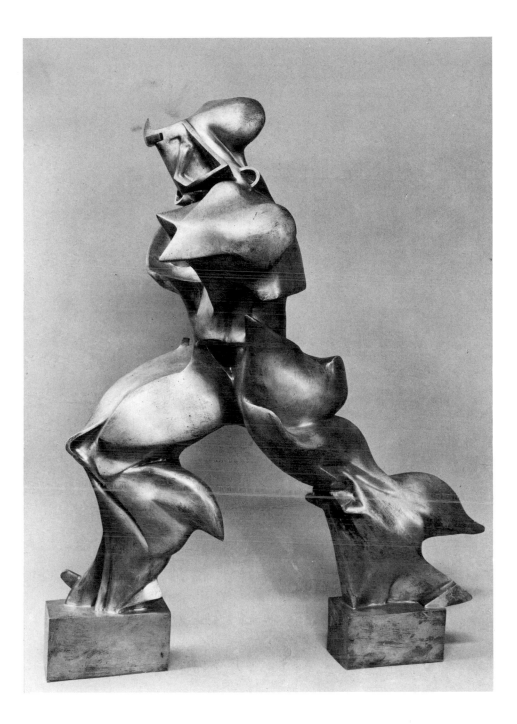

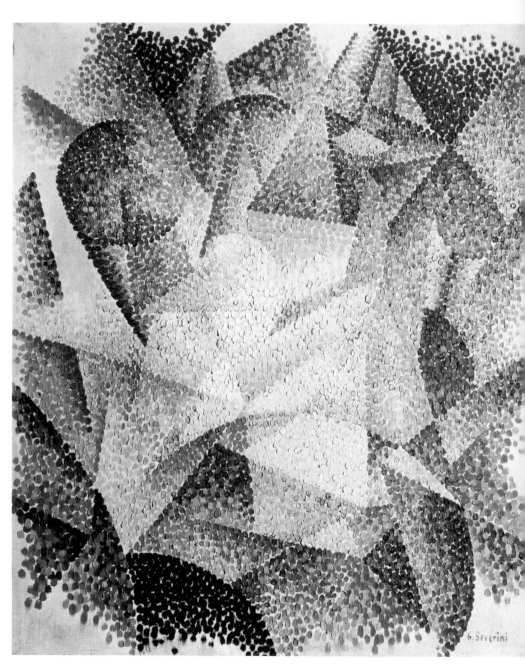

83 Severini *Spherical Expansion of Centrifugal Light* 1914

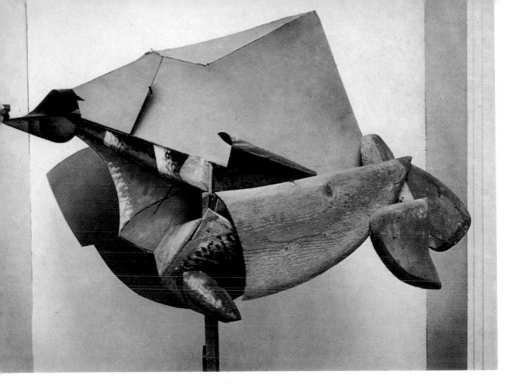

84 Boccioni *Horse + Rider + Houses* 1914

fugal Light of 1914. Boccioni was moving away from Futurism, and the key work in this distancing process was *The Drinker*. Even the title suggests that it was beyond the Futurist canon, and movement and dynamism were eliminated by the defined forms and physical solidity of Boccioni's last works. *The Pavers* of the same year could have been a continuation of the urban bustle of *The City Rises* [25], but was quite the opposite, a detail of city life transformed into still-life.

In the war years, while Carrà was to move into the Italian tradition, Boccioni turned to the Impressionist and Post-Impressionist experience he had never had, and above all to Paul Cézanne, buried prematurely by the Cubists. As he told Pratella in 1916: 'I have written to Mari-netti that it is terrible to elaborate in oneself a century of painting.' It must have been the Cubist misunderstanding and sterilization of Cézanne's philosophy of the representation of objects that had led him back to rediscover a stage before the vaunted scientific and experimental approaches of his generation. Boccioni's last works, *Portrait of Maestro Busoni* and *Study for a Head of Signora Busoni* of 1916, represented a return to first principles, an individual indictment of the superficial order of Cubism and the chaotic inventiveness of Futurism. This meant farewell to abstraction, to 'polymaterial' experiment, to everything contained in his own book *Futurist Painting and Sculpture*, which Papini had already dubbed 'the Bible of Futurism'.

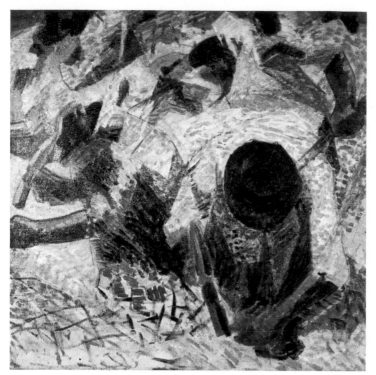

85 Boccioni
The Pavers 1914

86 Boccioni
*Study for a Head of
Signora Busoni* 1916

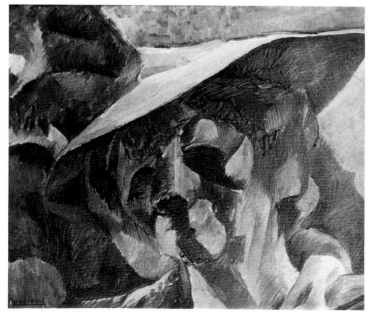

87 Boccioni
Maestro Busoni
1916

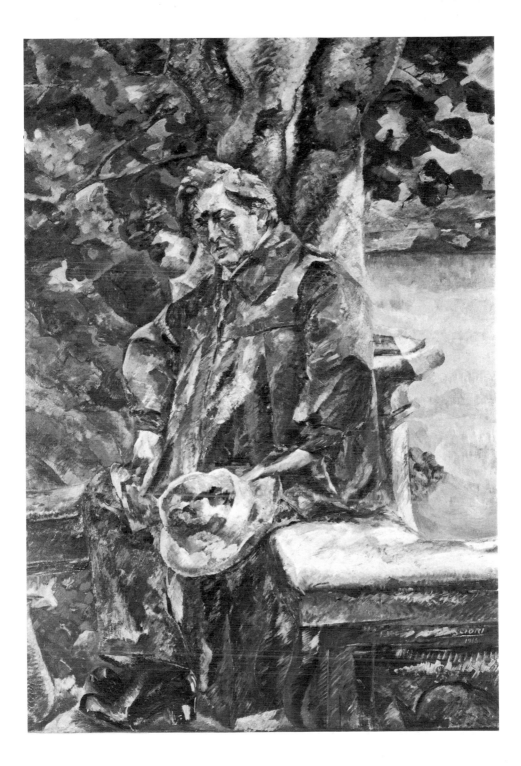

Literature and Theatre

'Let us not be afraid of ugliness in literature, and let us kill solemnity everywhere. Come on, don't put on those high priestly airs when you listen to me! Every day we must spit on the Altar of Art.
'Everything that is hissed at is not necessarily beautiful or new, but everything that is immediately applauded is certainly not superior to the average intelligence and is therefore medi-ocre, banal, revomited or over-digested.'
'Manifesto of Futurist Dramatists', January 1911.

In literature and theatre Marinetti was able to develop most fully his anti-principles of 'scorn of the public' (particularly first night audiences) and 'horror of immediate success'. For Marinetti the Pleasure of Being Booed was so great that he was delighted on occasions when others, including members of his own group, might well have been dismayed. What could have remained a straightforward case of late nineteenth-century bourgeois-baiting developed into an innovatory and highly motivated form of drama that was later to become a vital part of twentieth-century theatre, influencing Vladimir Mayakovsky and prefiguring, through Marinetti's advocacy of *fisicofollia* ('physical folly'), Antonin Artaud and the Theatre of the Absurd.

Marinetti's uninhibited panache in the face of insults and derision came partly from his early background and partly from the advantages of having both a vast fortune and some international experience behind him. Marinetti liked to boast that he had been nourished at the breast of a Sudanese wetnurse — a suitably exotic introduction to the Symbolist circles he was later to frequent in Paris. Expelled from his Jesuit *collège*, allegedly for smuggling a book by Emile Zola into the school, he was sent to Paris at the age of seventeen. A degree in letters from the Sorbonne was followed by a Doctorate of Jurisprudence in Pavia and Genoa, though he continued to commute back to Paris to keep abreast of cultural events, and wrote nearly all his poetry and plays in French until 1911–12.

Zola's earthy naturalism, Walt Whitman's songs of life, Emile Verhaeren's exultant faith in the science of the future, the poetry of Stéphane Mallarmé and Jules Laforgue, the philosophy of Bergson and Nietzsche, and the outrageously rude iconoclasm of Alfred Jarry's *Ubu* plays were the main formative influences on the young Marinetti. The *vers libre* — free verse — was the style he adopted, in common with the most progressive members of his generation, since the *vers libre* was to liberated literature what Divisionism was to progressive Italian painting. Marinetti's first major poem, 'Conquest of the Stars', was published in 1902, and attracted considerable attention in Paris. In four thousand lines which were recited by Sarah Bernhardt in her literary Salon, Marinetti whipped Hugoesque and Nietz-schean influences into a ferocious depiction of man as the conqueror of the universe, destined to impose change with the aid of science in a way reminiscent of

88 Marinetti *Title-page of 'Zang Tumb Tuum'* 1914

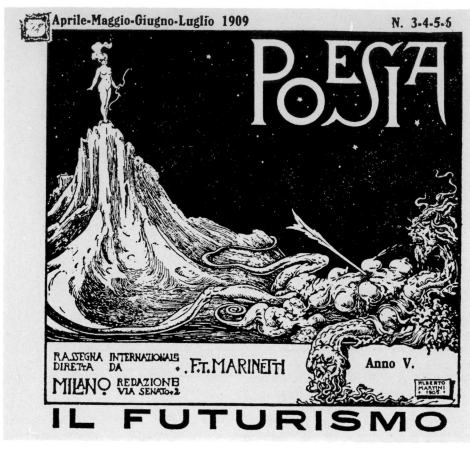

89 Martini *Cover of 'Poesia'* 1909

Mussolini's later role as the Man of Destiny. The theme was transformed into the supremacy of natural power in *Destruction*, a volume of poems on the theme of cataclysmic conquest of the heavens, published in 1904 by Léon Vannier, promoter of Symbolist poetry.

A year later Marinetti wrote his first play, *Roi Bombance*, first performed at the Théâtre de l'Oeuvre in 1909 – the very theatre in which Jarry's *Ubu roi*, Roi Bombance's mentor in extravagant crudity, had provoked pandemonium in 1896. The hero of *Bombance* is the Idiot Poet, ridiculed by the thick-headed plebs in his ceaseless quest of liberty. Though driven to suicide the Idiot Poet is vindicated on his return to life, and the play ends with the proto-Futurist slogan: 'The future – that's the only religion!' Described as a satire of sociology and revolution, a 'sauce-ology of eaters and eaten', *Roi Bombance* did indeed provoke a riot, caused by the thunderous sound effects of a priest's

digestive system in the second act, and won the praise of both Jarry and Paul Adam, the anarchists' friend.

In February 1905 Marinetti began his cultural crusade in Italy with the first appearance of the literary magazine *Poesia*. Through the pages of *Poesia*, to the cover of which was later added the red-printed name of *Il Futurismo*, Marinetti brought to Italy the best of the new masters, descendants of Mallarmé and Verlaine: Verhaeren, Paul Fort, Gustave Kahn, Swinburne, Yeats, Jarry and Georges Duhamel, plus a new Italian generation who were to become Marinetti's Futurist poets: Gian Pietro Lucini, Aldo Palazzeschi, Corrado Govoni, Paolo Buzzi, Armando Mazza and Enrico Cavacchioli. The highly Symbolist cover of *Poesia*, by Alberto Martini, figured a stout Muse slaying a dragon from the top of a mountain. *Poesia* was published from Marinetti's luxurious flat in Milan, where 'The Founding and Manifesto' was penned a few years later. The name of the publishing company was retained until the early 1920s, and it was under the imprint of *Poesia* that many books by Futurist writers and poets were to appear, as well as the immaculately printed and distributed manifestos of Futurism in leaflet form.

It may seem curious that a young writer who had already won a certain respect in the cultural capital of Europe should choose to return to Italy. But Marinetti was nothing if not a superb tactician. He probably realized that he could get so far and no further in Paris, while in Italy he would be outstanding. He wished to rival D'Annunzio's monopoly in Italy of themes both Nietzschean and modern. More positively, he did have the crusading fervour of the exile: *Poesia* served the double function of offering a much-needed platform to the young Italian poets,

for whom Marinetti had an infallible nose, and educating its public on international developments. Politically, too, Italy offered much more excitement with its rumbles of foreign wars, campaigns to oust the Austrian tyrant, and the new possibilities that emerged in the climate of tension generated in the newly industrialized northern cities.

Marinetti's awareness of the importance of theatre as the most popular art form in Italy was clear from the start. He chose to declaim 'The Founding and Manifesto' from the stage of the Teatro Alfieri in Turin before a performance of his play *Les Poupées électriques*. The play itself came close to the passéist eternal triangle that was to be condemned by the Futurist dramatists: a husband and wife plagued by the mechanical figures constructed by the husband – the symbols of bourgeois duty, money and old age. The moral takes on a Pirandellian psychological twist when the wife attempts to kill the figures, only to discover that they are in fact the couple's own *alter egos*. But that night in 1909 it was the manifesto that went down in history. By all accounts Marinetti was an astounding declaimer of manifestos, bringing out the full prose-poem potential of the form and transforming it into a riveting performance piece. This was to become an essential part of the new form of theatre evolved by the group in the course of the following year.

The invention of the Futurist Evening for once preceded theory, appearing before the manifestos on the theatre. The Evening was a dynamic concoction of manifesto reading, poetry declamation, theatrical interludes and outright provocation of the audience, in which poets and painters alike took part. The degree of success of such an Evening depended, as Marinetti said, on the level of abuse received, not applause. It

proposed an outrageous alternative to all that Marinetti hated in dreary traditional theatre: 'We feel deep disgust for contemporary theatre because it oscillates stupidly between historical reconstruction (*zibaldone* or plagiarism) and the photographic reproduction of our day-to-day life: niggling, slow, analytical and diluted theatre worthy at most of the age of oil lamps.'

The first Futurist Evening on 12 January 1910, was held, suitably enough, in the tense political atmosphere of Austrian-occupied Trieste: 'our beautiful munitions dump', as Marinetti called it in 'War, Sole Hygiene of the World'. It ended in a battle. The notoriety of such Evenings travelled quickly; each new Futurist product was heralded by advertisements which read like sales talk for purgatives. The tension would build up as the news spread that the Futurists were in town. Market stalls would do remarkable last-minute business in fruit and vegetables for use as projectiles. The Futurists themselves made it quite clear that it was trouble they were after, resorting on one occasion to double selling each seat in advance to ensure pandemonium even before the curtain rose.

Marinetti described the audience who swarmed to the Teatro Lirico in Milan for an Evening in February 1910: 'The stalls were packed with ultra-pacifist clerical conservatives, the gods with workers bellowing like the threatening waters of a dam!' Poetry and politics were mixed, Buzzi's anti-Austrian ode declaimed, and at Marinetti's cry of 'Long live War, sole hygiene of the world!' the audience exploded. Marinetti was arrested on stage, and next day the Austrian and German consuls delivered formal protests to the authorities. A caricature by Boccioni published in 1911 gives some idea of the chaos on stage, complete with paintings by Russolo, Carrà and Boccioni himself, simultaneous displays by gesticulating Futurists, brass instruments blaring under Francesco Balilla Pratella's direction (Russolo would present his own Art of Noises, see p. 114), and a heap of swooning passéists in the background.

One of the most clamorous Evenings of all was at the Teatro Verdi in Florence on 12 December 1913. This second 'Battle of Florence' was judged a disaster by the Futurist painter and poet Francesco Cangiullo but defined as 'ideal' by Marinetti. The Milanese group were joined by their allies of the Florentine *Lacerba* group. The curtain rose to showers of vegetables and even spaghetti. Marinetti started to declaim, and, as Cangiullo wrote, 'the showers of potatoes, oranges and bunches of fennel became infernal'. In such situations Marinetti would come out with topical quips: this time it was; 'I feel like a glorious Italian battleship in the Dardanelles, but the strong Turks aim badly.' Then a potato caught him full square in the eye, and Carrà yelled, 'Throw an idea instead of potatoes, you fools.' The theatre calmed down a bit, but when Marinetti, reciting Palazzeschi's 'Clock', reached the lines; 'Oh how beautiful to die with a red flower opening at one's temples', a member of the audience offered him a revolver; 'Carry on, kill yourself!' To which Marinetti replied, 'If I need a ball of lead, you deserve a ball of shit!'

After a tirade from Papini, Carrà delivered a diatribe 'Against Criticism', ending up: 'Every people has the government it deserves, every people has the critics it deserves, but today Italy has an art it does not deserve at all: Futurist Art.' Then it was Boccioni's turn with a talk on Plastic Dynamism, before Marinetti was back to politics again and launching an attack on

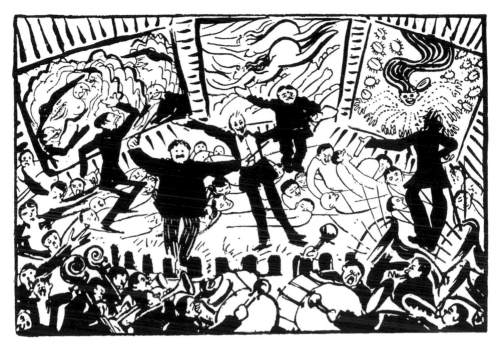

90 Boccioni *Caricature of a Futurist Evening* 1911

the Socialist government: 'the word Italy must dominate the word liberty . . . this word liberty which had meaning when spoken by Garibaldi and Mazzini has become imbecilic and exhausted in the mouth of a Turati or an anti-Libyan-War Bissolati.' The battle that ensued continued into the streets of Florence, the Futurists were taken off to the police station, probably to protect them, and the Commissioner of Police could only ask: 'Who on earth makes you do this?'

Other encounters with the Law had not been so lightly passed off. In October 1910, the year in which the Futurist Evenings had first appeared, Marinetti had been brought to trial for obscenity and affront to public morals. The offending book was *Mafarka the Futurist*, Marinetti's epic answer to D'Annunzio's 'African

passion'. The aim seems to have been not just to accuse Marinetti, but to discredit the entire Futurist movement in the eyes of the art world by outlawing them as pornographers. Marinetti was able to transform the trial into a theatrical performance in which the roles of accuser and accused were exchanged, the decadence and partiality of Italian justice were exposed, and, with the aid of a public that was vociferously pro-Marinetti, a victory was gained over the passéists of the law (see p. 14).

Although *Mafarka* was deliberately offensive in both content and language, Marinetti had still retained the traditional use of grammar and syntax. Between the appearance of *Mafarka* and his next major work, *Zang Tumb Tuum*, in 1914 he dedicated most of his energy to a number

imboscata di **T. S. F.** bulgari
vibbbrrrrrrarrrrrre
arrrrrruffarrre comunicazioni turche
Sciukri Pascià - Costantinopoli

PALLONE

TSF

vibbrrrrrrrrrrarre

altezza
400 m.

TURCO

FRENATO

vibbrrr Tsarigraad

TSF

TSF

vibbbrrrrrrrarrre

SCOPRIRE

CHE

TSF

TSF

vibbbrrrrrrrrarrre

assalto contro Seyloglou mascherare assalto

91 Marinetti *Turkish Captive Balloon* from
Zang Tumb Tuum 1914

of scintillating manifestos which laid the ground for the liberation of Futurist literature and theatre from its Symbolist heritage. In poetry this meant farewell to the *vers libre* and welcome to the new and liberated form of 'Words-in-freedom'. In prose it heralded the abolition of syntax and passéist grammatical conventions. And in theatre it meant that the speed and inventiveness of variety theatre and music hall could be extended into the new Futurist forms of Synthetic Theatre.

The 'Technical Manifesto of Futurist Literature' appeared on 11 May 1912, dedicated, at the behest of a whirling propeller, to the liberation of words from their Latin prison. In this state of freedom, nouns would be scattered at random, infinitives with their greater elasticity would replace the pedantic old indicative and would free nouns from the domination of the writer's ego. Out too was the 'old belt-buckle' of an adverb. Punctuation was, of course, annulled, and the 'foolish pauses made by commas and full stops' replaced by musical or mathematical signs ($+ - \times :=$) to indicate movement and direction. Now each noun would have its double: the noun to which it is related by analogy. 'Example: man-torpedoboat/woman-gulf'. The principle of analogy itself was not new, being held in common with Baudelaire ('Correspondances'), with Bergson and with Mallarmé, for whom the detachment of objects from rational control allows the free play of imagination, as in 'Un coup de dés . . .'. For Marinetti, analogy became of supreme importance, linking all things to create a universal network: 'Analogy is nothing more than the deep love that unites distant, diverse and seemingly hostile things. . . . When in my "Battle of Tripoli" I compared a trench bristling with bayonets to an orchestra, a machine-gun to a *femme fatale*, I intuitively introduced a large part of the universe into a short episode of African battle.'

The idea was to describe the life of matter (the universal *materia* that Boccioni too was attempting to express in paint). The life of matter was to replace the ego of the writer, whose function now would be to shape the nets of analogy that would capture elusive matter in the mysterious sea of phenomena: 'Destroy the *I* in literature, i.e. all psychology. The man side-tracked by the library and the museum is of absolutely no interest. We must drive him out of literature, and in his place establish *matter*, the essence of which can be grasped only by flashes of inspiration: something physicists and chemists will never be able to do.'

This lyrical obsession with matter was to protect it from the anthropomorphic emotions with which romantic poets and pantheists had endowed it: 'The solidity of a strip of steel interests us for itself.' The life of massed molecules and whirling electrons would form the modern poet's inspiration: 'The warmth of a piece of iron or wood is in our opinion more impassioned than the smile or tears of a woman.' Matter, for the Futurists, was to be 'neither happy nor sad'.

To capture even more faithfully the sense of matter, three neglected elements were to be introduced into poetry:

(1) Sound (manifestation of the dynamism of objects);
(2) Weight (faculty of flight inherent in objects);
(3) Smell (means by which objects spread and disperse).

By such means a landscape could be described as it is perceived by a dog, and the conversations of motors be reproduced, in much the same way as proposed by Carrà in his manifesto 'The Painting of Sounds, Noises and Smells' a year later, and in the dramas of objects that were to be a feature of the Futurist Synthetic Theatre.

All this would lead in turn to what Marinetti called 'Imagination without Strings' (*Immaginazione senza fili*, 'wireless imagination' or 'untrammelled fantasy') — the stage at which the first term of each analogy could be omitted to leave no more than an uninterrupted sequence of second terms. For this of course both the need to be understood and the pursuit of traditional beauty could be abandoned: 'It is not necessary to be understood. . . . We bravely create the "ugly" in literature and murder the solemn on all sides. . . . Every day we must spit on the Altar of Art.' Free intuition was the rule, where once logic and rationalism had inhibited the creativity of the poet. A year later a further manifesto, 'Destruction of Syntax — Imagination without Strings — Words-in-Freedom', reinforced the message, with further examples of the 'animalization, vegetabilization, mineralization, electrification or liquefaction of style. For example, to give life to a blade of grass, I say: "I will be greener tomorrow".'

The first example of Words-in-freedom appeared as an appendix to the 'Technical Manifesto of Futurist Literature'. 'Battle Weight + Smell' of 1912, like many of the Words-in-freedom pieces, is an account of a battle, in which not only smells and noises, but arms too, acquire a life of their own. An example of the use of analogy is this presentation of the green, white and red Italian flag: 'meadows sky - white-with-heat-blood'. But the masterpiece of Words-in-freedom and of Marinetti's literary career was the novel *Zang Tumb Tuum*. It was not published until 1914, though various parts of it were declaimed in February 1913 in Berlin and Rome. *Zang Tumb Tuum* is the story of the siege by the Bulgarians of Turkish Adrianople in the Balkan War, which Marinetti had witnessed as a war reporter. The dynamic rhythms and onomatopoetic possibilities that the new form offered were made even more effective through the revolutionary use of different typefaces, forms and graphic arrangements and sizes that became a distinctive part of Futurism. In *Zang Tumb Tuum* they are used to express an extraordinary range of different moods and speeds, quite apart from the noise and chaos of battle. The story has three poetic high points: the mobilization of the troops and departure for the front, the siege itself, and the harrowing fate of a trainload of injured soldiers left to die in the heat.

Audiences in London, Berlin and Rome alike were bowled over by the tongue-twisting vitality with which Marinetti declaimed *Zang Tumb Tuum*. As an extended sound poem it stands as one of the monuments of experimental literature, its telegraphic barrage of nouns, colours, exclamations and directions pouring out in the screeching of trains, the rat-a-tat-tat of gunfire, and the clatter of telegraphic messages.

It would be a misinterpretation to assume that it is an unqualified glorification of war: there are tragic interludes,

92 Balla
Trelsi trelno
1914

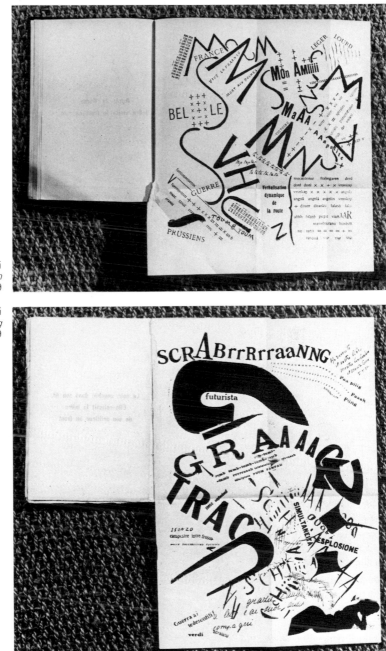

93 Marinetti
Words-in-freedom
1919

94 Marinetti
Scrabrrrrraanng
1919

too, and reflective passages in which Marinetti describes how war affects not only soldiers but the entire population — men, women and animals. The life of molecules, evoked ironically in the manifestos as a shared characteristic of the intestines and the poetic urge, now joins all forms of life in the vibration and heat of war:

'I counted the 6 milliard shocks my molecule sisters gave me I obeyed them 6 milliard times taking 6 milliard different directions . . . within the cells of my body (diameter I micromille of a millimetre) are contained 4 races of indivisible atoms this jolt=loss of weight of 6000 atoms leaving my right arm but 5000 atoms re-enter my left foot.'

This minute molecular study continues in the passages describing cholera and the trainload of sick soldiers:

'Karagath Station banging of opening doors at end of carriage doctors nurses stretchers carriers breeze lanced like this Anatolian captain's blister dysentery

trembling of weary hand bringing bottle of milk to mouth [here the typographic changes indicate the reaction of the milk as it encounters the body] furnace of microbes putrefaction of intestinal tube instal themselves multiply quickly attack putrify the walls avalanche of milk 6000 lactic fermentations onslaught tumult visceral battle. . . .'

After this myopic drama comes the large-scale battle:

'sshhooouuuutttt of 1500 sick men trapped by locked doors in front of 18 Turkish artillery lightning struck rags tatters coats officers thrown on to the rails'

— and in the distance, the sound of a flute carried downwind.

The final chapter is Marinetti's apotheosis of war as the 'sole hygiene of the world', the bombardment in which noises, weights, smells, turbines, molecules and chains are linked in a network of analogy and offered to his Futurist friends.

In the following years, Words-in-freedom became the house style of Futurism, for poets and painters alike. Boccioni, Carrà, Cangiullo, Balla and Soffici all experimented with the form. Each adapted it to his own interests. An article by Carrà attacking art critics, subtitled 'Words-in-freedom', appeared in *Lacerba* on 1 January 1914; it was little more than a series of words strung together with little of Marinetti's inventiveness. Boccioni's Words-in-freedom piece 'Society Shoe + Urine', again in *Lacerba*, was another strange exploration of his guilt-ridden attitude to women — with his girl-friend Inez somewhere in between the world of prostitutes and the purity of his sister.

For the writers it offered tremendous typographic possibilities, and meant a stimulating combination of visual art and poetry. Palazzeschi was a master of the art of the evocative onomatopoeia demonstrated in his evolution of a 'sick fountain':

'clof, clop, cloch,
cloffete
cloppete
clocchete
chchch . . .

This — now used in the Italian primary school curriculum — was greeted by Marinetti as 'the first glorious gob of spit which Futurism let fall on the ridiculous altar of Art with a capital A'. Other poets adapted the new typographic freedom to themes that were as far from war as Palazzeschi's fountain. 'The Sea', of 1915, by Govoni, is a lyrical example of the kind of precursor of concrete poetry that now appeared in the pages of *Lacerba* and in immaculately printed Futurist editions. In these the visual quality of print was

95 Soffici *BIF ZF + 18* 1915

amount of Cubist order on the exuberance of Marinetti's exploding word-clusters. Meanwhile, Severini applied Marinetti's principle of extended analogies to painting, in works like *Sea = Dancer + Vase of Flowers* of 1913.

Francesco Cangiullo, a Neapolitan adherent to the movement, was actually the most successful in adapting Words-in-freedom to a whole range of activities in painting, poetry and theatre. In *Dance of the Serpent*, printed in *Lacerba* in 1914, Severini had used blocks of evocative or onomatopoeic words to indicate colours and rhythms, fitting them into the abstracted Cubist planes of his painting. A year later Cangiullo took the much more radical step, in his *Free-word Painting*, of making the words themselves, painted in various

96 Severini *Dance of the Serpent* 1914

explored to the full, employing 'if necessary, 3 or 4 different inks and 20 different typefaces', in an extension of the possibilities offered by Apollinaire's *Ideograms*. At the same time it was a literary equivalent of Boccioni's demands for '20 different materials' in a single work of sculpture, and disrupted what Marinetti ungratefully called 'the static state of Mallarmé', just as the Futurist painters had suggested that *The Street Enters the House*.

The artists in turn extended the possibilities of the visual forms of Words-in-freedom into their 'free-word paintings' (*tavole parolibere*), including Balla's *Trelsi Trelno*, Carrà's *Interventionist Manifesto* [145], his illustrations for his own book *Guerrapittura* (*Warpainting*), and Soffici's *BIF ZF + 18* series of *Simultaneities* and *Lyrical Chemistries* of 1915, which succeed in imposing a certain

monti costa Francia

scendere

 s
 c
 e
 n
 d
 e
 r
 e

gambe di gomma incontrare una sonagliera un
rosario balzante di suoni al collo d'un galoppo incontrare un mendicante
= straccio vestito commesso viaggiatore della fame che va sul toboga della via
maestra lungo il mare rotondo sotto il sole biondo coi suoi piedi lunghissimi
100 km.

il MARE

quest'altro mendicante azzurro triste stracci di vele barcacce scarpacce
che fanno acqua suonare instancabilmente per le vie sotto le finestre

97 Govoni *The Sea* 1915

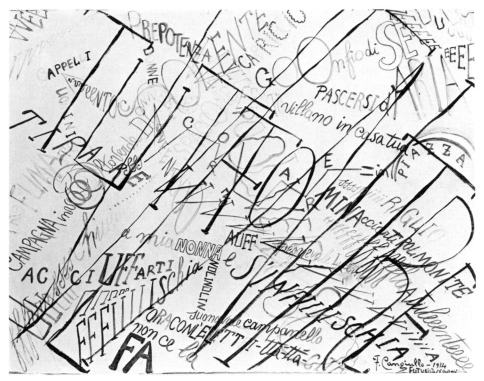

98 Cangiullo *Free-word Painting* 1915

colours, supply subject, composition and directional flow.

In the theatre the 'Manifesto of Futurist Dramatists' of 1911 and the turbulence of the Futurist Evenings had provided some indication of where the dramatic equivalent of Words-in-freedom might lie. However, the Futurists still offered little positive alternative to the four 'intellectual poisons' that they had diagnosed in D'Annunzio: '1. The sickly nostalgic poetry of distance and memory. 2. Romantic sentimentalism streaming with moonlight, rising towards Woman-Beauty, ideal *femme fatale*. 3. Obsession with lust and its eternal triangle of adultery seasoned with the pepper of incest and the stimulating spice of Christian sin 4. The profound passion for the past.'

In the next few years they were to evolve a form of theatre, the Futurist Synthetic Theatre, which had the contemporary inventiveness, speed, agility and ingenuity that Marinetti praised in 'The Variety Theatre', an important manifesto of September 1913. In this English genre Marinetti found contemporary relevance and humour, an antidote to the Solemn, the Sacred, the Serious, the Sublime of Art with a capital A'. For him, variety theatre represented 'the crucible in which the elements of an emergent new sensibility

are stirring'. Born, like the Futurists, from electricity, it had no tradition and no dogma. It was the form of theatre most open to current events, and to the essential ingredient: astonishment. Authors, actors and technicians joined in achieving this sense of wonder, partly through the use of every imaginable kind of modern mechanical marvel, not least among them the cinema, which could bring to variety theatre battles, races, cars and planes, voyages, oceans and skies.

In variety theatre, intelligence was pushed to the brink of madness, and the audience involved in an iconoclastic destruction of logic. A popular song, for instance, could be interrupted by a revolutionary political speech, and along with jugglers and wrestlers it would still all be part of variety theatre. Morals, pain and passion were shown to be equally ridiculous, and so were politics: 'A year ago at the Folies-Bergère, two dancers were acting out the meandering discussions between Cambon and Kinderlen-Wächter on the question of Morocco and the Congo in a revealing symbolic dance that was equivalent to at least three years' study of foreign affairs.' Other Futurist preoccupations were well catered for, too. Woman was portrayed with all her 'marvellous animal qualities . . . her powers of seduction, her faithlessness'. In the amplified Futurist vision of variety theatre the whole of Shakespeare could be reduced to a single act, and the works of Wagner, Bach, Beethoven and Chopin enlivened with Neapolitan songs. Variety theatre 'cooperates with the Futurist destruction of immortal masterworks, plagiarizing them, parodying them, making them look commonplace by stripping them of some of their solemn apparatus as if they were mere attractions. So we unconditionally endorse the performance of *Parsifal* in 40 minutes, now in rehearsal in a great London music hall.'

Now, with even less veneration for anything or anyone, 'Futurism will transform the variety theatre into a theatre of amazement, record-setting and physical folly.' Some of the suggested means were variations of the crude devices used at Futurist Evenings: 'sell the same ticket to ten people . . . offer free tickets to gentlemen or ladies who are notoriously unbalanced, irritable or eccentric . . . have actors recite *Hernani* tied in sacks up to their necks . . . soap the floorboards to cause tumbles at the most tragic moment.'

The 'Variety Theatre' manifesto was reproduced, in an edited version, in the London *Daily Mail* of 21 November 1913, under the title of 'The Meaning of Music Hall', attributed to the 'only intelligible Futurist', F.T. Marinetti, and then again two months later in Edward Gordon Craig's theatrical magazine *The Mask*. Between November 1913 and June 1914 Marinetti appeared no less than ten times in London, drawn partly by the music-hall tradition — perhaps the only one in Europe that could accommodate Futurist theatrical disruption — and partly by the activities of the Rebel Art Centre and the artists Marinetti liked, with some justification, to regard as his disciples: Wyndham Lewis, Christopher Nevinson, David Bomberg and Edward Wadsworth, all of whom (except Nevinson) resented their adoption as Futurist sons of Marinetti's movement, just as the Russian Futurists did. By the end of 1913 Wyndham Lewis, resentful of Marinetti's threat to his local leadership, was becoming openly cantankerous towards Marinetti, who had become the darling of the English press, which he had courted in 1912 at the time of the exhibition at the Doré Gallery. Everything that was new, daring or outrageous was

labelled 'Futurist', and by 1914 what purported to be 'Futurist Scenery' had already appeared in London music halls, proving Marinetti's point about the variety theatre latching on quicker than any other art form.

Marinetti's new form of performance, an extension of the Evening to include the lessons of variety theatre, Words-in-freedom and a greater degree of audience participation, was called Dynamic and Synoptic Declamation. Its first presentation was in March 1914 in Giuseppe Sprovieri's gallery in Rome. The main feature of the Evening was Cangiullo's Words-in-freedom drama *Piedigrotta*, featuring the Futurists as dwarfs producing a cacophony of allegedly onomatopoetic sound from violins, trumpets, drums, saws and bells, in mockery of Neapolitan moonlight, lugubrious mythology, musical virtuosity and the ecclesiastical processions that made up the festival of Piedigrotta in Cangiullo's native Naples. Marinetti and the author declaimed while the others left Balla's red-lit scenery and charged around tormenting the audience. A high point was the funeral procession for a passéist critic struck down by Futurism. From the back of the room came Balla the sacristan and his aides, their heads covered in tubes of black tissue paper with holes punched for eyes. Cangiullo played a funeral march on an out-of-tune piano while Balla struck a cowbell with a paintbrush and chanted mournfully. Marinetti gave the funeral oration and invited the audience to join him in lighting cigarettes to counter the 'putrid stench' of the corpse, so that smoking became part of the performance.

As outlined in the 'Manifesto of Dynamic and Synoptic Declamation' published two years later, the idea was to vary speed and rhythm, using the whole range

99 Balla and Cangiullo *Palpavoce* 1914

of voice tone, bodily movement and all parts of the theatre too, so that the spectator could no longer remain in a cool position of critical detachment — an idea which recurs a few years later, though in a calmer and more rational way, in the stage sets of the Russians Stepanova and Popova.

At the Doré Gallery in London on 28 April, extracts from *Zang Tumb Tuum* became the basis of Marinetti's Dynamic and Synoptic Declamation in a room 'hung with many specimens of the ultra-modern school of art', according to *The Times*, 8 May 1914. This time there were fewer actors, but Marinetti made up for that in a rendering of the Siege of Adrianople, accompanied by the extra ingredients described in the manifesto. To begin with, he did not stay put in one place facing the

audience but 'marched through the hall with dynamic gestures', as the *Observer* of 3 May reported. Three blackboards were placed at various points in the room, and during the declamation he 'alternately walked and ran' to them, drawing diagrams, theorems, equations and synoptic visualizations of the Words-in-freedom he was reciting, so that the audience had to keep swinging round to follow the rhythm of the words as their physical space was invaded. According to his account, 'the listeners turned continually to follow me in all my evolutions, participating with their whole bodies'. Sound, too, was stage-managed so that it came from different directions. On the table in front of him Marinetti had a telephone over which to pass the Turkish general's orders to Nevinson in the next room, ready and waiting to strike two enormous drums, while Marinetti beat out the sound of machine-gun fire with hammers: these were the 'imitations of artillery' picked up by *The Times* and the sound which 'boomed like guns heard across the hills' heard by the *Observer* correspondent. According to Nevinson's account of the Evening, Marinetti was so disappointed by the meagre amount of audience participation that he rushed back on to the stage at the end and roared: 'This was a very imperfect rendering. There should be no passive listeners. Everyone should take part and act the poem.'

It seems unlikely that Marinetti put into practice the manifesto's recommendation that the performer should move towards the elimination of idiosyncratic detail and towards a depersonalized, 'abstract' and mechanical delivery: what people remembered was his own magnetic personality.

The distinguished war correspondent Henry Nevinson, father of the artist, had this to say in the *Newark Evening News*: 'Antiquity exploded. Tradition ceased to breathe . . . I have heard many recitations and have tried to describe many battles. But listen to Marinetti's recitation of one of his battle scenes . . . the noise, the confusion, the surprise of death, the terror and courage, the shouting, curses, blood and agony — all were recalled by that amazing succession of words, performed or enacted by the poet with such passion of abandonment that no one could escape the spell of listening.'

Audiences were, it seemed, less spellbound by the presentation by Marinetti of the 'Art of Noises' at the London Coliseum two months later on 15 June 1914. An account of the sound that emerged from Russolo's Noise Intoners and the reactions they provoked on this occasion is given on p. 118. Here it is enough to admire Marinetti's persuasiveness in having what Ezra Pound dismissed as 'a mimetic representation of dead cats in a fog horn' put on as 'Item no. 12, Marinetti: The Art of Noises and the Great Futurist Concert of Noises', at London's leading music hall.

Back in Italy the admirable brevity that Marinetti admired so much in variety theatre was distilled still further into the most radical of Futurist theatrical innovations: the Futurist Synthetic Theatre. Once more a manifesto, written between 11 January and 18 February 1915, outlined its basic principles in a dramatic tone, heightened by Interventionist rhetoric aimed at a country poised on the point of entering the Great War. Concision was the key: 'It is stupid to write a hundred pages when one would be sufficient'. This theatre of brevity was to be 'technical, dynamic, simultaneous, autonomous, alogical, and unreal'. Only in this way could theatre rival and surpass cinema, synthesizing art and experience in an

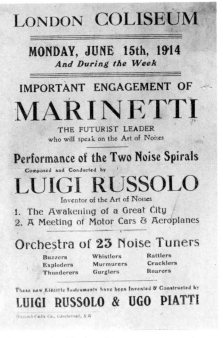


LONDON COLISEUM

MONDAY, JUNE 15th, 1914
And During the Week

IMPORTANT ENGAGEMENT OF

MARINETTI
THE FUTURIST LEADER
who will speak on the Art of Noises

Performance of the Two Noise Spirals
Composed and Conducted by

LUIGI RUSSOLO
Inventor of the Art of Noises

1. The Awakening of a Great City
2. A Meeting of Motor Cars & Aeroplanes

Orchestra of 23 Noise Tuners

Buzzers	Whistlers	Rattlers
Exploders	Murmurers	Cracklers
Thunderers	Gurglers	Roarers

These new Electric Instruments have been Invented & Constructed by

LUIGI RUSSOLO & UGO PIATTI
Haycock-Cadle Co., Camberwell, S.E.

100 Poster for Marinetti's appearance at the London Coliseum 1914

instant, free at last from the obligation to tell all in that logical, ordered detail which is so unlike the way events unfold and are perceived in life. In place of the exhausted forms of the past there would be 'the many forms of Futurist Theatre, such as: lines written in Words-in-freedom, simultaneity, interpenetration, the short poem enacted, dramatized sensation, comic dialogue, the negative act, the re-echoing line, "extra-logical" discussion, synthetic deformation, the scientific outburst that clears the air'. The most potent weapon was to be humour and 'fraternization with comic writers'. In place of respect from the audience, a 'current of confidence' was to be created through unbroken contact, a change from the scorn courted before, since Marinetti now hoped to use the theatre as a direct influence in the Interventionist cause: '90% of the Italians visit the theatre, while only 10% read books and magazines.'

The manifesto was signed by Marinetti, Emilio Settimelli and Bruno Corra, and stated that eleven 'Syntheses' had already been written by themselves, Remo Chiti, and Balilla Pratella the composer, and performed all over Italy. During 1915 and 1916 Boccioni, Balla, Depero and Cangiullo joined in enthusiastically, Cangiullo in particular proving himself to be the most Synthetic of all and master of split-second brevity. He described his Syntheses as no less than the 'synthesis of the entire modern theatre'. An example is *Detonation*: the curtain rises on a street at night, silent and empty apart from a street lamp. Pause, then a revolver shot. Pause, then curtain.

Marinetti's greatest interest was in the 'Drama of Objects' outlined in the manifesto, a theatrical extension of the 'animalized, vegetabilized and mineralized' life beyond man, explored in the molecular descriptions of *Zang Tumb Tuum. They're Coming* (*Vengono*) was the first of these Dramas of Objects, and the principal characters are not the three actors but tables and chairs. The scene is an elegant room with a table, a large armchair and eight chairs. A butler enters with two waiters and says 'They're coming, get ready.' The waiters place the chairs round the armchair, then the panting butler returns: 'Counter order: they're extremely tired — put out plenty of cushions and stools.' They do so, and the butler races in yet again: 'Briccatirakameke.' At this the waiters rush around arranging flowers, bread and wine, and placing the table in the middle of the stage. When the order is repeated they move the table again and place all the chairs in a row. While the

trembling waiters lurk in a corner, a spotlight moves over the line of chairs, giving the impression that they are leaving the stage.

Not all Marinetti's Syntheses relied on such elaborate props. *The Hands*, written with Bruno Corra, consisted simply of a curtain the height of a man stretched across the stage above which male and female hands appeared and disappeared against a black backdrop, beckoning and gesturing in a short hand-drama that suggested that all human emotion could be expressed through the use of one part of the human body. In a similar piece called *Bases* (*Le Basi*), Marinetti did the same thing for feet.

Another joint effort by Corra and Settimelli, *Before the Infinite*, satirized turgid Germanic philosophy. A wild-looking young philosopher of the 'Berlin type' paces up and down the stage holding a revolver in his right hand and a copy of the *Berliner Tageblatt* in his left: 'It's useless,' he exclaims, 'in the face of the infinite all things are the same . . . everything is on the same level . . . their birth, their life, their death, all is a mystery . . . how and what can one choose? . . . Ah, doubt . . . uncertainty . . . And here today in 1915 I do not know

whether, after my breakfast as usual, to read the *Berliner Tageblatt* or put a bullet through my head' (bored and indifferent, he looks from left to right hand, raising first the newspaper and then the revolver). 'Oh well, the bullet will do' (shoots and falls dead).

Boccioni concentrated on his regular obsessions with women, critics and artistic success, just as he had done in his Words-in-freedom. *Genius and Culture* is a typical example: a rich setting, a society lady putting on her make-up, a critic leafing through books, and an artist dying for art and suffocating for lack of love. Neither lady nor critic has the time or inclination to help him. As the critic says, 'I can't help, I'm a critic not a man.' The artist chokes to death spluttering the names of illustrious artists and philosophers, and the critic gives him the final blow. Seeing he is safely dead, the critic, triumphant, exclaims: 'Good, now I'll write a monograph', and, having rustled around his desk for the critics' bible, Croce's *Aesthetics*, he begins: 'Around 1915 there flourished in Italy. . . .' Stopping to measure the corpse he continues: 'Like all great artists he was 1·68 metres tall . . .' (Boccioni's own height).

101 Marinetti *Bases* 1915

The manifesto described the richness of material that lay waiting for the Futurist synthetic playwright: 'in the subconscious, in undefined forces, in pure abstraction, in pure cerebralism, in pure fantasy, in breaking records and physical folly'. Balla and Depero put into practice Marinetti's idea of Mechanical and Geometrical Splendour and the Numerical Sensibility in a number of light-hearted Syntheses, based on number sequences and nonsense words, that would have appealed to the Dadaists:

Giacomo Balla
Disconcerted States of Mind

Four people dressed differently.
White stage.

Begin all together.

1ST PERSON	*(loudly):*	666 666 666 666	together
2ND PERSON	,,	333 333 333 333	
3RD PERSON	,,	444 444 444 444	
4TH PERSON	,,	999 999 999 999	

(Pause, always seriously.)

1ST PERSON	*(loudly):*	aaa aaa aaa aaa	together
2ND PERSON	,,	ttt ttt ttt ttt	
3RD PERSON	,,	sss sss sss sss	
4TH PERSON	,,	uuu uuu uuu uuu	

(Always seriously.)

1ST PERSON	*raises his hat*	together
2ND PERSON	*looks at his watch*	
3RD PERSON	*blows his nose*	
4TH PERSON	*reads a newspaper*	

(Pause, very expressive.)

1ST PERSON	*(loudly):*	sadness — aiaiaiaiaiaiaiai	together
2ND PERSON	,,	quickness — quickly, quickly	
3RD PERSON	,,	pleasure — si si si si si	
4TH PERSON	,,	denial — no no no no no no	

(Leave the stage, walking rigidly.)

Giacomo Balla:
To Understand Weeping:

Two men, one dressed in a white summer suit and the other in widow's weeds, face each other against a canvas backdrop painted half red and half green, and conduct the following dialogue in grave tones:

BLACK MAN: . . . to understand weeping . . .
WHITE MAN: mispicchitirtirtirotiti
BLACK MAN: 48
WHITE MAN: brancapatarsa
BLACK MAN: 1215 but I . . .
WHITE MAN: ullurbusssssut
BLACK MAN: I think you're laughing
WHITE MAN: sgnacarsanipir
BLACK MAN: 111.222.022 I forbid you to laugh.
WHITE MAN:: parplicurplotorplaplint
BLACK MAN: 888 God and Thunder! Don't laugh!
WHITE MAN: iiiiirrrrrirririririr
BLACK MAN: 1234 That's enough! Stop it! Stop laughing!
WHITE MAN: . . . you have to laugh.

Balla's Syntheses took on a more abstract form too. In a number of them he replaced actors with coloured shapes, and the Drama of Objects became the Drama of Geometry: spheres, pyramids and squares.

This idea was extended into the remarkable scenery Balla made for Igor Stravinsky's ballet *Fireworks*, presented in Rome by Diaghilev at the Teatro Costanzi on 12 April 1917. For *Fireworks* Balla built a complex of prismatic wooden shapes covered with canvas and painted. These were topped with smaller forms of translucent fabric which could be illuminated from inside, and all these shapes were outlined against a black background[102]. Ballet dancers were replaced by the

movement of coloured light over these geometric surfaces, so that light and colour expressed the changing moods of the music. During the five minutes it took to perform, some forty-nine different sequences and combinations of light were projected on to the shapes from a keyboard devised by Balla in the prompter's box. The result must have been one of the most startling explorations of the new art of abstraction attempted in the theatre.

Balla's experiment, never repeated, was typical of his ability to transform ideas that were part of his time into Futurist forms. The Russian composer Alexander Scriabin, too, had attempted to marry music and colour with his Colour Organs, and Balla's ballet of light sounds remarkably like the theatrical innovations visualized by the influential stage designer Edward Gordon Craig. In 1909, when he was living in Florence and experimenting at the Arena Goldoni, Craig had been working towards 'an abstract synthesis of movement, sound and light' which was to 'take its expression chiefly from changes in the lighting as it strikes a number of shapes'. It is more than likely that Balla was aware of this, and of Craig's book, *A Living Theatre*, published in 1913.

Futurist theatre in Italy and abroad continued to draw audiences through the 1920s and 1930s. Many more Syntheses were written by Marinetti and the new disciples of his later second and third Futurism (see p. 198). Marinetti's last major contribution to drama was 'The Futurist Radiophonic Theatre', a manifesto written in 1933. In this, and the five plays he wrote for radio, his experiments with sound were of a radical nature that was only rivalled in the *avant-garde* music of the 1960s. His use of 'found sound' — the sounds of nature (fire crackling, water lapping, blackbirds calling) — added a new dimension to the Art of Noises. Marinetti's exploration of silence, as a positive compositional element to be 'heard' like sound, prefigured the concerns of John Cage's generation of composers.

It was typical of Marinetti's ideology of innovation that such radical insights should be thrown up among a host of schoolboyish pranks. Belief in innovation was both the strength and weakness of Futurism. The strength lay in the freedom it gave the inventor — relief from the tyranny of the idea of the 'masterwork', and the freedom to be prodigal with ideas and energy, to move on constantly to the next thing. This was the speed and momentum that Marinetti demanded, and which he was able to sustain for a surprisingly long time. But this constant search for innovation played against Futurism too, and perhaps more so in the scattered and ephemeral media of literature and theatre than in any other field.

Almost every twentieth-century attempt to release language from traditional rules and restrictions has a precedent somewhere in Futurism. So, too, do the various typographic experiments in marrying words and the visual qualities of print and poetic line, from the Vorticists' short-lived magazine *Blast* in 1914, strongly influenced by *Lacerba*, to the more recent developments in concrete poetry where typography is used to bring out the meaning of words, as in Govoni's 'The Sea' of 1915. And in the theatre, Futurist use of speed, brevity, absurdity, disruption and audience involvement to dislocate the spectator and break down the old barrier between art and life had in it the germs of the 'alternative theatre' of later generations: street theatre, actions, happenings. There are intimations too of developments in later mainstream theatre: Pirandello's psychological situations owe

102 Balla *Set for Stravinsky's 'Fireworks'* 1917 (reconstruction)

a recognized debt to Futurist sketches of the dramatic presence of the *alter ego* or of 'simultaneous states of mind', Samuel Beckett's tramps and pebble-counting characters suspended in their own limbo are there, as well as Ionesco's situational absurdity. But the precedents set by Futurism find little recognition in either literary or theatrical histories. History is as wary of ceaseless innovations as it is of prankish jokes, and apart from the recognized transformation of the Futurist Evening into Dada cabaret by Tristan Tzara in Zurich in 1916, the rest was largely ignored or forgotten until the 1960s. It was then, too, that interest in Marinetti was revived from the shadowy legacy of Fascism, and *Zang Tumb Tuum* reinstated as his one concession to that despised phenomenon, the masterpiece.

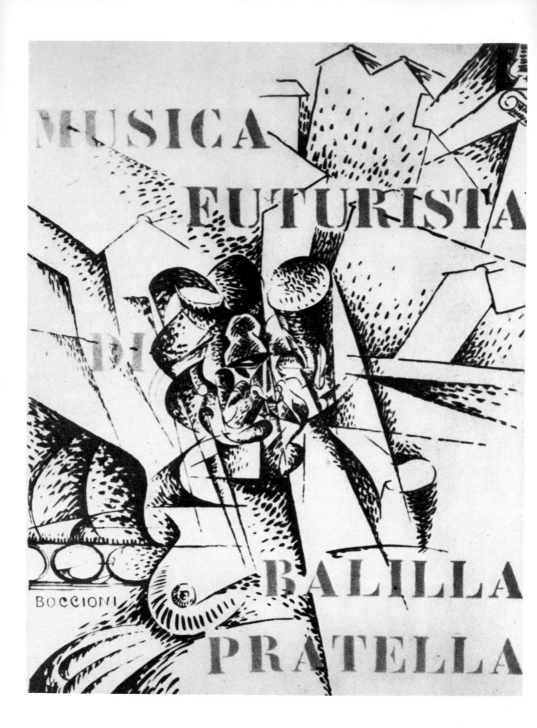

Futurist Music

'I repudiate the title [of Maestro] as a sign of equality in mediocrity and ignorance.'
Francesco Balilla Pratella, 'Manifesto of Futurist Musicians', 1910

'Ancient life was all silence. In the nineteenth century, with the invention of the machine, Noise was born. Today, Noise triumphs and reigns supreme over the sensibilities of men.'
Luigi Russolo, 'The Art of Noises', 1913

Noise was Futurism's contribution to music. The principle of noise was not introduced by a musician but by the most eccentric of the Futurist painters, Luigi Russolo, whose own painted homage to *Music* [49] was a swirl of pianistic crescendos. He was one of the few Futurists who actively dared to branch out into another field, and he explained his temerity in the following way: 'I am not a musician, I have therefore no acoustical predilections, nor any works to defend. I am a Futurist painter using a much loved art to project my determination to renew everything. And so, bolder than a professional musician could be, unconcerned by my apparent incompetence, and convinced that all rights and all possibilities open up to daring, I have been able to initiate the great renewal of music by means of the Art of Noises.'

Russolo's aim was to widen the accepted definition of music in much the same way as Marinetti's Words-in freedom and Destruction of Syntax had challenged the traditional boundaries of literature. Music, and preconceptions of beauty in music,

had traditionally been confined to the invention of pure sound, artificially made and predictably ordered. But beyond invented sound, as it was known and recognized, there lay a whole world of noise, an untapped source of energy and acoustic enrichment. Noise did not mean just din and cacophony, though this too held its attraction. The wealth of sound in the world ignored by the conventions of music ranged from the primary noises of nature to the roar of life and machines in the modern city, and was being added to daily. The recognition of the potential of brute noise as a source of art was a radical departure, still advocated by the musical *avant-garde* more than sixty years later, and still generally unaccepted.

Russolo's attempts to put some of the Futurist theories of music into practice brought about some of the most extraordinary musical experiments of the pre-First World War years: the Noise Intoners or *Intonarumori*. The Noise Intoners reproduced some of the novel noises of the modern world, and added others besides. As signs of the new will to experiment beyond the accepted bounds of music, both the Intoners and the theory behind them belonged to the innovatory climate of the first two decades of the century which extended well beyond Futurist activities in Italy. In terms of more traditional forms of music, this spirit of change found major expression in the works of Stravinsky, Arnold Schoenberg and Erik Satie. But since the late nineteenth century more

103 Boccioni *Cover for Pratella's 'Musica Futurista'* 1912

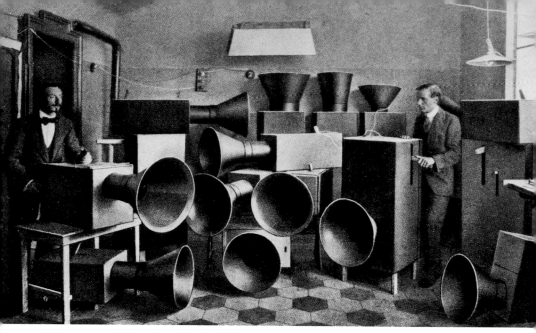

104 Russolo and his assistant Piatti with Noise Intoners

eccentric researches had been made into the possibilities of creating completely new musical instruments and forms. Usually they were to perform the dual function of interpreting both colour and sound: Bishop Bainbridge's Colour Organ was one example, and Alexander Wallace Rimington's Colour Music was another. Both were later superseded by Scriabin's Colour Organ, and his attempts to capture the nature of abstract values in colour and sound, and by the poet Léopold Survage's theories of Coloured Rhythms. All these experiments had one feature in common: they were the result of an enthusiastic belief in music produced by machines of one kind or another, and it would have been surprising if the machine-mad Futurists had not come up with some form of mechanical music too.

The official Futurist musician was not Russolo but Francesco Balilla Pratella (1880–1955). He was at heart a fairly conventional composer, though he was to incorporate Russolo's machines into some of his Futurist works. He later became best known for his extensive use of the folk songs and themes of his native Romagna, and remained firmly attached to the peasant traditions of that most earthy of regions. One of his great life-works, still unpublished, was a lengthy volume on mushrooms, and even when his reputation as a conductor forced him to travel as far afield as Paris, he still retained a most un-Futurist aversion to travel and speed: 'If God had intended me to cross sea or sky he would have made me a fish or a bird,' was his reaction to an invitation to go to America, and his greatest regret when his native Ravenna was bombed during the Second World War was the loss of his trusty bicycle.

Nevertheless, Pratella was an early recruit to Futurism, partly because he loathed the humbug of the official Italian

music world. His 'Manifesto of the Futurist Musicians' of 11 October 1910 was one of the earliest signs of Futurism's spread from literature and painting into other fields. Shortly before writing it, Pratella had won an official and prestigious prize, the Premio Baruzzi, for an opera for which he had also written an innovatory libretto 'in free verse' as he proudly explained. Pratella started with a justified criticism of the state of music in Italy, based on the assumption that having won a prize he was in a position to judge. He described the intellectual mediocrity that prevailed in Italy as compared to other countries, though his list of foreign composers who had contributed some degree of new blood was fairly conservative: Richard Strauss, Claude Debussy, Gustave Charpentier, Edward Elgar, Modest Mussorgsky, Alexander Glazunov and Jean Sibelius, all born well before 1870.

Pratella blamed the academicism of the conservatories, the impotence of Italian composers in the face of symphonic form, and their banal belief in the virtues of *bel canto*. But the greatest culprit was opera: 'that heavy and suffocating crop of our nation'. Opera was sustained by a publishing mafia which was responsible for the 'base, rickety and vulgar operas of Giacomo Puccini and Umberto Giordano'. Pratella had a word of praise for Pietro Mascagni, not so much for his operatic skill as for his courage in opposing the publishing mafia.

Against this Pratella unfurled 'the red flag of Futurism'. The conservatories should make way for areas of 'free study'. Reactionary critics, rigged competitions, imitations of the past, the belief in 'well-made' music, the reign of the singer and the nauseating repetitiveness of Neapolitan songs and sacred music: all this belonged to the past. The future lay in 'The liberation of individual musical sensibility from all imitation or influence of the past, feeling and singing with the spirit open to the future, drawing inspiration and aesthetics from nature, through all the human and extra-human phenomena present in it. Exalting the man-symbol everlastingly renewed by the varied aspects of modern life and its infinity of intimate relationships with nature.'

Pratella wrote two more manifestos, the 'Technical Manifesto of Futurist Music', and 'The Destruction of Quadrature', and all three were published together in 1912 in a volume which contained the piano version of Pratella's *Futurist Music for Orchestra*, and which carried a splendid cover drawing by Boccioni. The Destruction of Quadrature was very much a musical parallel to Marinetti's Destruction of Syntax, and the 'Technical Manifesto' recommended rhythmic irregularity, atonality and micro-tones. But Pratella's own music fell far short of the radicalism he advocated in theory. Even *Futurist Music*, which caused such a stir when it was first performed, was fairly repetitive and amorphous, and relied heavily on whole-tones. Confusion reigned when it was performed at the Teatro Costanzi in Rome on 21 February 1913. The clamouring of the audience was expected, but not the bewilderment of the composer. The Neapolitan poet Cangiullo recorded somewhat maliciously that Pratella suddenly rushed off to Marinetti in the wings, shouting desperately that half the orchestra had disappeared. Five minutes later he reappeared: the orchestra had told him that the piece was over anyway. The critics were justifiably severe: as Cangiullo said, 'Fifteen years ago it would have been reasonable, but after the music of Schoenberg, that of Pratella sounds absolutely passéist.'

Nevertheless, the 'Technical Manifesto' contained some phrases, perhaps added by Marinetti in an effort to pep it up, which may well have inspired Russolo to the invention of a mechanical means of interpreting 'the musical soul of crowds, great industrial complexes, transatlantic liners, trains, tanks, automobiles and aeroplanes . . . the domination of the machine and the victorious reign of electricity'. One of Marinetti's useful maxims was that originality is often as much the product of will as of genius, and the invention of the Noise Intoners was certainly an act of will. Once again, theory came before practice. Russolo's manifesto 'The Art of Noises', which calls for a vast battery of Noise Intoners, appeared on 11 March 1913, but when the great new invention was unveiled to the public in Modena three months later there was just one of them there: an Exploder reproducing the noise of an internal combustion engine with a range of ten whole-tones.

Russolo's 'The Art of Noises' begins and ends with tactful dedications to Pratella, and the explanation that the author, though not a musician, was inspired by the music of Pratella: 'In Rome, in the Teatro Costanzi, packed to capacity, while I was listening to the orchestral performance of your overwhelming *Futurist Music* with my Futurist friends, Marinetti, Boccioni, Carrà, Balla, Soffici, Papini and Cavacchioli, a new art came into my mind which only you can create, the Art of Noises, the logical consequence of your marvellous innovations.'

Russolo described the passage through history from silence to sound and on to noise-sound and musical noise. He argued that the limited range of musical instruments could no longer satisfy modern man's acoustic thirst. Orchestras had grown in size since the eighteenth century,

but that only made the situation more laughable: 'Do you know of any sight more ridiculous than that of twenty men furiously bent on redoubling the mewing of a violin?'

Russolo's manifesto was refreshingly lyrical and constructive, partly because he was arguing for the acceptance of a new awareness of beauty in which the perception of the primary sounds of nature was balanced with the excitement of city noises:

'To convince ourselves of the amazing variety of noises, it is enough to think of the rumble of thunder, the whistle of the wind, the roar of a waterfall, the gurgling of a brook, the rustling of leaves, the clatter of a trotting horse as it draws into the distance, the lurching jolts of a cart on pavings, and of the generous, solemn white breathing of a nocturnal city; of all the noises made by wild and domestic animals, and of all those that can be made by the mouth of a man without resorting to speaking or singing.

'Let us cross a great modern capital with our ears more alert than our eyes, and we will get enjoyment from distinguishing the eddying of water, air and gas in metal pipes, the grumbling of noises that breathe and pulse with indisputable animality, the palpitation of valves, the coming and going of pistons, the howl of mechanical saws, the jolting of a tram on its rails, the cracking of whips, the flapping of curtains and flags. We enjoy creating mental orchestrations of the crashing down of metal shop blinds, slamming doors, the hubbub and shuffling of crowds, the variety of din from stations, railways, iron foundries, spinning mills, printing works, electric power stations, and underground railways.'

Russolo raised a number of points that went beyond the usual Futurist cataloguing of urban excitements. The possibility of

105 *Concert for Factory Sirens* 1920

a form of expression 'made by the mouth of man without resorting to speaking or singing', which is hinted at in 'The Art of Noises', has continued to fascinate philosophers and linguists involved in the study of expression beyond words and language, and it is regrettable that Russolo did not pursue it further.

Later on in the manifesto he introduced another prophetic note: the 'Futurist Ear' would be the stage at which 'the motors and machines of our industrial cities will one day be consciously attuned, so that every factory will be transformed into an intoxicating orchestra of noises'. The implications of this bring to mind Walter Benjamin's condemnation of the aestheticization of politics, which he saw as a Fascist tendency, but the prime example of Russolo's aestheticization of city life took place, not in Futurist or even Fascist Italy, but in the hopeful days of young Soviet Russia. In 1920 the *Concert for Factory Sirens* was performed: work was beautiful, and the sweetest noise for the workers was the orchestrated unison of the sirens that summoned them. This was certainly carried out quite independently of anything Russolo had written, but it illustrates the complexity of both the aesthetics and the politics of those years in which a shared experimental enthusiasm could inspire tendencies which were later to emerge as political polarities.

The Art of Noises was not to limit itself to imitative reproduction, a point that was constantly stressed in the field of painting too. The artist could extract and synthesize combined noises from the range available, just as the painter could transform colours and shapes. There were to be six main families of noises, and machines that produced them were to form the basis of the Futurist orchestra:

1	2	3
Rumbles	Whistles	Whispers
Roars	Hisses	Murmurs
Explosions	Snorts	Mumbles
Crashes		Grumbles
Splashes		Gurgles
Booms		

4	5	6
Screeches	*Noises*	*Voices of*
Creaks	*obtained by*	*animals*
Rustles	*percussion on*	*and men:*
Buzzes	metal	Shouts
Crackles	wood	Screams
Scrapes	skin	Groans
	stone	Shrieks
	terracotta	Howls
	etc.	Laughs
		Wheezes
		Sobs

The manifesto's descriptions of the tonal range and rhythmic possibilities of the new machines were detailed and sophisticated, but technical discussion of how they would actually work was astutely avoided. Only once did Russolo risk a comment on their construction: 'The practical difficulties in constructing these instruments are not serious. Once the mechanical principle which produces the noise has been found, its tone can be changed by following the same general laws of acoustics. If the instrument is to have a rotating movement, for instance, we will increase or decrease the speed, whereas if it is not to have rotating movement, the noise-producing parts will vary in size and tautness.'

The demonstration of a single Exploder at Modena on 2 June 1913 was enough to bring a flood of newspaper articles, even though the first concert was not held until 1914. Many were in the foreign press: the *Daily Chronicle* carried an account, as did the *Evening Standard*, the *Berliner Tageblatt*, *Le Temps* and *Le Matin*. In an article in *Lacerba* on 1 July 1913, Russolo answered some of the comments that had been made, repudiating accusations of having produced a cacophonous mixture of noise without sense or logic, or an imitation of life's sound, or a snobbish theory to shock the bourgeois. He thanked Marinetti, 'still vibrating from the great acoustic emotion he felt at Adrianople', for his support in front of a crowd of two thousand at Modena, and the Futurist painter Ugo Piatti for his help in perfecting the Noise Intoners. He described the machines as follows:

'It was necessary for practical reasons that the Noise Intoner be as simple as possible, and this we succeeded in doing. It is enough to say that a single stretched diaphragm placed in the right position gives, when its tension is varied, a scale of more than ten tones, complete with all the passages of semi-tones, quarter-tones, and even all the tiniest fractions of tones. The preparation of the material for these diaphragms is carried out with special chemical baths, and varies according to the timbre of noise that is required. By varying the way in which the diaphragm itself is moved, further types and timbres of noise can be obtained while retaining the possibility of varying the tone.'

He went on to state that four families of noise had so far been perfected: Exploders, Cracklers, Buzzers and Scrapers. The simple manipulation of a lever at the side of the machine gave the required pitch of each noise, and the rhythm could be easily regulated too. On 1 November he returned to the subject in a most complicated discussion of the 'enharmonic possibilities' of the Noise Intoners, and in a third *Lacerba* article on 1 March 1914 he proposed a new notation in which traditional notes such as crotchets and semiquavers would be replaced by a number system, and the continuity of notes indicated by a solid line. The new system was illustrated in *Lacerba* with a section of the new-style score for Russolo's *The Awakening of a City*. This was one of two

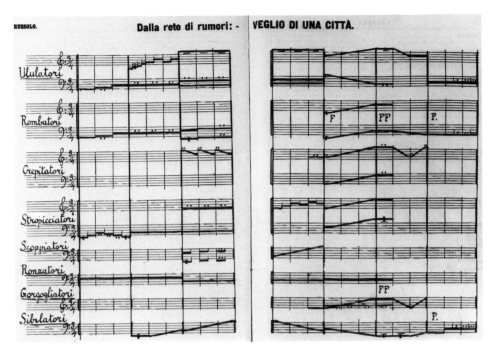

RUSSOLO. **Dalla rete di rumori: - VEGLIO DI UNA CITTÀ.**

Ululatori
Rombatori
Crepitatori
Stropicciatori
Scoppiatori
Ronzatori
Gorgogliatori
Sibilatori

106 Russolo *Score of 'The Awakening of a City'* 1914

compositions which he referred to as 'Networks of Noise', the other being *Meeting of Automobiles and Aeroplanes*

No Noise Intoners seem to have survived, but there are photographs. The individual machines were comically basic in appearance: solid boxes of varying sizes and heights, each fitted with a huge metal speaker to thrust the sound out into the world. Russolo and Piatti worked away at the perfecting of them with feverish excitement, and were ready to give their first full-scale concert in April 1914.

But before this first public performance there was a very special private demonstration of the new music in Marinetti's house. Marinetti, Pratella, Boccioni, Carrà, Cangiullo, Piatti and Russolo's brother were there, and the audience was illustrious. Stravinsky, Diaghilev, Léonide Massine, another Slav pianist, a Bohemian lady painter, and the Viscount of Modrone. Marinetti was extremely proud of his Futurist musicians, and promoted them tirelessly. This evening had a dual purpose. Diaghilev was keen to have Cangiullo's poem *Piedigrotta* set to music by Pratella for a theatrical production, while Stravinsky had expressed some interest in the possibility of using the Noise Intoner in one of his ballets.

Cangiullo reconstructed the evening in his autobiography: 'Pratella, the swan of Romagna, arrived in Milan hoping to find that none of the guests had turned up, and that he would not have to play a note. But he was dragged to the piano and forced to play and sing his music with a mouth that would rather have opened to a good bowl of fish soup.' Somehow or other the piece

117

was finished, and Russolo approached one of the eight or nine Noise Intoners:

'A Crackler crackled and sent up a thousand sparks like a gloomy torrent. Stravinsky leapt from the divan like an exploding bedspring, with a whistle of overjoyed excitement. At the same time a Rustler rustled like silk skirts, or like new leaves in April. The frenetic composer hurled himself on the piano in an attempt to find that prodigious onomatopoetic sound, but in vain did his avid fingers explore all the semi-tones. Meanwhile, the male dancer [Massine] swung his professional legs, Diaghilev went Ah Ah like a startled quail, and that for him was the highest sign of approval. By moving his legs the dancer was trying to say that the strange symphony was danceable, while Marinetti, happier than ever, ordered tea, cakes and liqueurs. Boccioni whispered to Carrà that the guests were won over. The only person who remained unmoved was Russolo himself. He tweaked his goatee beard and said there was a lot to modify: he hated praise. As a polite murmur of disagreement started, Piatti declared that experiments would have to begin again from scratch. Stravinsky and the Slav pianist played a frenzied four-handed version of *The Firebird*, and Pratella slept soundly through it all.'

On 21 April 1914, in the Teatro dal Verme, in Milan, three pieces for Noise Intoners were performed in the context of a regular Futurist Evening: *The Awakening of a City*, *Luncheon on the Kursaal Terrace*, and *Meeting of Automobiles and Aeroplanes*. After the afternoon rehearsal the performance had been banned by the police on the grounds that it would create a public disturbance, and it was on this occasion that the day was saved by the intervention of two parliamentary deputies, and of that same Maestro Giordano

who had been reviled in Piatella's manifesto. In spite of the dignified appearance of the musicians in their evening dress complete with gardenia buttonholes, there was the expected commotion, and Russolo finished up in court for striking the Honourable Agostino Cameroni, who had insulted and defamed both him and Futurism in the Catholic paper *L'Italia*. He was acquitted.

Marinetti had described the experience of demonstrating the Noise Intoners to the incredulous public as 'like showing the first steam engine to a herd of cows'. This certainly reinforced his pride in his 'great Futurist musicians', and during the elaborate London visit of summer 1914 there were no less than twelve Noise Intoner concerts, all at the London Coliseum. Press reactions, particularly in *The Times*, were politely puzzled. In *Lacerba* of 15 July 1914, Marinetti, Russolo and Piatti confronted their Italian detractors with the news that after the first London concert, which had been violently mocked and disrupted by the public, the eleven successive performances that followed were warmly applauded, and that some thirty thousand people had heard the music of the future.

Pratella, meanwhile, had responded rather slowly to the great new potential of Russolo's machines. But in the early summer of 1914 he declared that he had kept silent simply because he could find no fault with them. *Lacerba* of 15 May 1914 carried an article by him to this effect, together with an extract from an orchestral work, *Joy*, that would unite Noise Intoners of the exploding and buzzing kinds with conventional instruments. Pratella explained: 'In practice the Noise Intoners lose all sense of objective reality. They start from objective reality and move away from it immediately until they form a new

107 Pratella *Score of 'Joy'* 1914

abstract reality: abstract expressive element of a state of mind. Their timbre is not united with the other elements as heterogeneous material, but as a new sonorous element which is emotive and essentially musical.'

For Pratella, in other words, the Noise Intoners could be incorporated into the more traditional forms of music in much the same way as any other instrument. He was not particularly concerned with Russolo's perception of the possibility of matching the evolution of the sense of hearing with forms that could extend it still further. But in one work, his most truly 'Futurist', *Aviator Dro* of 1911–14, he did use the Noise Intoners to real effect when the hero's plane crashed to the ground. The other composition for mixed orchestra, *Joy*, was more or less the finale of *Aviator Dro*. A footnote in the score gave a fascinating foretaste of Karlheinz Stockhausen: 'Immense shout from the crowd. Each single individual will attempt the most acute intonation of his own chosen tone. The intonation and the duration will be arbitrary and independent, but the entries will be rigorously observed.'

The heroic years of the Noise Intoners ended with the war, though a notable later adherent was Franco Casavola (1891–1955). His Futurist music using Russolo's machines, and his five manifestos, all date from the years 1920–27. Russolo himself suffered severe head wounds during the war, and after a long convalescence left Italy, disgusted he said with its deplorable and disgraceful political and civil life. He moved to Paris, and his subsequent elaborations of the Noise Intoner principle were carried out there, although he did occasionally return to Italy. His concerts in Paris in the early 1920s still caused fierce controversy, but impressed several outstanding composers, including Maurice Ravel, Arthur Honegger, Darius Milhaud and the prophet of future *avant-gardes*, Varese. Later versions of the Noise Intoners included the *Rumor armonio*, or Noise Harmonium, and the Russolophone, which combined several Noise Intoners with a rudimentary keyboard. This was presented to the Parisian public in 1929 by Varese, and there was some hope of putting it into quantity production. Nothing came of it, and Russolo, somewhat discouraged, turned more and more to his painting and his philosophy. None of his machines, early or late versions, seems to have survived the Second World War.

The Futurist City

'We no longer feel ourselves to be the men of the cathedrals, the palaces and the podiums. We are the men of the great hotels, the railway stations, the immense streets, colossal ports, covered markets, luminous arcades, straight roads and beneficial demolitions.'

Antonio Sant'Elia, 'Manifesto of Futurist Architecture', 11 July 1914.

Futurist life was essentially urban. Its inspiration came from the teeming activity of the North Italian industrial cities, worlds away from the quiet of Tuscany or the medieval feudalism of the South. Marinetti had shown prophetic awareness of the effect of the environment on the individual, and the 'primitives of the new sensibility' were inhabitants of the great new conurbations. The Futurists had been railing against the anachronism of the museum cities of the past for five years before they found their own architect. By then they had recruits in just about every area that could possibly exert any influence on society, bar a representative of the field that most directly conditions the physical environment. It was an irony and a failing that perturbed Marinetti, and he was to welcome Antonio Sant'Elia (1888–1916) with relief.

Without an architect, the Futurist polemic on the theme of the city had been a polarized one. The 'museum city' of the past had been the object of scorn; the modern city had been the battery of human and mechanical energy, a highly coloured and romantic collage of arsenals and ship

yards, greedy railway stations, factories and bridges 'striding the rivers like giant gymnasts', still owing something to the romanticism of Walt Whitman. In the early manifestos, as in the paintings, the city is a backdrop on to which the dynamism of Futurist life is projected, and isolated buildings are singled out to symbolize the modern age. No concrete proposals are put forward; it was the Futurist transformation of human mentality that was to dynamize the old stones. And even Sant'Elia's projects for *The New City* were essentially visionary concepts; no truly Futurist building, let alone city complex, was ever built.

The Futurist painters had included a vision of the city in their 1910 manifesto, and again it was presented in terms of dynamic movement, as a dramatic backdrop to the action set in motion by the new perception of space: 'Space no longer exists; the street, soaked in rain and glistening in the glare of electric lights, sinks right down to the centre of the earth'. Through an extension of the principle of Dynamic Interpenetration, the noises of the street could be graphically represented as they entered the house; but the house was the same old solid block as in the bourgeois nineteenth century. And in the same manifesto, ironically enough, the painters had also called for an end to 'Big Business architecture and reinforced concrete construction'.

In Futurist painting the city had, of course, replaced the landscape as the setting for the excitement of modern life,

used again as little more than backdrop. Balla's pre-Futurist paintings of 1902–04 were an exception. With the life-size graffiti-covered doors of *Bankrupt* [109] or the close-up studies of *Work* and *The Workman's Day* [53–4], he had explored the fabric and the psychological implications of city life with a realism that stripped off the romance to expose the bare bones. And in 1908 Boccioni had paid painted tribute to the rising suburbs through which Marinetti's snorting automobile was to charge a year later in 'The Founding and Manifesto of Futurism'. The industrial sprawl of *Factories at Porta Romana* [14], executed in his pre-Futurist style, was hardly a subject that would have appealed to the painters of the academies—

or even, indeed, to Severini, who was busy painting the patchwork light of the boulevards of Paris. In the next couple of years it was the turmoil of rushing or rioting crowds in Milan that inspired both Boccioni and Carrà. Carrà's *Leaving the Theatre* of 1910–11 [33] and Boccioni's *Riot in the Galleria* [26], of a year later, are typical of this fusion of urban tumult, broken brushwork and heightened colour. Carrà's *Nocturne in Piazza Beccaria* of 1910 is as close to the romanticism of Whistler as a Futurist could get, and with *The City Rises* [25] Boccioni paid tribute to the physical energy that was throwing up the square blocks of the spreading suburbs, as old-fashioned in form as the horse that symbolizes that energy. This

109 Balla *Bankrupt* 1902

was the same heroic spirit that had inspired a poem by Paolo Buzzi two years earlier, dedicated to Boccioni:

'Raise the massive constructions of the future city,
Raise them into the free open sky of the aviator.'

And even by 1911, when the fully fledged painterly vocabulary of lines of force and dynamic interpenetration had enabled Carrà to tell *What the Tramcar Said to Me*, or Boccioni to record how *The Street Enters the House* [30], the city on to which they projected their vision of a world in flux and motion was still the solid reality of square stone blocks. They envisaged a Futurist city life, but not the Futurist city.

In the first years of the movement the dynamism of the new was used as a bludgeon to beat the old. Prime targets were revered historic centres from Venice and Florence to Oxford and Bruges: the museum cities and cemeteries of the past. The attacks were delivered with gusto and infuriating enjoyment, and received by the inhabitants as a personal affront. The manifesto 'Against Passéist Venice' was hurled down in 800,000 copies from the campanile of St Mark's in 1910, and proposed that the pride of the city, the 'stinking little canals', could be filled in to make way for the Futurist Venice which sounds remarkably like the present-day ruinous industrial sprawl of Mestre: 'Your Grand Canal, widened and dredged, will become, inevitably, a great mercantile port. Trains and trams racing along the roads constructed at last over your filled-in canals will bring you mountains of merchandise.' The drooping curves of Ruskin's beloved Gothic would crumble under the advance of metal bridges and smoking factories.

Ruskin had come under fire a few months before in March 1910, when, in a speech at the Lyceum Theatre in London, Marinetti had assaulted the English mania for reconstructing and preserving other people's heritages, for 'crisscrossing Italy only to meticulously sniff out the traces of our oppressive past', particularly the cities of Venice, Florence and Rome: 'the running sores on the face of the peninsula'. 'When, oh when,' he asked, 'will you rid yourselves of the lymphatic ideology of your deplorable Ruskin . . . with his morbid dreams of primitive rustic life, with his nostalgia for Homeric cheeses and legendary spinning-wheels, with his hatred of the machine, of steam and electricity, this mania for antique simplicity is like a man who in full maturity wants to sleep in his cot again and feed again at the breast of a decrepit old nurse in order to regain the thoughtless state of infancy.'

The Futurists themselves were as affected as anyone else by the anachronisms that surrounded modern life and modern thought, carried out against a background that had remained basically unchanged since the eighteenth century. What could be more incongruous than the tumultuous meetings conducted in the passéist surroundings of Marinetti's own Casa Rossa? To be sure, the trams rattled past on the Via del Senato, but at the back the sluggish old canal drifted on as it had for centuries. Far from seeking out one of the 'well-ventilated apartment houses' with all mod. cons. that Marinetti recommended as fitting the spirit of modern man, he himself lived in the setting described at the beginning of 'The Founding and Manifesto', a background of 'hanging mosque lamps with domes of filigreed brass', and of 'rich oriental rugs', exotic maybe, and decadent too, but more the world of the Symbolist poet than of the electric Futurist.

Palazzeschi described Marinetti composing his tracts in a bedroom decorated in the style of 1800, while that famous drawing-room, editorial office of the magazine *Poesia*, glowed with enchanting azure light, filtered from the mosque lamps, and radiated 'an enveloping sense of softness and warm voluptuousness'. This was the atmosphere that was so abruptly shattered in 'The Founding and Manifesto' by 'the famished roar of automobiles'.

Three years later, in *Le Futurisme*, Marinetti was able to give a more synthetic description of the changes in society that called for a change of environment.

'The contradictory forces of the banks, the leaders of fashion, revolutionary trade unions, metallurgists, engineers, electricians and aviators, the right to strike, equality before the law, the authority of numbers, the usurping power of the masses, the speed of international communications and the habits of hygiene and comfort, demand large well-ventilated apartment houses, railways of absolute reliability, tunnels, iron bridges, vast high-speed liners, hillside villas open to the breeze and views, immense meeting halls and bathrooms designed for the rapid daily care of the body.

'Aesthetics, responding directly to utility, have nothing to do nowadays with royal palaces of imposing line and granite basements.'

Now the picture of the Futurist city begins to emerge: an efficient, fast-moving machine, with a technocratic ring to it that strikes a chill in an age that is no longer innocent of the dangers inherent in such a vision. There was still no architect to give it a convincing shape. By 1913 Marinetti was often heard to say: 'By now we have all the arts with us, but no architecture.' Russolo, who was already nurturing the philosophical streak that was later to become a full-time occupation, was sceptical about the whole issue. He saw no glimmer of a new architecture emerging; and, that being the case, for him the question was superfluous. Boccioni had already formulated a concept of space, radiating out from a central point, that could have been an architectural analogy. It had appeared physically in the *Development of a Bottle in Space* [76], and theoretically in the 'Technical Manifesto of Futurist Sculpture' of 1912: 'We must take the object which we wish to create and begin with its central core.' The influence of Bergson is clear again in that, but it was also Bergson's theories of transience and flux that led Boccioni to remark drily that since architects are after solid things, Futurism could hold little appeal for them.

Among the painters it was Carlo Carrà whose attitude towards architecture was the most constructive. In 1913 his manifesto 'The Painting of Sounds, Noises and Smells' introduces a new and expanded concept of the Polyphonic Architectural Whole, which placed it in the Futurist context: 'When we talk of architecture, people usually think of something static; this is wrong. What we are thinking of is an architecture similar to the dynamic and musical architecture achieved by the Futurist musician Pratella. Architecture is found in the movement of colours, of smoke from a chimney, and in metallic structures when they are expressed in states of mind which are violent and chaotic!'

And it was Carrà who introduced the group to their new white hope for a truly Futurist architecture: Antonio Sant'Elia.

Carrà had met Sant'Elia at the Famiglia Artistica, the stamping ground of Milanese artists. In May 1914 Sant'Elia and a group of friends, notably Mario Chiattone, held

110 Sant'Elia

work for a time as a draughtsman for the city council and for the Villoresi Canal company. In 1909 he enrolled at the Brera Academy in Milan. Here he met the friends who were to form the New Tendencies group, among them Romolo Romani, one of the signatories of the 'Manifesto of the Futurist Painters', who had hastily withdrawn before the tumult began. New Tendencies certainly had a Futurist air, but its more cautious nature and conservative tone laid it open to the mocking label of 'right-wing Futurism'.

Carrà described Sant'Elia as a reserved and unsociable type. Others saw him as the epitome of generosity and *mondanité*; an habitual frequenter of dance halls and cafés, never without a cigarette in his mouth, and so elegant that a Milanese tailor lent him clothes for publicity purposes.

Early projects were done in collaboration with others, and include a number of designs, dated 1912, for the new station in Milan, which was one of the most challenging commissions offered during that period. In the same year he entered the competition for the cemetery at Monza with a monumental, decoration-encrusted fantasy that epitomized everything he was to attack a few years later. For one who was to die so young and whose enthusiasm was for the living future, it is doubly ironic that the few commissions he actually did receive were for tombs and cemeteries, notably the military cemetery of Monfalcone near Trieste, of which he himself was to be one of the first inmates. The story goes that when the plans were presented one of the most salient tomb inscriptions on the design was to the very general who had given him the commission.

Although early collaborations make Sant'Elia's individual contribution hard to

an exhibition under the group name they had already been using for two years: 'New Tendencies' (*Nuove Tendenze*). The remarkable thing about this display of architectural designs, paintings and drawings was that it showed how closely the visionary projects of Sant'Elia paralleled the Futurist aesthetic. But that was not all. the young architect had written an accompanying 'Message', the strident and challenging tones of which had all the makings of a Futurist manifesto. Carrà and, subsequently, Marinetti were quick to see that Futurism had found its architect.

Sant'Elia at this point was twenty-six, and had graduated two years before from the Accademia di Belle Arti in Bologna. Born in Como, the son of a hairdresser, he had shown a precocious interest and deft talent in architectural drawing. He studied first of all in Como, then moved to Milan to

111 Mendelsohn
*Projects for a Car-Body
Factory, Film-Studio,
Crematorium and
Goods Station* 1914
or later

define, his own sketches clarify his development. His beginnings were decidedly *fin-de-siècle* and Symbolist, just like Boccioni and Marinetti in their fields of painting and poetry; the most extreme examples of Sant'Elia's Symbolism were his illustrations for Poe's tales and Dante's *Inferno*. Strains of Art Nouveau and Charles Rennie Mackintosh were mingled with this Symbolism, leading to the encrusted confusion that comes from a surfeit of badly digested architectural magazines. This anxious borrowing was the bane of young Italian architects, and in his 'Message' Sant'Elia dismisses as cowards those who 'borrow originality from clandestine and compulsive devouring of art journals'.

More significant was his knowledge of the Viennese School of architecture, even though this too had been culled from the pages of publications like the magazine *Ver Sacrum*. Throughout his years of study he had assiduously used a volume on the Wagner School as his source book, and the influence is reflected both in the drawing style and the grandiose conception of mass. Early designs for monumental buildings and cemeteries relate closely to the drawings in his Vienna School book by Hoppe, Schöntal and Bastl. From them he cribbed his soaring towers, massive flights of stairs, huge, heavy arches, and domes. But a significant difference between the imaginary Babylon of the Viennese and that of Sant'Elia was to emerge: his visions

were to be protected on to a modern city, and his dreams, like those of his German contemporary Mendelsohn, were to be of power stations, not archaic temples.

From 1912 on, Sant'Elia's style had been growing steadily more synthetic and dynamic. Right from the beginning he had shown an extraordinarily dramatic grasp of

112 Sant'Elia *The New City: Stepped Profile Building on Two Street Levels* 1914

the expressive possibilities of architectural draughtsmanship, manipulating light and shade to emphasize the sculptural quality of his projects, and colour washes to achieve a sense of flowing space. Once he had shaken off his fascination for elaborate and hieratic decoration the clear stark lines of his *New City* were revealed. As the surface detail disappeared, the unbroken upward surge of volume in space increased, and the tense energy that emerged was much closer to the economy of Adolf Loos than to the cluttered surfaces of the other Viennese architects. By 1913 the term 'Architectonic Dynamism', which in itself implies an interest in Futurism, sets the tone for a series of drawings that introduce the individual ingredients of *The New City*. The baroque curves and encrustations had been stripped away to reveal the essential lines of forms unprecedented in their simplicity. The energy of these sketches shares the tenseness of Boccioni's best drawings, and echoes Boccioni's belief in the expressive possibilities of the straight line: 'For us the straight line will be alive and palpitating, will lend itself to all the expressive necessities of our material, and its basic bare severity will be a symbol of the metallic severity of the lines of modern machinery.' This equation of the beauty of the straight line and of the machine is prophetic of the aesthetics of the 1920s, as Rayner Banham points out in his *Theory and Design in the First Machine Age*.

The drawings of 1913 were single studies for power stations, lighthouses, aircraft hangars and railway termini, objects of excitement, but isolated as yet and without a city plan or a context. *The New City*, shown a year later in the New Tendencies exhibition, presents this plan. In Sant'Elia's vision of the city, habitation and communication systems were to be

127

LA CENTRALE ELETTRI

fused into a whole. Every aspect of city life was to be rationalized and centralized into one great powerhouse of energy, and it is highly significant that the power station itself plays so dramatic a role in Sant'Elia's imagination. For a young architect it was still the epitome of all that could be most challenging: the power station was the cathedral of the electric religion. The Società Thomas Edison's power station, the first in Milan, had been built in 1883, and its presence was as much of an inspiration to Sant'Elia as the expanding suburbs had been to Boccioni. Marinetti too had sung the beauties of the power station in the manifesto 'Geometric Splendour and the Numerical Sensibility' of March 1914: 'Nothing is more beautiful than a great humming power station that contains the hydraulic pressures of a whole mountain chain and the electric power of a vast horizon, synthesized in marble control panels bristling with dials, keyboards and shining commutators.'

A few drawings for *The New City* had been shown in March 1914 at the 'First Exhibition of Lombard Architects' in Milan. When the full set of sixteen drawings appeared in May at the New Tendencies show they were accompanied by Sant'Elia's own catalogue statement, the 'Message' that excited Carrà and Marinetti. This was to form the basis for 'The Manifesto of Futurist Architecture', distributed in leaflet form in July and published in *Lacerba* on 1 August, the language suitably pepped up and with the odd addition inevitably by Marinetti and company. The original 'Message' was rediscovered only in 1956, and the differences between it and the 'Manifesto' have been minutely scrutinized by subsequent historians, sometimes in the hope of proving that Sant'Elia was not as Futurist as he is made out to be.

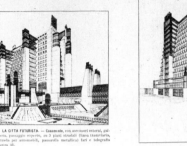

114 Sant'Elia 'Manifesto of Futurist Architecture' 1914 (extract)

In fact, the original 'Message' certainly reads like an example of Futurist polemic. It was divided, manifesto-style, into one section attacking the traditions and follies of the past and another proposing sweeping changes for the future. In both documents the attack was levelled at the archaic state of urban architecture, which had remained unchanged since the eighteenth century: 'A moronic mixture of the most varied stylistic elements, used to mask the skeletons of modern houses, is called modern architecture.' Only when the onanistic practices of the academies had been overthrown could young architects concentrate on 'throwing their minds open in the search for new frontiers and the solution to the new and pressing problem: THE FUTURIST HOUSE AND CITY. The house and the city which are

129

113 Sant'Elia *Electric Power Station* 1914

ours both spiritually and materially, in which our tumult can rage without seeming a grotesque anachronism.' The static forms inherent in traditional styles — perpendiculars, horizontals, cubes and pyramids — were denounced as being fundamentally incompatible with modern sensibility, along with materials that were 'massive, voluminous, enduring, antiquated and costly'.

But Sant'Elia was proposing more than change. He was arguing for a completely new attitude to architecture, one that was founded on the confident belief that each generation should build its own environment, not inherit the setting of the past: 'THE HOUSE WILL LAST FOR LESS TIME THAN WE WILL. EACH GENERATION MUST BUILD ITS OWN CITY.' The fundamental characteristics of his own generation, and of Futurist architecture, were to be independence of the past and impermanence: 'This architecture cannot be subjected to the laws of historical continuity. It must be as new as our state of mind.' The terminology, and the insistence on transience and mobility, reflect both Bergson and Boccioni.

The new aesthetic was to be conditioned by the extension of architecture beyond the solid known world of human sensibility: 'Our lives have been enriched by elements the possibility of whose existence the ancients did not even suspect. Men have identified material contingencies, and revealed spiritual attitudes whose repercussions are felt in a thousand ways.' In promoting the idea of ephemeral architecture Sant'Elia was echoing the hope expressed in 'The Founding and Manifesto', that successive generations would continually move even further ahead, and anticipating Le Corbusier's belief in an architecture of impermanence.

The new architecture was to be based on 'calculation, audacious daring and simplicity'. Materials were to be those that offered the elasticity and lightness of modern times: reinforced concrete, steel, glass, cardboard, textile fibre, and all the contemporary substitutes for stone, wood and brick. The list and the intention behind it parallel Boccioni's demands for twenty different materials laid out in the 'Technical Manifesto of Futurist Sculpture' two years earlier (see p. 73). Sant'Elia was at pains to stress that this was not to be an aridly utilitarian architecture, and he reserved for it the status of art: 'synthesis and expression'.

Lines were to be dynamic, oblique and elliptical. In place of the absurd encrustations of the past, the only decorative element was to come from 'the use and disposition of materials left raw or bare or violently coloured'. Above all, architecture was to be the most beautiful expression of the mechanical world. Inspiration was no longer to be found in nature, but in the artificial world, a theme that was taken up a year later by Balla and Depero in their science-fiction proposals for 'The Futurist Reconstruction of the Universe'. Such faith in technology is perhaps too easily dismissed with hindsight as naïve and foolish, if not dangerous. It had its roots in Sant'Elia's conviction that mankind was on the threshold of a new and challenging dimension: 'the endeavour to harmonize the environment and Man with freedom and great audacity, that is, to transform the world of things into a direct projection of the world of the spirit'.

The drawings for *The New City* are essentially visionary, and they relate closely to the febrile excitement of the 'Message' and the 'Manifesto'. The beautifully worked-up line drawings of multi-level urban complexes are the embodiment

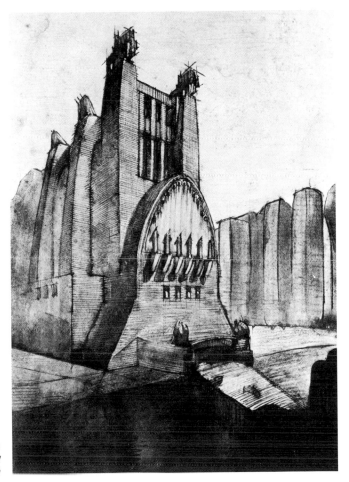

115 Sant'Elia
Monumental Building
1915

of the description of the Futurist city as 'an immense and tumultuous shipyard, agile, mobile and dynamic in every detail'. The Futurist building was to rise up from the complex network of communications beneath: 'it must soar aloft on the brink of a tumultuous abyss: the street will no longer lie like a doormat at ground level, but will plunge many storeys down into the earth, embracing the metropolitan traffic, and will be linked up for necessary interconnections by metal gangways and swift-moving pavements'. It was a complex in which buildings, mechanized and pedestrian traffic, were to share a space but function separately, and the drawings give the idea a rationality that still eludes city planners.

Buildings were to be grouped together in high-rise clusters, each element 'extraordinarily "ugly" in its mechanical simplicity, higher and wider according to need rather than the specifications of municipal laws'. A significant and pro-

131

phetic feature is the stepped-back profile of the buildings, designed to increase the light access and to vary the outline. This was a feature shared by Sant'Elia's contemporary Henri Sauvage in Paris, and one which was later to become the rule in the skyscrapers of the 1930s in New York. Occasionally the excitement of the skyline is increased with illuminated advertisements which anticipate both Tony Garnier's projects in Paris and those of Alexander Vesnin in post-revolutionary Russia.

By splitting the levels, Sant'Elia was envisaging a city in which all the essential services became a characteristic and integral part of the urban centre. This was by no means an isolated vision. In France again, Tony Garnier's drawings for *The Industrial City*, on which he worked from 1899 to 1917, and which were published later than Sant'Elia's *New City*, highlighted the dramatic intrusion of the docks into the heart of the city. In Garnier's opinion: 'Industrial requirements will be responsible for the foundation of most new towns in the future.' Garnier's understatement indicates his less radical and more respectable position as a visionary planner. His *Industrial City* differed from Sant'Elia's totally artificial environment in that it was to preserve both a low-level intimacy of scale and the inclusion of green spaces. This is a concept that is certainly closer to our taste now, and a far cry from Sant'Elia's deliberate exclusion of any reference to nature. And it is significant that the drawings for *The New City* usually exclude any suggestion of human presence. When tiny figures do appear they are there as an indication of the huge scale of the buildings rather than as human measure.

The apparent similarity between Sant'Elia's statement of intent to invent and rebuild the Futurist house 'like a gigantic machine' and Le Corbusier's phrase *'une machine à vivre'* has been seized on with rather too much alacrity. Le Corbusier's machine was to be based on smooth running and convenience, while for Sant'Elia the habitation was to be an extension of the sensory bombardment of factory life and of the flashing lights and excitement of the city. This was to be high-density living. Every bit of urban space was to be utilized, and more space gained by raised transport levels, underground and rooftop building. Special attention was given to the science-fiction concept of airports atop railway stations, and sophisticated underground rail networks. Lifts, too, were elevated in status. They were no longer to hide in the stairwells but 'swarm up the façades like serpents of glass and iron'.

No ground plans exist for this *New City*, and Sant'Elia gave no indication of how the interiors of his 'gigantic machines' were to be arranged. This reinforces the impression that even for him *The New City* was a dream and not a practical reality. The only single building attributable with certainty to him is in fact a Tyrolean-style gnomes' home of 1909: the Villa Elisi at San Maurizio near Como. In 1930 one of his designs for a lighthouse was adapted by his fellow Futurist Enrico Prampolini and subsequently elaborated and re-adapted as the Monument to the Fallen of the First World War in Como. This is a sadly diminished and ill-proportioned ghost of an idea, carried out by the architect who designed the House of Fascism in Como, Giuseppe Terragni.

Sant'Elia's considerable influence on the theory of subsequent architecture came from the ideas embodied in the drawings, the 'Message' and the 'Manifesto'. Most influential of all was the

concept of impermanence expressed in the 'Manifesto'. Even this has often been interpreted as an example of Marinettian interference, largely on the strength of the account given in Carrà's autobiography. Carrà described Sant'Elia's reactions when he saw this part of the 'Manifesto': 'With his usual laugh he said: "Don't attribute this nonsense to me. You know I believe the opposite."' As usual with Futurist reminiscences, there were no other witnesses; and the opinion expressed smacks more of Carrà than of Sant'Elia. Carrà's book was published in 1943, and since 1915 Carrà had been promoting an anti-Futurist return to order and stability. The concept of a new city for each generation had after all been a recurring theme in Sant'Elia's original 'Message', and was fundamental to his attitude to materials and to progress. Ultimately, the significance of Sant'Elia's contribution rests on the realization that 'in the course of history changes of fashion are frequent and are determined by alterations of religious conviction and political disposition. But catalysts of deep change in the state of the environment are extremely rare, changes that unhinge and renew, such as the discovery of natural laws, the perfecting of mechanical means, the rational and scientific use of material.' This was writ clear in the 'Message', and indicates that Sant'Elia, like Marinetti, was capable of applying the complexity of contemporary advance in all fields to his own discipline of architecture: at least in theory.

Sant'Elia added his signature to those of Marinetti, Boccioni, Piatti, Sironi and Russolo on the Interventionist manifesto 'Italian Pride' of October 1915, but apart from that his name does not appear in further Futurist manifestations. Along with Marinetti, Boccioni and Russolo he had enrolled in the Lombard Volunteer Cyclist Battalion in July 1915. He was awarded two silver medals, one for his gallant and useless death in October 1916 at the age of twenty-eight.

Of the other participants in the New Tendencies exhibition, Mario Chiattone did go on to a long and fairly active architectural career, but the period of his work that could in any way be called Futurist was short. Chiattone's father was the first collector of Boccioni's work. The young Chiattone had in fact been imprisoned with Boccioni in the spring of 1915 for their part in an Interventionist demonstration. Chiattone had shared a studio with Sant'Elia, and largely because of this had been drawn into the New Tendencies group. At the exhibition he had shown three drawings, the most ambitious of which was the *Construction for a Modern Metropolis*. Although this is a splendid drawing, comparison with Sant'Elia's city centres shows a more two-dimensional approach, and the effect of an elaborate stage set is increased by the vagueness of the spatial arrangements, particularly at street level, which indicates that he was less involved in the Dynamic Interpenetration of levels and masses that was central to Sant'Elia's vision. Chiattone's most convincing designs were for single buildings, notably the series of drawings for apartment blocks on which he worked in 1914–16 These are truly prophetic of later thinking in their use of clear rounded mass articulated in different colours, and one drawing of 1916 shares the curved glass curtain wall of later buildings, from Mendelsohn's Stuttgart store to the UNESCO building in Paris. After 1918 he returned to his native Switzerland and turned to an increasingly neoclassical style: 'that idiotic flowering of stupidity and impotence' that had been attacked so virulently in Sant'Elia's mani-

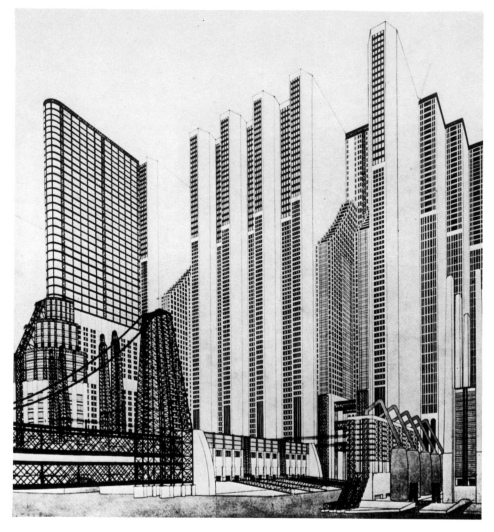

festo. In this his course paralleled that of Carrà, whose interest in the calm, ordered classical past had been growing since 1915. And even in the 1950s he was still designing buildings in the Metaphysical spirit of De Chirico and Carrà.

A third, though minor, Futurist architect was Virgilio Marchi. He was much younger than Sant'Elia and Chiattone, and his contacts were with the Roman group centred round Prampolini's review *Noi*. His designs verge on science fiction and elaborate scenography, but one recurrent feature, the use of reinforced concrete in circular forms, predates the Florence Stadium by Pier Luigi Nervi. Marchi produced a 'Manifesto of Futurist Architecture' in 1920 and a book on the

subject in 1923. But these, like Prampolini's 'Futurist Atmosphere-Structure — Basis for an Architecture', dated 1914–15 by him (but more probably written in 1918, when it was published in *Noi*), add little that is new or original to the initial polemic laid out by Sant'Elia.

Among the architects Sant'Elia was the only one who was widely publicized by Marinetti. After his death, copies of his 'Manifesto' and drawings were sent to the De Stijl group in Holland in 1917, and his reputation spread steadily abroad. The closest thing to a completely Futurist

complex ever constructed in Italy was the Fiat-Lingotto factory in Turin, by Giacomo Matteo Trucco. This was built in 1919–23, and featured multi-level workshops sunk into a raised racing-track. During the period of Fascism Sant'Elia's dynamics were evoked through the pages of a 'newspaper' bearing his name in 1933–34, but the various faces of Fascist architecture, from the International Style of Terragni's House of Fascism in Como to Mussolini's neo-Roman EUR, would bitterly have disappointed the champion of flexible and expendable architecture.

116 Chiattone
*Construction for a
Modern Metropolis* 1914

117 Chiattone
*Platform and Study
of Volumes* 1914

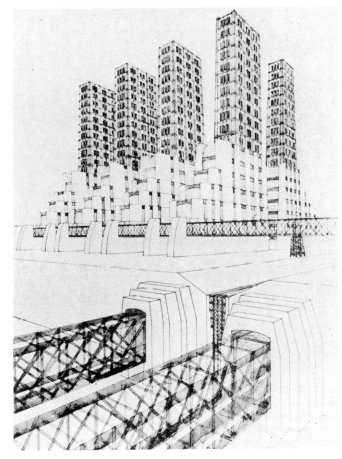

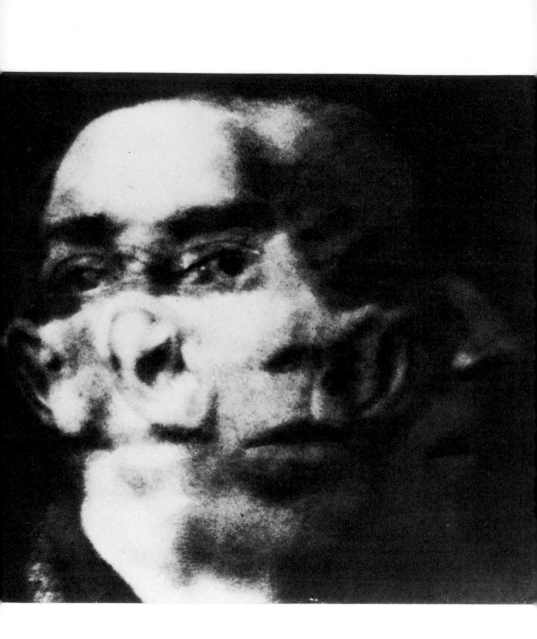

118 Bisi *Photodynamism of Boccioni c.* 1915

Photodynamism and Futurist cinema

'The Universe will be our vocabulary '
'The Futurist Cinema', 1916.

The backgrounds of the original adherents to Futurism made it inevitable that the first signs of the revitalization of the arts should be in the traditional fields of poetry, painting, sculpture and music. The boundaries of each of these had been extended in theory or in practice, and theatre in particular had become the versatile vehicle for the rapid bombardment of sensations which for Marinetti was the equivalent of the aesthetic and political upheaval of life in the twentieth century. But there were other means of expression still relatively free of tradition and history, and although attacking the past of the established arts had been part of the fun, it would have been strange indeed if Futurism had not found its own exponents of photography and cinematography.

Photography was assiduously used in the documentation of Futurist events, but its role long remained simply that of part of the publicity machine. Official mention of it within the movement did not appear until 1913. In that same year the virtues of the cinema as a widener of experience were praised in Marinetti's 'Manifesto of Variety Theatre': 'The variety theatre is unique today in its use of the cinema, which enriches it with an incalculable number of visions and otherwise unrealizable spectacles (battles, riots, horse races, auto-mobile and aeroplane meetings, journeys, the depths of the city, the countryside, oceans and skies).' That implied a subsidiary role for the cinema, and it was not until 1916 that a manifesto on the subject appeared, together with the first of the handful of films that could be called Futurist. Even then it must be said that, where the cinema was concerned, Marinetti's usually keen nose for spreading the Futurist message seems to have failed him. There is little to suggest that he realized, at least at the beginning of the Futurist programme, that cinema was to be the most popular and influential means of communication of the early twentieth century.

If cinema was initially treated as a convenient extension of the theatre, then photography, at least in the eyes of the Futurist painters, was considered irremediably inferior to painting. It was particularly Boccioni's resistance to the idea of photography as an independent and challenging art form that marred the group's relationship with the major exponent of Futurist Photodynamism: Anton Giulio Bragaglia (1890–1960).

Bragaglia had been producing the photographic images he called Photodynamism since 1911, but the first announcement of this new art in a Futurist form appeared in *Lacerba* on 1 July 1913. On the penultimate page was an advertisement which read: 'Published yesterday: "Futurist Photodynamism" by Anton

Giulio Bragaglia with 16 magnificent plates. Special introductory price for this edition: 10 soldi.'

Photodynamism first appeared in 1911 when Bragaglia lectured on the subject and produced a series of sepia photodynamic postcards. He claimed that the 'Manifesto of Futurist Photodynamism' was written in 1911, though the first record of it is the advertisement in *Lacerba* two years later. The manifesto is defensive in tone, though full of references to Bergsonian concepts of time and movement couched in Futurist terms. Bragaglia was at pains to dissociate himself from the mechanical side of photography, from the analytical experiments of E.J. Marey's chronophotography, and from cinematography. He claimed that the only common ground between these fields and Photodynamism was their mutual dependence on the physical properties of the camera.

His claim was that Photodynamism was a new art with ideals quite unique within the spectrum of existing representational means. Only Photodynamism could capture the complexity of movement, rhythm, reality and dematerialization, and bind them all together in the synthesis which Bragaglia understood to be the aim of all true art. This distinguished it from the 'glacial reproduction of reality' which jeopardized the status of photography, and from the mechanical arbitrariness and shattered rhythm of cinematography: 'To put it crudely chronophotography could be compared to a clock on the face of which only the half-hours are marked, cinematography to one on which the minutes too are indicated, and Photodynamism to a third on which are marked not only the seconds, but also the intermomental fractions existing in the passages between the seconds.' This is another Bergsonian echo, relating to the notion that it is 'more than human to capture that which happens in the interval'.

Since photodynamic images were most likely to be confused with Marey's analytical reconstructions of bird flight and human movement, it was his chronophotography that came in for the most criticism in the manifesto: 'Marey's chronophotography, being a form of cinematography carried out on a single plate or on a continuous strip of film, even if it does not use frames to divide movement, which is already scanned and broken up into instantaneous shots, still shatters the action.' This Bragaglia judged sufficient, perhaps, for the teaching of gymnastics, but inadequate even for the reconstruction of movement, let alone the sensation of it that he, like the Futurist painters, was trying to capture: 'We are involved only in the area of movement which produces sensation, memory of which still palpitates in our awareness.'

As justification for the claims made in this manifesto, Bragaglia referred to photodynamic images like *Carpenter Sawing*, *The Bow* and *Changing Positions*. Such images were obtained through long exposure while the subject itself moved, though Bragaglia was secretive about his methods. They were all interior shots, and were usually single subject compositions, the *Portrait of Balla* being an exception. They fell into two main groups. There were figures carrying out specific movements, usually of the hands, like *Carpenter Sawing*, *The Typist* and *The Guitarist*, in which Bragaglia was focusing attention on the communication of energy and rhythm which he called 'the algebra of movement'. Then there were images which implied the transition from one position to another: moments of change like a man standing up, bowing, walking or delivering

119 Bragaglia *The Slap* 1913

120 Bragaglia *Image in Motion*
1913

a slap. The manifesto made much of such moments of transition, and introduced a psychic note which was typical of Bragaglia and which distinguished him from the rest of the group with the exception of Boccioni, whose writings make occasional reference to paranormal phenomena. While the other Futurists claimed that a man's body penetrated the chair on which he sat, Bragaglia attempted to take perception one stage further, and claimed that: 'When a person gets up the chair is still full of his soul.'

Such a formulation reflects Bragaglia's involvement with contemporary spiritualistic speculations (and photographic experiments); and it was presumably the communication of psychic emotion to the spectator to which he was referring when he wrote of Photodynamism as 'an active transmitter'. Certainly a record exists of a curious sensation transmitted to a correspondent of the *Corriere Toscano* in 1913, though it was a sensory rather than a psychic experience. In an excited front-page article the journalist recorded the range of olfactory sensations he had had in front of Bragaglia's *Photodynamic Images*, which he firmly referred to as 'paintings' rather than photographs. He reported that the smells of sawn wood, fish glue and turpentine fairly oozed out of *Carpenter Sawing*. Bragaglia confirmed that he always attempted to give each subject the smells that would make it 'alive and complete', though it is not clear whether this was a figure of speech or an additional ingredient. Either way it pre-dated and probably influenced Carrà's manifesto 'The Painting of Sounds, Noises and Smells', of August 1913, as an 'environment-force' indispensable for the painter in the presentation of the 'pure plastic whole'. The difference was, of course, that Carrà translated smells back

121 Bragaglia *Carpenter Sawing* 1913

into colour analogies and characterized them as red, green and so on.

No further mention of this new step into modern media was made until the autumn. Then, again in *Lacerba* on 1 October, came a sour note sounded by the six painter members of the Milanese Futurist group, Boccioni, Carrà, Balla, Russolo, Severini and Soffici: 'Warning. Given the general ignorance in matters of art, we Futurist painters declare that everything referred to as "photodynamic" has to do exclusively with innovations in the field of photography. Such purely photographic researches have nothing to do with the PLASTIC DYNAMISM invented by us, nor with any form of dynamic research in the fields of painting, sculpture or architecture.'

This was neither the first nor the last time during the history of modern art that the

relative status of painting and photography has caused dispute and rivalry. But in the context of Futurism the statement was particularly self-contradictory. The painters had declared themselves to be the champions of the bold and the new, yet here they were, jealously guarding the definition of what art could be in a very old-fashioned way. In this their negative response was identical to that of the academic artists to whom Bragaglia in his innocence had put the question 'Can photography be art?' one year previously. But more than that: by placing a territorial patent on the term 'Plastic Dynamism' the painters were virtually defining the limits of what was meant to be a universal phenomenon open to a myriad of interpretations.

122 Bragaglia *The Typist* 1912

Marinetti alone seemed eager to include Bragaglia as a Futurist, and so add yet another discipline to the Futurist stable. He financed Bragaglia's researches into the development of photographic means of capturing the essence of movement, wrote the introduction to his exhibition of Futurist Photodynamism at the Sala Pichetti in Rome in 1912, and invited him to participate in some of the Grand Futurist Evenings. Admittedly this was only when they were in such far-flung outposts of the Futurist world as Sicily, Naples or Gubbio, and always on occasions when Boccioni was not present. Boccioni was intransigent in his insistence that photography was nothing more than a technical device. He even went so far as to write to the owner of the gallery where the Futurists' work was shown, Giuseppe Sprovieri, recommending: 'in the name of the Futurist friends that you exclude all contact with Bragaglia's Photodynamism, a presumptuous, useless effort which damages our aspirations to liberation from schematic or successive reproduction of motion'. Though at the bottom of the letter he added: 'Keep what I say to yourself, because I like him personally.'

In fact it was precisely this liberation of 'reproduction of motion' which interested Bragaglia above all: with his photodynamic images he was attempting to liberate the art of photography from the slavish imitation of reality to which it had been relegated. He saw untapped possibilities in photography as a means of experimentation, and was particularly attracted to its potential for capturing the *sensation* of movement rather than the sequential stages that had been analysed one by one by such pioneers in the study of movement as Marey and Eadweard Muybridge. Images achieved through long exposure, like *The Slap, Young Man*

123 Bragaglia *Balla in front of 'Leash in Motion'* [55] 1912

Swinging, The Typist or *Man Rising*, represent an interesting complement to the painters' attempts to capture the essence rather than the appearance of movement. They looked more like an alternative means of capturing an effect that was elusive and laborious in paint than a threat to the integrity of Futurist researches. Seen as independent images they are strikingly beautiful effects achieved through simple means. It may well be that Photodynamism started initially as an accident, and that the perfection of this accident came through Bragaglia's realization that this was a parallel to Balla's attempts to render the sensation of movement with paintings like *Girl Running on a Balcony* [60] or the *Violinist's Hands*, both of 1912. But it is equally possible that Balla in turn was in-fluenced by Bragaglia's continuous wave of motion when he came to paint *Leash in Motion* [55], and Bragaglia's photo-dynamic portrait of Balla in front of this painting seems to commemorate such an interchange

After his rebuff from the Futurist painters Bragaglia could take comfort in his belief that: 'The things that seem to be magic today are para-scientific and will enter consciousness with time.' Photo-dynamism and the involvement with Futurism had not been his only activities. Like the other later members of the movement, Depero and Prampolini, he had an experimental mentality less committed than Marinetti's to a single-minded Fut-urist life. Immediately after 'Futurist Photo-dynamism', he published a study of the

great inventions of the seventeenth century, and went on to write books and articles on subjects ranging from pantheism to prophecy, anticipating the invention of the televisual telephone, collaborating with writers like Pirandello, and founding numerous magazines of which the theatre and art review *L'Artista* was one.

But Bragaglia's driving interest both before and after Photodynamism, was the cinema that he had criticized in his manifesto. His father had been a pioneer of the Italian film industry, and at the age of sixteen the young Bragaglia had joined him in the film production company Cines, where he stayed until 1904 when he turned to the photographic experiments that were to lead to Photodynamism. After that, in 1916, he founded his own film company, La Novissima, and produced three full-length films, first *Thais*, then *Il perfido incanto* (*The Perfidious Enchant-*

ment) and *Il mio cadavere* (*My Corpse*), as well as one comic short, *Dramma in Olimpo* (*Drama in Olympus*). Ironically enough, it was also in 1916 that Marinetti at last felt that the movement should concern itself with the most modern medium, that of film. In that year the 'Manifesto of Futurist Cinema' was written, and the film *Vita futurista* (*Futurist Life*) was made. Bragaglia was not even asked to sign the manifesto, and his only involvement with the film was as its distributor.

Any discussion of Futurist cinema is complicated by the sad fact that all but one of the four films have been lost. There is even confusion about the identity of the survivor, which is kept unaccountably unavailable in the Cinémathèque Française. It now seems almost certain that this film is Bragaglia's *Thais*, but since it has remained unseen since a single showing in

124 Bragaglis *Thais*
1916: Thais Galitzky

1969 any assessment of its value as a film or as a contribution to Futurism has to be based, as with Bragaglia's other two films and *Vita futurista*, on surviving still photographs, contradictory recollections, and scanty documentation.

According to Bragaglia's daughter Antonella, *Thais* (length 1446 metres) was an ironic love story with a tragic end, and mingled both surreal and abstract imagery: 'Geometric shapes were formed and dissolved by movement, steam rose from walls, and mist disrupted perspective. The Mouth of Truth breathed out clouds of smoke. There were the shortest of captions, fragments of Baudelaire. Black and white alternated with dark blue or fiery orange toning.' This hint of the use of colour is significant, since it indicates a commitment to experimentation that the melodramatic story contradicts. The protagonist of *Thais* was Thais Galitzky, a legendary beauty who seems to have caught the Futurist imagination as much as the Marchesa Casati [131–2].

But probably the most daring feature of *Thais* was the way in which the actors played out their small human tragedy against a daringly bold abstract backdrop. This was designed by Enrico Prampolini, and seems to have played a most active part in the drama. Indeed, judging by the still photographs of the final suicide scene, by the end of the film the black and white horizontals and verticals of the background had been transformed into lethal spikes on which the heroine remained impaled. In this use of dramatic abstraction Bragaglia was anticipating Balla's rendering of Stravinsky's *Fireworks* a year later, in which coloured abstract mechanical shapes replaced human ballet dancers as the interpreters of the music [102].

The choice of subject matter was just as melodramatic in Bragaglia's other two films. *Il mio cadavere* (length 1380 metres) was based on a late nineteenth-century Neapolitan popular novel, the story of a bad baron assailed by the fear of death and related visions. Antonella Bragaglia described it as 'expressive of changing states of psychic obsession', and the censor suppressed some of its more horrifying moments. *Il perfido incanto* (length 1389 metres) was a series of idyllic and violent episodes set in an enchanted castle, ranging from murder and bank robbery to rape, sorcery and madness. It is hard to imagine less Futurist surroundings. The sets were once more by Prampolini, and Thais Galitzky again played a leading role. Of the three films this seems to have been the most truly experimental in techniques and in terms of exploration of the effects that could be achieved through film. In it Bragaglia applied the principle of Photodynamism to film, making the play of light and line an integral part of the action. The surreal effect of the scenography was increased by the use of different kinds of lenses and prisms, as well as the convex or concave mirrors that were also used in *Vita futurista*.

Bragaglia claimed that *Il perfido incanto* was 'a very modern film', and certainly the use of experimental effects indicates a growing concern for the possibilities of cinema as a conveyer of light and movement. Historians of the cinema have put forward both *Il perfido incanto* and *Vita futurista* as candidates for the title of 'first avant-garde film'. In fact it seems that the film *Drama of the Futurist Cabaret No. 13*, made by the Russian Futurists in 1913 or 1914 and involving Vladimir Mayakovsky, the Burliuk brothers, Mikhail Larionov and Natalya Goncharova, pre-dates both of them, and is probably more deserving of the title. Bragaglia never really seems to have released cinema from the stage

125, 126 Bragaglia *Thais* 1916: Thais Galitzky

127 Ginna *Vita futurista*
1916: Remo Chiti

settings and frontal positions of the theatre, and his special effects relate less to Futurism than to the bizarre disturbances of normality of later Surrealist films.

Vita futurista certainly was experimental, in that it broke the continuous storyline tradition of the theatre that had been applied wholesale to early cinema too. And it was full of technical tricks and devices: a mixture of fun and ingenious cinematic experiment. The producer-director-cameraman, at Marinetti's invitation, was Arnaldo Ginna, and it was made in Florence in the summer of 1916.

According to Ginna, he had been involved with cinema since 1907, and was particularly interested in the possibility of introducing colour into the medium. This provides another link in the fascinating chain of cinematic experiment that was attempted in far-flung parts of Europe before the First World War. The Russians were intrigued by the possibility of abstract cinema, as were Archibald McLaren and Léopold Survage in Paris round about 1912. Apollinaire and Blaise Cendrars were among those who tried in vain to

encourage such experimenters to produce a finished product. But they, like Ginna, were hampered by the limited technical possibilities of the machinery available to them. In 1910 Ginna and his brother Bruno Corra tried a simple experiment. They painted colour directly on to simple celluloid film untreated with silver nitrate. They painted four rolls: a colour composition based on a painting by Segantini, a study of effects with the complementary colours red and green coupled against blue and yellow, an interpretation in colour of Mendelssohn's *Spring Song*, and another of Mallarmé's 'Les Fleurs'.

This directly cinematic experimentation was not used in *Vita futurista*, and colour is mentioned only in passing in the 'Manifesto of Futurist Cinema'. This was written in September 1916, after the film had been made: a reversal of the anticipation of events that was usual in Marinetti's manifesto-publishing activities. The manifesto appeared in November in *Italia futurista*, since *Lacerba* had closed. It was signed by Marinetti, Bruno Corra, Emilio Settimelli, Arnaldo Ginna, Giacomo Balla

128 Ginna *Vita futurista* 1916: Balla

and Remo Chiti They had all been involved in the making of the film that summer, and Balla is noticeably the only member of the old guard of Futurists to have participated in this new field of activity.

Marinetti's interest in cinema had been stimulated by its potential as an extension of the variety theatre, as the burlesque tone of *Vita futurista* reflects. In 1913 he had seen the cinema as the means of transforming the variety theatre into 'a theatre of amazement, record-breaking and psycho-folly'. This grew from his advocacy of the sharp swiftness and economy of the Futurist Synthetic Theatre, in which everything was pared down to a minimum, and this is probably why *Vita futurista* took the form it did. According to Marinetti the eight episodes of *Vita futurista* were as follows:

'1. Projection of the principal innovative affirmations of the Manifesto of Futurist Cinema.

'2. Presentation of the Futurists: Marinetti, Settimelli, B. Corra, Remo Chiti, G Balla, Arnaldo Ginna.

'3. Futurist Life: How a Futurist sleeps — interpreted by Marinetti, Settimelli, Corra, Giulio Spina.

'4 Morning gymnastics — fencing, boxing — swordplay between Marinetti and Remo Chiti — discussion on boxing-gloves between Marinetti and Ungari. Futurist breakfast. Intervention of symbolic old men.

'5. Searches for inspiration — drama of objects. Marinetti and Settimelli approach assorted objects very carefully in order to see them in new lights Exploration of herrings, carrots, aubergines *Finally* to understand these animals and vegetables by placing them completely outside their usual surroundings. For the first time and from every point of view, an entire rubber ball is seen as it falls on the head of a statue and remains there, not in the hands of a playful boy. Interpreted by Settimelli, Chiti Bruno Corra

'Futurist declamation.

'Settimelli declaims. Ungari expresses his sensations by gesture, Chiti by his drawing.

'Discussions between a foot, a hammer,

129 Ginna *Vita futurista*
1916: dance sequence

130 Ginna *Vita futurista*
1916: Marinetti's
fisticuffs

and an umbrella — extractions of human expression from objects to project oneself into new realms of artistic expression.

'6. Futurist stroll. Study of new ways of walking — caricature of the neutralist walk, interpreted by Marinetti and Balla.

'Interventionist walk sketched out by Marinetti — creditor's walk, sketched by Balla — debtor's walk, sketched by Settimelli.

'Futurist march interpreted by Marinetti, Settimelli, Balla, Chiti.

'7. Futurist tea-party — invasion of a passéist tea-party — conquest of the women — Marinetti declaims amid their enthusiasm.

'8. Futurist work — paintings ideally and outwardly deformed — Balla falls in love with a chair and a footstool is born — interpreted by Marinetti, Balla and Settimelli.'

Originally there was another sequence at the end of *Vita futurista*: 'Why Cocco Beppe Did Not Die'. This featured Remo Chiti as death in a black suit painted with white skeleton bones, plus a caryatid and a foul odour, but was suppressed by the censor.

The film took three months to shoot, but for Ginna the greatest problem was the undisciplined behaviour of the Futurist friends, which reached the height of passéist bohemianism. They were lazy and slept late into the day. They disappeared when they should have been on set and had to be hunted down by telephone, or rounded up by taxi. The whole episode had the air of a summer romp, but in spite, or maybe because, of this the film was full of eccentric departures from matter-of-fact cinema, some of which could be called experimental, some original and some culled perhaps from important pioneers like Méliès The scene that demonstrated how the Futurist slept, as compared with the passéist, made use of some sort of split-screen device. Distorting concave or convex mirrors added dynamism to Balla's love affair with the chair. Double exposures gave figures a Futurist transparency, and metallic costumes worn by girls in a 'dynamic-rhythmic' dance in sequence 5 reflected the light and succeeded in 'destroying the ponderousness of the bodies'. Sequence 6, with its discussion between a foot, a hammer and an umbrella, is also a forerunner of the Surrealists' rediscovery of Lautréamont's 'chance

meeting of an umbrella and a sewing machine on a dissecting table'. Sequence 7 was intended to convey an Introspective Research into States of Mind, and to express this the film was toned deep violet. Six years after *Vita futurista* had been made, Ginna and his assistant found the film covered with white spots caused by dust and painted it pink to suggest a soft state of mind.

Although Ginna was in overall control of the film, the separate sections seem to have varied so much in approach that each artist must have been given a scene to concoct. The fisticuffs suggest Marinetti's aggressive idea of fun, while the drama of objects is much more in keeping with Balla's gentler quizzical wit. And this quick succession of contributions was in itself an echo of the way Futurist Evenings were conducted.

Ginna lent the last surviving copy of *Vita futurista* to a friend, and never saw it again. Impressions of the film can only be vague, but the manifesto gives a clear, if ambitious, picture of the aims of Futurist cinema. It was written in the strident tones of the aggressive Interventionist period, and included the usual references to bellicose dynamism, Italian creative genius and hygienic war. It begins with an attack on the book form: 'static companion of the sedentary, the nostalgic, the neutralist', and goes on to claim that: 'the Futurist cinema will co-operate in the general renewal, taking the place of the literary review (always pedantic) and the drama (always predictable) and killing the book (always tedious and oppressive).' But with a swift double-take it is admitted that: 'The necessities of propaganda will force us to publish a book once in a while. . . .'

The manifesto goes on to declare that the rehabilitation of the theatre had already been achieved, and that the next logical step after the Futurist Synthetic Theatre and the variety theatre was the new theatrical zone: the cinema. 'The Futurist cinema will sharpen and develop the sensibility, will quicken the imagination, will give the intelligence a prodigious sense of simultaneity and omnipresence.' Far from slavishly reflecting things as they are, it was to be 'a joyful deformation of the universe, an alogical fleeting synthesis of life in the world'. But although young and apparently free of tradition, the cinema had first to be freed of its abject role as 'theatre without words', and relieved of the adopted conventions of theatre and backward drama that had already made it profoundly passéist. This freedom achieved, the cinema would emerge as 'the expressive medium most adapted to the complex sensibility of a Futurist artist'. As such it would become an autonomous art, equally free from the stage, from reality, from photography, from the graceful and the solemn.

This was to be the cinema of analogy, and nothing less than the universe was to be its vocabulary. Suffering could be shown as a huge and jagged mountain, cheerfulness as a chair flying through the air to join a coat stand. Anger would disintegrate a figure into a whirlwind of little yellow balls. The cinema would pit itself against pomposity and ridicule sentimentality: 'We show the hero in the act of making an inspired speech to a great crowd. Suddenly we bring on Giovanni Giolitti who treasonably stuffs a thick forkful of macaroni into the hero's mouth, drowning his winged words in tomato sauce.'

It was to be cinema in which images would replace words, and captions would be rendered redundant. 'Example: if a character says, ''I contemplate your fresh and luminous smile as a traveller after a

long rough journey contemplates the sea from high on a mountain," we shall show traveller, sea, mountain.' And in place of Giosuè Carducci's vapid lines to Homer, Carducci himself would be shown 'wandering amid the tumult of the Achaians, deftly avoiding the galloping horses, paying his respects to Homer, going for a drink with Ajax to the inn, the Red Scamander, and at the third glass of wine his heart, whose palpitations we ought to see, pops out of his jacket like a huge red balloon and flies over the Gulf of Rapallo.' The most nostalgically weepy poetry would be transformed into violent, exciting and highly exhilarating spectacles that sound like a formula for generations of Hollywood epics.

The technical recommendations of the manifesto touch on many of the innovations that were later to emerge through the abstract films of Viking Eggeling and Hans Richter, or in the animated objects that play out their roles in Fernand Léger's *Ballet Mécanique* or Man Ray's *Emak Bakia*. The section in *Vita futurista* which featured the Drama of Objects appeared in the manifesto as: 'Filmed drama of objects (objects animated, humanized, baffled, dressed up, impassioned, civilized, dancing – objects removed from their normal surroundings and put into an abnormal state that by contrast throws into relief their amazing construction and non-human life).' There would be linear, plastic and chromatic equivalents for thoughts, feelings, smells and noises, though they would be nothing like Kandinsky's points and lines on painted surfaces: 'With white lines on black we shall show the inner physical rhythm of a husband who discovers his wife in adultery and chases the lover – rhythm of soul and rhythm of legs.'

There was much play on the manipulation and distortion of scale and context, and this again was prophetic of Surrealist vision. Two or three visual episodes were to be projected simultaneously. A big nose could silence a thousand congressional fingers. Two policemen's moustaches could arrest a tooth. There would be 'filmed dramas of disproportion: a thirsty man who pulls out a tiny drinking straw that lengthens umbilically as far as a lake and dries it up *instantly*'. There were to be dramas of numbers, letters, typography and geometry. Achievement in practice might so far have been slight, but the accumulative process of Futurism, gathering all that was new and dynamic inevitably to itself had to be seen to be at work. The definition of Futurist cinema was the sum total of all the events to date: 'Painting + Sculpture + Plastic Dynamism + Words-in-freedom + Composed Noises + Architecture + Synthetic Theatre – Futurist Cinema.'

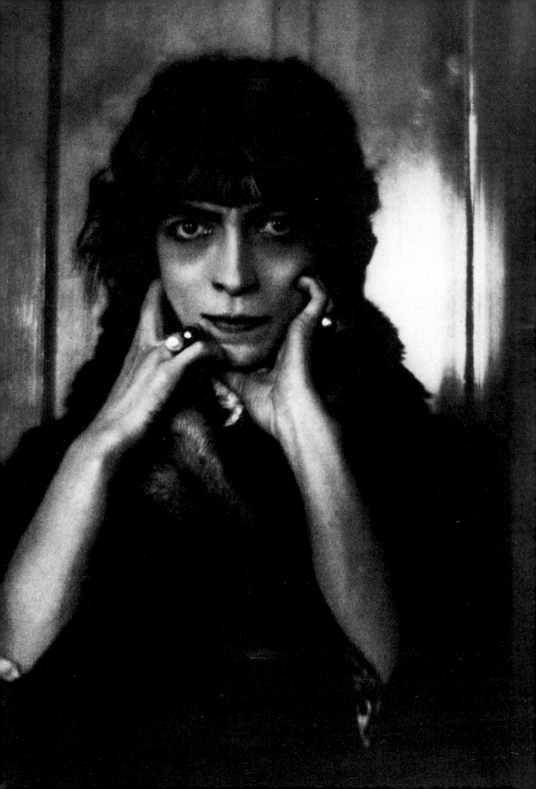

Futurism and Women

'We will glorify war— the world's only hygiene— militarism, patriotism, the destructive gesture of the anarchist, beautiful ideas worth dying for, and scorn for women.'
Marinetti, 'The Founding and Manifesto of Futurism', 20 February 1909

Glorification of war and overt scorn for women are not traditionally associated with the gentle arts or with cultural movements. The blatant advocacy of both together in the 'Founding and Manifesto' has caused consternation and disgust ever since, just as the Futurists' promotion of technocratic and aggressive virility has brought upon them the retrospective label of proto-Fascists. These are not aspects of the movement's programme that should be passed over quickly, swept under the carpet or whitewashed. There is no doubt that Marinetti meant what he wrote, and that such odious and outrageous statements were motivated partly by belief and partly by tactics. Italy was not only one of the most socially and culturally backward of the European countries, it was also one of the few that had not yet attempted to play the role of colonial power or conqueror: the Libyan campaign did not begin until 1911. It still tended to act as a collection of regions rather than as a united country. While a gentle murmur might instigate change or at least interest in Paris, the most amplified of shouts would not carry far in Italy.

But even allowing for overstatement, the issues of war and women in Futurism relate directly to the confused complexity of that moment in history. It was a time when opinions that now with retrospect and knowledge of Fascism seem regressive or abhorrent were precisely those which seemed to threaten the old repressive order of society. War and sex were seen as closely connected, releasers of aggressive or courageous individualism and agents of emancipation from repressive tradition.

The original statement of scorn for women in the 'Founding and Manifesto' was backed up by a declaration of war on 'moralism, feminism, every opportunistic or utilitarian cowardice'. It was fundamentally an attack on the sentimental and romantic treatment of love and women as epitomized by the adulterous heroines of D'Annunzio, and was gradually expanded into part of a social programme that attacked sexual morality, marriage and the structure of the family as the main causes of the repressive castration of the individual, male and female. By 1919 Marinetti's bald statement of scorn for women had been completely reformulated: 'We want to destroy not only the ownership of land, but also the ownership of women.' That, in terms of Futurist Democracy, meant the abolition of the 'Legal prostitution' of marriage.

As early as 1913, in the manifesto 'Imagination without Strings', he claimed that one of the consequences of the new sensibility brought about by the expanded communications of the modern world was:

131 Marchesa Casati

'Semi-equality of man and woman and the lessening of the disproportion in their social rights.' The same conditions had also brought about: 'Disdain for *l'amore*', though this, as Marinetti admitted, was 'a complex question: all I can do is raise it.' *L'amore* for the Futurists represented everything that was false and hypocritical between the sexes. They saw 'love' as a sentimental disguise for lust, accompanied by the novelist's staple diet of small flattering lies, deceit, coquetry and moonshine. *L'amore* was conditioned by small-minded bourgeois regulations and prudery, its ultimate aim being marriage, and its ultimate tragedy the eternal triangle, obsessive theme of a thousand plays and novels which Pirandello too was to mock.

In January 1913 Valentine de Saint-Point's 'Futurist Manifesto of Lust' was published as a leaflet by the direction of the Futurist movement. Valentine de Saint-Point was a granddaughter of Victor Hugo, a dancer and later a painter. Her concept of dance was later described and criticized along with Isadora Duncan's by Marinetti in the 'Manifesto of the Futurist Dance' of 1917: 'Valentine de Saint-Point conceived an abstract, metaphysical dance that was supposed to embody pure thoughts without sentimentality or sexual excitement. Her *métachorie* consists of mimed and danced poetry. Unfortunately it is passéist poetry that navigates within the old Creed and medieval sensibility: abstractions danced, but static, arid, cold, emotionless.'

Valentine de Saint-Point first appeared in the Futurist context when she lectured at the 1912 Futurist exhibitions in Brussels and Paris, and the 'Futurist Manifesto of Lust', which is far from being 'arid, cold and emotionless', came as a reply to press comments on these lectures: 'A reply to those dishonest journalists who twist phrases to make the Idea seem ridiculous;

to those women who only think what I have dared to say; to those for whom Lust is nothing but a sin; to all those who in Lust can see only Vice, just as in Pride they see only Vanity.'

Her main point was that man and woman were equal in lust, which she defined as an essential part of life's dynamism, a powerful source of energy, the expression of a being projected beyond itself: 'It is the sensory and sensual synthesis that leads to the greatest liberation of the spirit. It is the communion of a particle of humanity with all the sensuality of the earth.' She criticized the development of the spirit at the expense of the body, equated art and war, the great manifestations of sensuality, as emphatically as Marinetti, and praised lust as a process of natural selection. She blamed Christian morality and sentimental romanticism for the prevailing sense of hypocritical shame. In place of this she demanded that men and women throw off their cowardly hankering for security and face up to lust in full consciousness: 'Lust should be made into a work of art, formed, like every work of art, both instinctively and consciously.' This was strong stuff coming from a woman, stemming from understandable disgust for the hypocrisy of nineteenth-century morality and couched in alienatingly aggressive and militaristic language.

The standards that Saint-Point attacked, those prescribed and sustained by the Catholic Church and by petty provincialism, were criticized most savagely by the Florentine writer Italo Tavolato in the pages of *Lacerba* in the spring of 1913. Three articles appeared in February, March and May, each one more heretical and outspoken than the last, and all of them bristling with Tavolato's caustic wit. The first was 'Against Sexual Morality', in

which he set out to demonstrate that hypocritical moralism is the only real depravity, and that immorality is essentially chaste. He ridiculed the persecution of homosexuals in much the same way as Marinetti had upbraided the English for their treatment of Oscar Wilde in his 'Speech to the English' at the Lyceum in 1910. The article was an attack on the Church's dogma of intercourse for procreation only: the logical consequence of which should be that: 'Intercourse that is not followed by fecundation should be forbidden. Sensuality should be prohibited. Artists should be outlawed. Life should be abolished since it is not conceived immaculately.' The norms of morality had been set out by mediocre minds which condemned any deviance from them as criminal and depraved, and therefore would outlaw among others Diogenes, Socrates, Virgil, Alexander the Great, Kierkegaard, Goethe, Rousseau, Winckelmann, Gogol and Verlaine! Progress in the thinking of those who called themselves moralists could be measured by the fact that in the seventeenth century Carpzov urged that homosexuals be sent to the stake for causing earthquakes, plagues, poverty, floods, Saracens and large voracious country rats, while in the twentieth century a university professor claimed that homosexuality could be cured – through castration. . . . Tavolato offered to sacrifice a massacre of moralists to anyone who could tell him what came first: the Categorical Imperative or bathing suits, and concluded by going over the top, Futurist style, in an advocacy of sadism and masochism.

The second of Tavolato's articles was 'Commentary on the Futurist Manifesto of Lust by Valentine de Saint-Point', couched in the language and form of the Creed: 'I believe . . . in the carnal communion that enlivens the spirit, in the remission of virtue, in earthly life. Amen.' And the third, 'In Praise of Prostitution', was a lyrical satirical masterpiece, written as a series of heretical parables, exploding the myth of sin and the slavish woman, making moral vampires of Christ, Kant and literature in general, and singing the praises of Zaza, Lilly and Lulu, the sincere, the heroic and the shamelessly chaste. Morals come and go, change and disappear, but prostitution stays; 'therefore, if duration is an indication of value, prostitution is superior to ethics'. A few months later, in November 1913, the theme of prostitution appeared again in *Lacerba*, this time as an excerpt from Roderich Hellmann's pioneering book, *On Sexual Freedom*, published in Berlin in 1878. In this artists and prostitutes are placed on the same level, both being paid to give pleasure, the greatest artists being those who give the most, and all arts appealing through the senses. Marriage comes under fire again: 'The married woman could be compared to a slave bonded forever, the prostitute to a free working woman with an open contract.'

In spite of the implicit acknowledgment of equality, few women were allowed any voice on the issues at stake. Valentine de Saint-Point's contribution was a rare exception, and although there were other high society and professional women who were admired by the group, like Madame Rachilde, Parisian editor of the literary review *Mercure*, or the dancer Loie Fuller, the only other woman to be dubbed Futurist was the soulful Marchesa Casati. She seems to have been something of a *femme fatale*, of the kind that had been rejected in theory as a Symbolist trapping. She was a beautiful, rich and fascinating collector, and her eyes held a particular attraction for Marinetti and Balla, rather

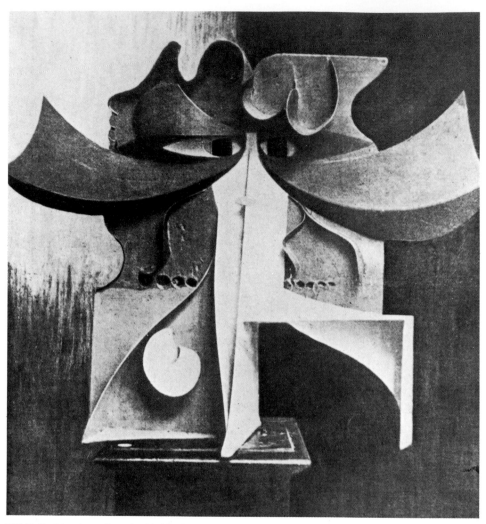

132 Balla *Marchesa Casati with Moving Eyes* 1916

like the Futurist equivalent of the power exerted over the Surrealists by the eyes of Gala Eluard. On the lower left-hand corner of Carrà's Marinetti portrait [17], of 1911, is a dedication to Casati on a piece of painted paper stuck to the canvas which Marinetti himself added: 'I give my portrait painted by Carrà to the great Futurist Marchesa Casati, to her languid jaguar's eyes which digest in the sun the cage of steel which she has devoured.' And in 1916 Balla constructed his delightfully playful *Marchesa Casati with Moving Eyes*, which many years later was to find an unromantic echo in Richard Hamilton's *Hugh Gaitskell with Revolving Eyes*.

Futurist writings indicate a gradual shift from the simplistic 'scorn of woman' as symbol of sentiment to a wider onslaught on the sacred structures of society, and eventually to a political strategy of supporting women's suffrage. In practice the movement remained very much a male club, with a puerile and indeed sinister insistence on aggressive virility. There are echoes in all this of an out-of-context reading of Nietzsche's 'Of the Friend': 'In woman, a slave and a tyrant have all too long been concealed. For that reason, woman is not yet capable of friendship: she knows only love.'

The Futurist hero was the man of iron, the aviator and the engineer. In a letter of 1914 to A.W. McLeod, D.H. Lawrence described both the attraction and the weakness of the Futurist attitude: 'It interests me very much. I like it because it is the applying to the emotions of the purging of the old forms and sentimentalities. I like it for its saying — enough of this sickly cant, let us be honest and stick by what is in us. . . . Only I don't believe in them. I agree with them about the weary sickness of pedantry and tradition and inertness, but I don't agree with them as to the cure and the escape. They will progress down the purely male or intellectual or scientific line. They will even use their intuition for intellectual or scientific purposes.' This, of course, is far from Lawrence's utopia where all art and creation is 'the joint work of man and woman'

Literature was the field in which the Futurists were most determined to shake off the sentimental cloying woman of the past. Here the male club spirit was at its most overt and silly. Giovanni Papini's writings foreshadowed his later solidarity with Fascism in their biting savagery and total dismissal of women. Marinetti was to marry the daughter of the lawyer who defended him in the obscenity trials caused by *Mafarka futurista*, and became a doting husband and father in spite of theory. Yet *Mafarka* is a book that dispenses with women, to such an extent that Mafarka's son Gazurmah, a huge mechanical and invisible bird with flexible wings to embrace the stars, was conceived and borne by Mafarka himself, unaided by the weaker sex, through the exercise of 'externalized will'! And in the Futurist Synthetic Theatre, particularly in the plays written by Boccioni, the women are either silly creatures adorning art galleries and drawing rooms, boring wives with inept lovers, or electric dolls.

The portrayal of women in painting was equally at odds with the wider view taken in manifestos and *Lacerba* articles. Boccioni's favourite model [67, 71, 75, 103] was his mother, large, comfortable and wide-lapped. She was the subject and possibly the inspiration of a number of his major paintings, including *Materia* of 1912, and *Horizontal Volumes* of the same year, a massive archetype, hands firmly folded in lap, whose solidity defies all Futurist lines of force and interpenetration. The same face graced the cover of Pratella's 'Manifesto of Futurist Music' when it was reprinted in 1912, and was carried into three dimensions with the *Antigrazioso* (*Antigracious*) head and the more advanced *Head+House+Light* of the same year. Boccioni often posed for studio photographs surrounded by his domestic entourage of mother, sister and fiancée, and if *Modern Idol* [23] is a homage to the bright lights of night-life, and to the allure of the modern prostitute, he was certainly careful to keep that side of his activities well beyond the bounds of house and home, in true bourgeois fashion. His images of strength and dynamism,

133 Boccioni in his studio with his mother and Balla 1913

whether of cyclists, footballers or striding figures, are relentlessly masculine. In his autobiography, Carrà claimed that Boccioni's penchant was for little helpless women, the milliners and flowergirls of the nineteenth-century bohemian.

Carrà himself painted the only female image that really departed from archetypes of one kind or another, whether of the mother, the prostitute or the dancer. His *Women Swimmers* (*Nuotatrici*) [34] is a strange linear pattern of bodies cutting through water, in which attractiveness and sexuality are set aside to emphasize the energy of the forms.

Russolo's *Perfume* of 1910 is perhaps the most unabashedly Symbolist image of Futurism, a great swirl of spiralling colour and a languidly swooning female head straight from the world and the imagination of Previati. For Severini the bright, swirling creatures of the cafés and cabarets

were the starting points for elaborate studies of dynamic colour, light and movement. His gyrating dancers are sequinned mannequins, costumed dolls whose glittering clothes provide the painter with syncopated rhythms and patterns. The allure of *The Obsessive Dancer* comes from her clothes and her movements, and any personality the *Blue Dancer* might have had is quite irrelevant to the painting. The dancers of the Monico or the Bal Tabarin were delightful objects from which 'dynamic hieroglyphics' could be abstracted. This was very much Severini's world, and his own dancing prowess was such that when he lived in Paris the *cafés-dansants* welcomed him free of charge [41, 45].

In August 1913 Severini married Jeanne, the sixteen-year-old daughter of the 'prince of poets', Paul Fort, whose portrait he was to paint in 1914–15. In

marrying her he was flying in the face of all the Futurist propaganda against the institution of marriage, which had after all appeared in that very same year. The group reacted to this traitor in their midst with outraged horror and righteous indignation. Boccioni sent him a letter condemning the 'bestial thing' that he had done, declaring that his act had disgraced Severini and art itself, and fervently hoping that the artist in Severini would triumph and overcome such trivial distractions.

It says something for Severini's courage that he dared to appear in Milan with his new bride. An article written by Soffici in *Lacerba* on 13 September described what happened during the course of an evening when the two were present in the Ristorante Savini in the Galleria. Boccioni launched into the attack, quoting the 'Futurist Manifesto of Lust', and railing against marriage from a point of view that was more Jesuit than libertine. Marriage, he said, was a terrible weakener of spiritual force, a bourgeois sapping of energy. Then, more mildly, Russolo had his say, in the terms of an extended musical metaphor: marriage was a breeder of 'discord and dissonance'. His condemnation was sufficiently clear, but he qualified it by admitting that, as an exercise, some advantage might be drawn from this 'school of enharmonic discipline'. Then it was the turn of Ida and Bianchina, representatives of Futurist love, but although their words would certainly have been worth remembering, they could not get a word in edgewise. At this point the proceedings were interrupted by an outburst from Severini in evening dress, his style slightly cramped by Jeanne who was by now weeping copiously on his shoulder. All the group dropped the offensive and set about comforting them, declaring

134 Russolo
Perfume 1910

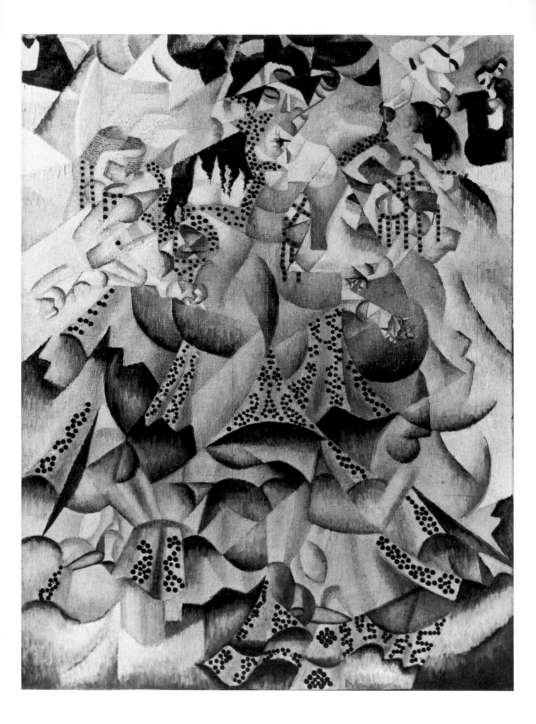

136 Severini *Paul Fort* 1914–15

135 Severini *Blue Dancer* 1912

that their passion was their only defence. Carrà alone stayed silent and unmoved, waiting his time like a watchful mastiff, calculating the right moment to pounce. It came. He jumped to his feet. 'Marriage,' he began, but his opinion was lost to record as he collapsed vomiting over the chair next to him.

With the outbreak of war and the repercussions of the suffragette movement in England, Marinetti expanded his anti-feminist programme into a renewed discussion of women in politics. His book *War, Sole Hygiene of the World*, which was published in 1915, argued the historical, political and Futurist reasons why Italy should drop her neutral position and join in on the side of England and France against the Germans. In one of the sections: 'Against *Amore* and Parliamentarianism', he managed to bring together in one unlikely context two of the most recurrent themes of Futurism. He claimed that: 'In this campaign of ours for liberation, our best allies are the suffragettes, because the more rights and powers they win for woman, the more she will be deprived of *Amore*, and by so much more will she cease to be a magnet for sentimental passion or lust.' It was clear from the start that Marinetti's support of the cause was a double-edged sword. His argument was that women were pressing for a mediocre and passéist right: the right to vote in a system that had long since shown itself to be corrupt, undemocratic and hypocritical. This limited vision and aspiration he attributed to centuries of subjugation, but nowhere does he suggest that women would change through experience: 'As for the supposed inferiority of woman, we think that if her body and spirit had, for many generations past, been subjected to the same physical and spiritual education as man, it would perhaps be legitimate to

speak of the equality of the sexes. It is obvious in any case that in her actual state of intellectual and erotic slavery, woman finds herself wholly inferior in character and intelligence, and can therefore be only a mediocre legislative instrument. For just this reason we most enthusiastically defend the rights of the suffragettes, at the same time as regretting their childish eagerness to have the miserable, ridiculous right to vote.'

For Marinetti, women's suffrage would represent the final downfall of the parliamentary system, and that of course was his reason for welcoming it. He was sure that they would win their struggle, though here it is worth remembering that the vote for women in Italy was not achieved until after the Second World War. And in winning this right they would 'involuntarily help us to destroy that grand foolishness made up of corruption and banality to which parliamentarianism is now reduced.' Marinetti considered this style of government to be exhausted. The majority had the illusory sense of participation in government, but in reality they were estranged from it by delegating responsibility, and letting themselves be represented by 'spokesmen whom they do not know how to choose'. The result of this was the sacrifice of intelligence to eloquence, and the qualifications for entry into the 'noisy chicken coops, cow stalls or sewers' of the European parliaments were: '(1) financial corruption, shrewdness in bribery to win a seat in parliament, and (2) gossipy eloquence, grandiose falsification of ideas, triumph of high-sounding phrases, tom-tom of negroes and windmill gestures'.

The entry of women into this system would deliver the final *coup de grâce*: 'Where could we find a dynamite more impatient or more effective? . . . Let us

hasten to give women the vote. And this furthermore is the final and absolutely logical conclusion of the ideal of democracy and universal suffrage as it was conceived by Jean-Jacques Rousseau and the other preparers of the French Revolution. Let women achieve with the speed of lightning this great proof of the total animalization of politics.' The participation of women would kill off the despicable traditions of professional careerist politicians, and lead the country into such a slough of pacifism and Tolstoyan cowardice, of clerical and moralistic hypocrisy, that the reaction would be more drastic than anything that could be achieved by men 'filthy with millenarian wisdom'.

Marinetti foresaw that there would in fact be masculine opposition to the abolition of the family: 'All rights and all liberties must be given to women, you cry, but the family must be preserved.' As for woman herself, the problem there was that, in spite of dreaming of political rights, she still held 'the unconscious and intimate conviction of being, as mother, wife and lover, a restricted circle, purely animal and absolutely bereft of usefulness'. But in spite of this the logical extension of the entry of women into politics would be the demise of the family and the release of the individual from the grasp of the 'fabricators of justice who by means of the ductile iron of the law assiduously build traps for fools'. These were the arguments that Marinetti pursued through 1919, 1920 and 1921, with publications like *Futurist Democracy, Beyond Communism* and *Futurism and Fascism* The themes of Family, Church and Law became part of a campaign to overthrow the power of the Catholic Church as personified by the Pope and to abolish the monarchy. As we shall see in the next chapter, such measures were too radical for Mussolini, and this led, in 1921, to an open confrontation between Marinetti and Mussolini, and the relegation of Futurism to the fringe of the Fascist Party's programme.

lingua di piccione bianco leccare
leccare

CLOWN Altissimo Tour Eiffel
CORRENTI di rumori da Sud a Nord

leccare cervello

CoZzO NᵒᴰI

linguaggi poliritmici

nell'aria rinchiusa

A CONVEGNO DI ⟩ FORZE

amanti im pro vvisati
AVAMPOSTE EU RO PA ARTᴵSTI CA

rumori
(acutitsimo alto
vertiginoso 300 m.)
vetri infranti
musica drammatica del Boulevard
Saint-Michel
sconposizioni e velocità
architetture (**fuggente sferico ellissoidale fluttuante**)

luci colorate

ARCOBALENI ⟨ negli spessori
dei corpi umani
e dei pilastri

ISCRIZIONI (luuuuuuuuuungo fuggente balzante intrecciato bianco su fondo celeste)

MONTROUGE CHATELET TOMBÉ-ISSOIRE

═══ ⟩ pace delle campagne primavera
ciuffi di neve Alpi Italia
attirare
respingere
30 specchi ⟨ colare colare colare
colarecolori lucelettrica
GARA di 318000 lettere
+ 26 000 000 numeri
PRIMATO
lottare vincere
cancellare sopraffare
cristalli giocare tutto
ottoni maioliche conflitto
guerra commerciale per la

fosforescente
minuzioso
accanito
feroce
intransigente
acciaiato

VITTORIA

del **PROPRIO** PRODOTTO

nero
fumoso
zigzazante

bilanci *bilanci* *bilanci* bilanci *bilanci* BILANCI

titoli bancari porti porti porti docks
quotazioni di Borsa fumaiuoli maone

nella **NOOOTTE** dei **MAAARlii** che non
vedrò mai

inesplorato

meneinfischio ⟨ SI NO N 00000
NO SI FORSENNATO
SI NO S iiiiiii

18.000.000 di uomini in rissa
senza conoscersi

ricchezza del mio spirito

GRAVITARE di masse perpendi-

colari sul piano orizzontale del mio **TAVO-LINO** di marmo
BIBITE RᵢBᴱLˡI contro volontà
SETE CEREBRALE LUSSO
8 odori di **4I** femmine (**occasionale cronametrato rastrellante**) = **8** siluri = **LUS SI-LURI A** slittare slittare
slittare sul pensiero

DOMᴵNANTE
della
mia
POVERTÀ
FORZA COMMERCIALE della per-
sonalità fisica di questi capolavori d'

A
LᴄᴏᴠA
mercato notturno **FIERA** (meraviglioso
giostrante illuminatissimo tintinnante)

EQᵁᵢVᴏCO della prudenza

Provinciale | accidentalità inebriante

avvilimento visione (**nostalgico sprezzante in-**

Lacerba

'The birth of Lacerba *was an act of liberation.'*
Papini and Soffici, 1 December 1914.

The most hectic years of Futurism coincided with the period during which the remarkable experimental newspaper *Lacerba* was published. This was also the time when the movement's bid for popular support was at its strongest, and *Lacerba* was certainly a powerful instrument in the spreading of Futurist ideas. The first issue was published on 1 January 1913, and the last on 22 May 1915. Over the two and a half years there were seventy issues: it appeared at first as a fortnightly cultural paper, and then, with the urgency of the war climate, was transformed into a political weekly. At no time was it the official organ of the Futurist movement; it started and ended without Marinetti's Milanese group, and their collaboration, when it came, lasted only about a year. Significantly enough, the only Futurist who continued to make whole-hearted contributions to *Lacerba* after it had become a purely political newspaper was Marinetti himself.

The variety of opinions expressed in *Lacerba*, as well as the ups and downs in the relationship between its main Florentine contributors, Giovanni Papini and Ardengo Soffici, and the Futurism of Marinetti, are a reminder that the Milanese group were not the only advocates of change in Italy Since the turn of the century Papini and Soffici had been involved with a number of periodicals whose policy was to overthrow official academic art. Together they made a formidable team, Soffici on the cultural front and Papini on the political. They collaborated on a number of publications that were typical of this time in Italy, and whose common characteristic was the desire for a thriving Italian *avant-garde*. The most important of these were *Il Regno*, *Leonardo* and *La Voce*. Papini had been editor-in-chief of *Il Regno* from 1903 to 1904, and of *Leonardo* from 1903 to 1907. *La Voce* was the magazine in which Papini and Soffici had put most hope. One of the early issues of *Lacerba* explained their disappointment in *La Voce*, and gave the reasons for the transference of their allegiance: '*La Voce* started as a meeting-place for different spirits with common cultural and human ends, based on clearing out the deadwood of the intellectual world, the rapid and intelligent dissemination of Italian and foreign development, and the honest study of practical matters beyond the scope of political parties.'

But *La Voce*'s ambitious aim to foster the 'new spiritual world of organic intelligence, a coherent culture based on truly logical and human values' had been betrayed by internal disagreement brought about by the limited outlook of its editor, Giuseppe Prezzolini. An additional reason was certainly Prezzolini's refusal to print contributions by the brilliant and original poet Palazzeschi, who was to be one of the major contributors to *Lacerba*.

Lacerba was born with the withdrawal of Papini and Soffici from *La Voce*. Initially its democratic structure reflected its anarchic contents. There was no editor until the very last issues, when Papini took over, and by then it had become the mouthpiece for his aggressive political opinions. *Lacerba* was financed and printed by Attilio Vallecchi, who also published *La Voce* and other periodicals, supported by his considerable publishing empire in Florence. In fact *La Voce* and *Lacerba* could be bought together at a discount, and the books by the Futurists advertised in *Lacerba* were distributed by the *La Voce* bookshops. Financially, Vallecchi was happy if *Lacerba* broke even; which, remarkably, it did. The paper cost 4 soldi, and during the Interventionist period this was dropped to 2 soldi to encourage sales. It was probably then that the much-vaunted circulation figure of twenty thousand, four-fifths of which were bought by workers, many on subscription, was achieved. It was Vallecchi who stood by *Lacerba* when prosecutions followed the appearance of the most outspoken articles, notably when cases were brought against Tavolato's 'In Praise of Prostitution' on the grounds of offence to public morals, and again against Papini's 'Jesus the Sinner' for offence to state religion. Both cases were dismissed, but in financing a publication whose stated aim was to react outspokenly to everything that happened in Italy, Vallecchi was running a considerable risk. This was increased after the outbreak of war in 1914, when *Lacerba*'s attacks on the Germans and Austrians, and its intransigent line on Italian intervention, were often solidly blacked out by the censor.

The fantastic typographical innovations which were to be an outstanding feature of *Lacerba* once the Futurists joined in were not in evidence in the earliest issues. What

138 Papini and Soffici 1906

was new was the clarity of the layout, which justified *Lacerba*'s claim to be a truly modern newspaper. The first two issues continued the irreverent and anti-academic arguments of Papini and Soffici, with the addition of contributions from Palazzeschi and Tavolato, who quickly set about his castigation of the false morals of Italy. Soffici was alone in his coverage of art, and in the second, third and fourth issues wrote a series of articles entitled 'Cubism and Beyond', without even mentioning the Futurists. When these articles were reprinted as a separate volume, however, illustrations of Futurist works were included, partly in response to a letter from Carrà, emphasizing the innovatory contribution of Futurism in the fields of pictorial dynamism and movement.

A long history of bitterness between the rival groups reached a peak at the end of

1911 with the publication of Soffici's article 'Free Art, Futurist Painting', a criticism of the Futurist Exhibition at the Padiglione Ricordi in Milan. In this he had vaunted his French connections, and used them to prove that the Futurist painters were vastly inferior to the Cubists, that they were little more than revamped Expressionists, and that Boccioni was an outright passéist. Marinetti, Boccioni, Russolo and Carrà had set off on a punitive expedition to Florence, and had been conducted to *La Voce* haunts by the mischievous Palazzeschi. In the Caffé delle Giubbe Rosse he pointed out Soffici to the Futurists, who did not then know him by sight, and although the aggressive Papini was not present, a fierce fight ensued. The

139 Page of *Lacerba* with pencil sketch by Severini

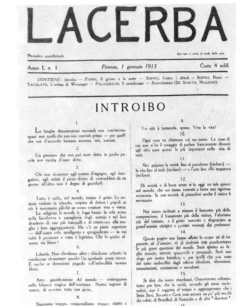

140 First page of *Lacerba* 1913

next morning the associates of *La Voce* turned out as the Futurists were leaving from Florence station, and another fight broke out. This time it was broken up by the police, who locked all of them in the station waiting-room. There the fight cooled into a discussion, and they found that they had much in common after all. But the 'Peace of Florence' was not declared until later. It was recommended in a letter of 17 October 1912, signed by the Futurist group and sent to Severini who was off to Florence. They urged him to impress the Florentines with the 'mathematical lethalness' of their cause, to convince them that the French press were now accusing the Cubists of imitating the Futurists, and to find out what it was that Soffici had against Futurist sculpture in particular. Part of the motivation for this conciliatory move was certainly the

rumour that a new and important publication was to start in Florence; and a few months later it paid off, with the first issue of *Lacerba*.

The first mention of Futurism in *Lacerba* appeared in the third issue, with Papini's article 'The Meaning of Futurism'. While this indicated a certain grudging sympathy, it was patently obvious that Papini had completely failed to understand Marinetti's deliberate use of publicity in culture, and his understanding of Futurist painting and its objectives was equally shaky. In much the same way as later critics, he accused the Futurists of being tragic clowns trying to frighten placid spectators, of using unnecessarily crude and noisy means: 'Great artists have never needed to sign proclamations or theories to make art. Genius imposes itself without theory and declarations of rights.'

In terms of painting, it was particularly the Futurists' attempts to interpret movement that upset Papini: 'What has the "representation of movement" to do with painting? Painting can be truly great and modern when representing immobility.' And he found the group's efforts to transform the subject matter of painting equally absurd: 'Painting cares nothing for subject. A woman, a ship, a potato can result equally in a pictorial masterpiece. The pretension to render movement through immobility is like the attempts of the musicians to give a realistic representation of landscapes or scenes from life with harmonic currents of sounds.'

On 21 February 1913 Papini publicly accepted Marinetti's proposal for collaboration, made in a speech during a Futurist Evening at the Teatro Costanzi in Rome. The issue of *Lacerba* that appeared on 15 March was full of Futurist contributions, including Marinetti's 'Siege of Adrianople', Boccioni's 'Plastic Foun-

dation of Futurist Painting and Sculpture', and Carrà's 'Plastic Planes as Spherical Expansions in Space'. The Communist Antonio Gramsci later called Papini 'a creator of back-to-front commonplaces', and just to prove his contradictory nature, Papini's own contribution to this issue was 'Against Futurism', in which he once again demonstrated his lack of understanding of the group's tactics, even to the extent of assuming that, ideally, Marinetti would have liked the Futurist Evenings to have been listened to in silence.

The next eleven months of co-operation marked the prime both of *Lacerba* and of Futurism. The newspaper became a daringly innovative example of the most sophisticated experimental typography and Words-in-freedom, sometimes of an intricacy that would make any printer blench. The artists contributed original works, often conceived in newspaper terms, as well as manifestos and articles. The music of Russolo and Pratella was reproduced uncompromisingly in its score form. Special paper was introduced to do justice to photographic reproduction of works of art. The number of pages was brought up to sixteen, and a six-inch-high pitch black LACERBA masthead replaced the more restrained literary brown of the earlier issues. In this way *Lacerba* became the model for the English Vorticists' art-oriented magazine *Blast*, which first appeared in June 1914, and could be considered the peer of the other international reviews which were advertised in its pages: Apollinaire's *Les Soirées de Paris*, Paul Fort's *Vers et prose*, Alfred Vallette's *Mercure de France*, and Herwarth Walden's *Der Sturm*.

Soffici had already formed sound contacts abroad, notably with Apollinaire and Picasso, but during the period of Futurist co-operation the foreign contributions

increased in Marinetti's international spirit. Max Jacob was represented with ten pieces, ranging from 'The Establishment of a Community in Brazil' to his own poems Poems by Paul Fort and Jules Laforgue were printed, as well as Mallarmé's 'Demon of Analogy'. There was Ambroise Vollard on Cézanne, and reprints of Lautréamont's 'Hermaphrodite' and 'God III', long before the Surrealists were to rediscover the Count as an honoured forebear. These writings, like Apollinaire's poems, were all published in the original French, but an exception was made for Apollinaire's 'Futurist Anti tradition', presumably so that none of the impact of his accolades of ROSES to Futurists and MERDE to passéist academics would be lost.

Once they had been involved, the Futurists' contribution was enthusiastic and prolific. For the Futurist poets Cangiullo, Buzzi, Folgore, Govoni and Binazzi it became an ideal platform, and in the pages of Lacerba are arrangements of words placed with an expressive simplicity and lyricism rarely surpassed in the history of concrete poetry. The artists were equally keen to show their paces. Carrà contributed an amazing nineteen pieces in all, ranging from the technical to the comical, while Boccioni produced twelve, including some of his key theoretical works on painting and sculpture, as well as attacks on Italian cultural ignorance and cowardice. Music was covered by Russolo with seven articles and by Pratella with six, while Marinetti himself with eighteen contributions scarcely missed an issue. Severini was his usual recalcitrant self, and the one manifesto 'The Plastic Analogies of Dynamism' was all that could be squeezed out of him. An extra bonus for the artists was the reproduction of their art work in Lacerba: ten works by Carrà, four by Boccioni and three by Severini. For some reason only Balla's name did not appear, and even his manifesto of 'Anti-Neutral Clothes', ideal Interventionist material it would seem, was not printed in Lacerba.

The success of Lacerba lay in its balance of deadly earnest and outrageous fun. Papini tended to write topical articles which were as virulent as they were long, and these were balanced partly by the cultural contributions and partly by a number of short regular joke spots. Papini's own selection of offensive quotes from the famous, Spazzatura (Rubbish), was one formula. Another was Sciocchezzaio (Nonsense Bin), in which the writers and philosophers who were particularly odious to the Futurists were quoted at their most ridiculous. The philosophy of Hegel out of context was a favourite target, as were the logic and aesthetics of Benedetto Croce. Examples of Croce's 'imbecility' included: 'The concept is of value because it is, and it is because it is of value.' Or: 'In every concept there is the whole concept and all the other concepts, but together they give that determined concept.' Mazzoni the poet was quoted as having penned the following:

 . . . mother
likes your verses so much. You must indeed be good: everyone says so.'

For two issues Carrà and Russolo had their own short feature in which ironic strips were torn off official Italian art. They called it Medical Bulletin, and it was an excuse for the extended schoolboy humour in which the Futurists specialized: 'CASE OF DYSENTERY' . In one hour G.A. Sartorio has painted three square kilometres for the frieze of the new parliamentary hall. . . . The patient's arm is lengthening at the rate of three metres a

second. Ancient history, medieval history, exhausted Risorgimento history. Historians from every country are urgently sought to provide story-lines; night and day duty.

'ANOTHER CASE OF DYSENTERY: Ettore Ferrari has finished his 178933rd Garibaldi. To prove that he is not an intransigent republican he will today begin his 178933rd Vittorio Emanuele. Bronze diarrhoea, marble urine. The patient will be transported to a Carrara quarry for suitable intensive nutrition. Anal cementation is recommended, but cementation of the illustrious patient himself is feared.'

Anal humour found its echo in the advertisements in *Lacerba*. The only advertisements accepted from outside the movement were from Cooper Roberts of Florence, manufacturers of laxative pills, and they were couched in purgative Futurist language as antidotes to the 'ancient dominators' of constipation and lethargy. All other advertisements were for publications and books by the contributors to *Lacerba*, or for parallel reviews in other countries. An exception was the support given to two books written by a worker, Lorenzo Cenni, one of which was entitled 'Workers' Aristocracy', and to the small rival magazine *Quartiere Latino*, run by the young Ugo Tommei who had joined them on *Lacerba*. Sales techniques were varied: often a subscription to *Lacerba* was offered on acquisition of a book, or readers were most strongly advised to buy the indispensable writings of Papini, or those who had not bought, say, the Purgative Almanac, were upbraided for their imbecility. Sometimes there were warnings to readers: the Futurist painters' denial of Bragaglia's Photodynamism was one example, and another was a notice from Lumière of Paris warning that only his process produced 'true colour photo-

graphy' and that the long list of names that followed was of those dishonest people in Italy who were dealing under false pretences.

The period of co-operation between the Milanese Futurists and *Lacerba* ended officially with an article by Papini on 15 February 1914. In his article 'The Circle Closes' he accused the Futurist writers, painters and musicians of falling into their own brand of academicism, an accusation that no self-respecting Futurist could take lightly. The basis of Papini's objection was that the very process that the Futurist and other *avant-garde* artists considered revolutionary amounted to nothing more than the substitution of reality for the artistic process of transformation. He was not convinced by Picasso's use of wood and cloth applied to canvas, any more than he was by Severini's addition of real moustaches or velvet collars. He rejected Boccioni's use of wood and metal to render effects that could not be achieved with traditional materials. Marinetti's Words-in-freedom destroyed the logical articulation of language, and menaced syntax itself, which was, after all, the hard-won conquest of the spirit over the incoherent exclamations of primitive language. The visual image of a poem's subject, which had already been explored by Apollinaire, was introduced intrusively in the *Ideograms* (poem-pictures), just as imitative sound in its crude natural state was dragged in for realistic effect. And the same accusations could be levelled against Futurist music and philosophy. All of them, according to Papini, tended to 'substitute the object itself for the lyrical or rational transformation of the object. . . . If the method were pushed to its ultimate consequences the result would be that the best still-life would be a furnished room, the best concert would be the total noise of

2 Intuizione velocità ubiquità

Colpi

Libro o vita imprigionata o fonocinematografia o **Immaginazione senza fili**
Tremolismo continuo o onomatopee più inventate che imitate
Danza lavoro o coreografia pura
Linguaggio veloce caratteristico impressionante cantato fischiato camminato o corso
Diritto delle genti e guerra continua
Femminismo integrale o differenziazione innumerevole dei sessi
Umanità e appello all'oltre-uomo

e

ferite

Materia o **trascendentalismo fisico**
Analogie e giuochi di parole trampolino lirico delle lingue calcolo Calcutta guttaperca pergamena Agamennone ameno armeno anormale animale malanimo Marmara aromatico

u u u u flauto rospo nascita delle perle apremina

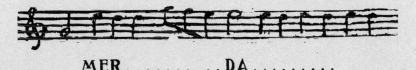

MER........ ..DA........

ai

Critici
Pedagoghi
Professori
Musei
Trecentisti Quattrocentisti Cinquecentisti
Rovine
Pàtine
Storici
Venezia Versailles Pompei Bruges Oxford Norimberga Toledo Bénarès, ecc.
Difensori di paesaggi
Filologi
Scrittori di saggi

Néo e *post*
Bayreuth Firenze Montmartre e Monaco di Baviera
Lessici
Buongustismi
Orientalismi
Dandismi
Spiritualismi o veristi (senza sentimento della realtà e dello spirito)
Accademisti

I fratelli siamesi D'Annunzio e Rostand
Dante Shakespeare Tolstoi Goethe
Dilettantismi merdeggianti
Eschilo e teatri d'Orange e di Fiesole
India Egitto Fiesole e la teosofia Scientismo
Montaigne W a g n e r Beethoven Edgard Poe Walt Whitman e Baudelaire Manzoni Carducci Pascoli

ROSE

a

Marinetti Picasso Boccioni Apollinaire Paul Fort Mercereau Max Jacob Carrà Delaunay Henri-Matisse Braque Depaquit Sévérine Severini Derain Russolo Archipenko Pratella Balla F. Divoire N. Beauduin T. Varlet Buzzi Palazzeschi Maquaire Papini Soffici Folgore Govoni Montfor R. Fry Cavacchioli D'Alba Altomare Tridon Metzinger Gleizes Jastrebzoff Royère Canudo Salmon Castiaux Laurencin Aurel Agero Léger Valentine de Saint-Point Delmarle Kandinsky Strawinski Herbin A. Billy G. Sauvebois Picabia Marcel Duchamp B. Cendrars Jouve H. M. Barzun G. Polti Mac Orlan F. Fleuret Jaudon Mandin R. Dalize M. Brésil F. Carco Rubiner Bétuda Manzella-Frontini A. Mazza T. Derème Giannattasio Tavolato De Gonzagues-Frick C. Larronde ecc.

PARIGI, il 29 Giugno 1913, giorno del Grand Prix, a 68 metri al disopra del Boulevard S.-Germain .

141 Apollinaire *Futurist Anti-Tradition* 1913 (extract)

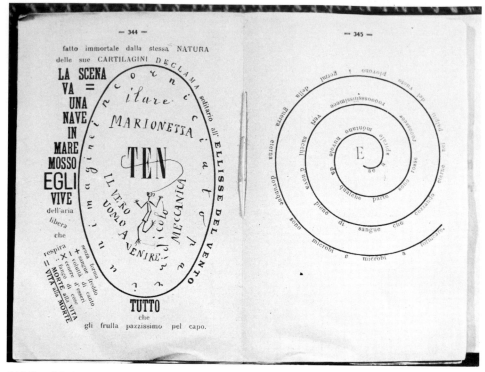

142 Buzzi *Spiral* and *Helix*

a densely populated city, and the best poem would be a battlefield (at Marinetti's disposal) with its sonorous cinematography. And the most profound philosophy would be that of the peasant digging, or of the blacksmith hammering away without a thought in his head.'

For Papini this introduction of reality represented the complete opposite of art. For him, art was the transforming process, the result of a form of alchemy: 'The human spirit emerged from simple and unformed material, gradually rose above it and drew away from it, creating another material that was completely its own, a spiritual substance called art.' By introducing reality the Futurists were returning to a primitive position: 'We find ourselves once more confronted with primary material. The circle closes. Art returns to reality. Thought is once more abandoned for action.' Papini would have drawn no comfort from the knowledge that this same introduction of reality, primary material, or life, into art, was to be one of the most influential guidelines along the course of its passage and development over the next fifty years, and that the furnished room as the ultimate still-life was not as far away as he might have thought.

The Futurists' reply appeared in the next issue of *Lacerba* on 1 March 1914, and was written by Boccioni on the group's behalf — had it been written by Marinetti it would certainly have been different. Boccioni started with the usual Futurist

172

preamble and propaganda, and then replied directly to the accusations that concerned the use of materials. When 'real objects were substituted for the lyrical or rational transformation of objects' this did not mean that the circle had closed, as Papini claimed. It was precisely at this point that the circle of creative possibilities expanded: 'And this is the moment when the artist, escaping from the imitative process that leads inevitably to the most worn-out appearances, substitutes reality itself.' It was the blending of reality and elaboration that transformed the object: 'Art is nothing other than elaborated primary material; but it is precisely this material, elaborated to the point of exhaustion, that is given the name of ART, and which we refuse to accept *a priori*. We wish to create works of art which are confirmations of reality, and above all of the new reality, and not traditional repetitions of outward appearances.'

A note at the bottom of the article announced that the discussion would be taken up in the next issue by Palazzeschi, since Papini was out of Florence. But on 15 March it was Papini himself who replied in 'Open Circles' that his intent had been 'to offer some of my friends the chance to define, explain and discuss an important feature of the most modern researches.' He felt that the time had come for open discussion among themselves, and for a halt to the maltreatment of the stubborn passéists. As extra ammunition he brought Picasso into the argument again, quoting what Picasso had said to him, apparently, a few days previously: 'I can understand that someone uses a moustache to make a painting, but if the moustache is placed in the right place it is buried in the waxworks museum.' Papini went on to describe how Picasso had shown him photographs of his studio in which he had arranged various objects to which he had given the status of art. Papini continued: 'Picasso of course is a man of great talent, a most intelligent man who does not fall for such things. He did this more for fun than for anything else. He uses all kinds of materials, just as another painter would use pigment and pencil, but he does not use wood to represent wood.' As a Parthian shot, Papini delivered a scathing attack on Boccioni's book

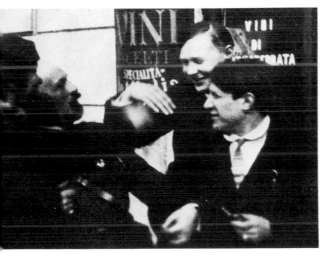

143 Marinetti and Picasso in Rome 1915(?)

Futurist Painting and Sculpture, accusing him of being a moralist, an old sociologist, and a classicist.

In spite of the bitterness caused by this exchange, relationships with *Lacerba* were not broken off completely. Marinetti and Carrà continued to contribute, as did Pratella, who could not, however, restrain himself from writing a most violent letter to Soffici and Papini which ended: *Mi fate schifo* ('You revolt me'). On 12 August 1914 Marinetti wrote to Pratella informing him of imminent changes in *Lacerba*: 'I have just come back from Florence, the reason for my visit being to co-operate with Soffici in transforming *Lacerba* into a political newspaper with the sole aim of preparing the Italian climate for the war with Austria.' And three days later the campaign for Intervention started in *Lacerba*. It was to continue without interruption for twenty-eight issues, and with more and more suppressions by the censor, until Italy's entry into the war was declared in May 1915.

Papini explained the reason for the transformation of *Lacerba*, and gave arguments for Italian Intervention that apply equally to the Futurist movement: 'If the current war had been simply political and economic, we would, while not remaining indifferent, have been concerned with it only at a distance. But since this is not simply a war of guns and ships, but also of culture and civilization, we are determined to take up a position, and to follow events whole-heartedly. It is a question of safeguarding and defending everything that is most Italian in the world . . . we cannot keep silent. This is perhaps the most decisive hour in European history since the Roman Empire. . . . Beginning with this issue, *Lacerba* will be exclusively political, and to increase its circulation, it will be sold for 2 soldi. When it is all over we will resume our theoretical and artistic coverage.' That, of course, was not to be.

Italy at that time formed part of a triple alliance with Germany and Austria, but the pact of alliance enforced participation of individual states in war only in the case of aggression from other countries. Italy had used the pretext of the aggressive invasion of Serbia by Austria to detach herself from the alliance, and had thus remained neutral, and this was the position favoured by Mussolini's Socialists. Papini outlined the advantages to Italy of participating on one side or the other, but he saw it particularly as the choice between one form of culture and another, and came down, inevitably, on the French side: 'We owe to the French Revolution our first patriotic and military awakening, our present civil and intellectual liberty. We owe to the French army the decisive victory in the unification of our country. We owe to France half our culture and our art over the past two hundred years. This sympathy is vividly alive today. As soon as the war was declared there were Italian volunteers, but on the French side.' Significantly enough, now that the argument was political, the original statement of antagonism to overbearing French influence in culture that had formed an important part of the 'Founding and Manifesto of Futurism' was reversed.

More than a quarter of the article was blacked out by the censor, and the censored parts were all declarations of hostility to Germany. But Papini did not forget the Church and the monarchy either: 'A telephone call from Rome on the night of 1 September denied the rumour of the king's indisposition, but confirmed that at the time in question the king was finishing proof-corrections of his fifth volume of his study of Italian coins.' This was Papini's way of commenting on Vittorio

144 Censored page from Papini's 'Il dovere dell'Italia', from *Lacerba* 1914

Emanuele's complete lack of participation in the Interventionist issue — many commentators felt that he had disappeared altogether. As the weeks went by, the attacks grew more and more violent, and the language of abuse hurled against the recalcitrant ministers and monarch became ever more virulent. *Lacerba* of 15 October 1914 announced the organization by the newspaper of an 'Italian Referendum' to decide the Austrian question, and on 24 October a special extra issue 'dedicated entirely to our amorous eastern neighbour' appeared.

At the beginning of 1915 the typefaces and layout of the paper again changed, and price and pages were halved. Papini took over the running of *Lacerba*, partly because it was now politically necessary

that one individual should shoulder the responsibility for the contents. Papini was both critical of the Futurists' behaviour during this time, and disappointed by their lack of support: 'Since the beginning of the war, from the time when *Lacerba* was transformed into an instrument of political propaganda in the purely Futurist irredentist and warlike sense, we have felt with amazement, and must declare it, that our friends are no longer with us. Futurist manifestations in favour of Italian Intervention which we invoked, and which we expected to be numerous and impetuous, have been sparse and insignificant, and culminated in the little Milanese demonstration, and in the inopportune and vacuous manifesto by Balla on neutral [sic] clothing.' So much for the much repeated myth of the Futurists as the most fanatical advocates of war in Italy.

The last two issues of *Lacerba* came little short of blackmailing the Italian state, the aim being to consolidate the growing call for the overthrow of the monarchy and the establishment of a republic. The penultimate issue contained three ultimata and a reason for the king's silence:

'1. War on the Germans or civil war.

'2. War on the Germans or revolution.

'3. War on the Germans or a republic.

'4. His Majesty thinks that in many cities the cry "Up with War" has been transformed into "Up with the Republic".'

The last issue of 22 May 1915 coincided with the declaration of Italy's entry into war, the fulfilment of Papini's immediate aims. *Lacerba*'s tradition of superb organization was maintained right down to the last item on the last page: a notice to subscribers on how to obtain reimbursement for the issues that would not follow, since the contributors, as true patriots, were off to war.

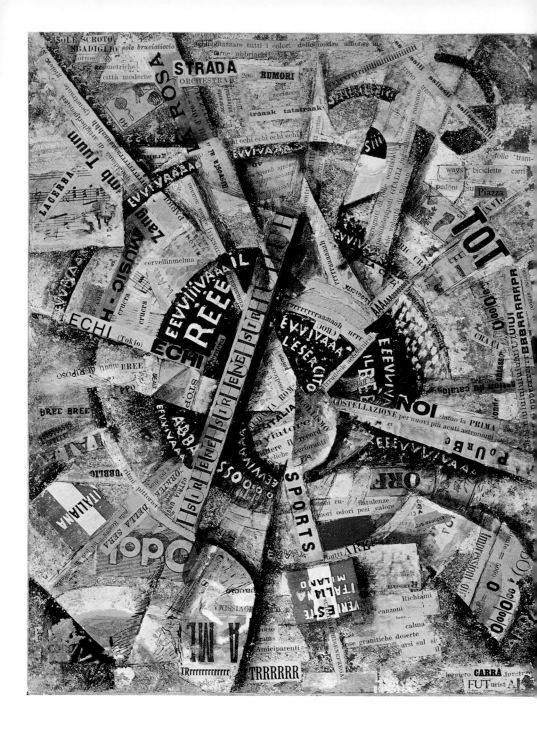

Art of the war years and after

'What we need is not only direct collaboration in the splendour of this conflagration, but also the plastic expression of this Futurist hour. I mean a more ample expression that is not limited to a small circle of experts, an expression so strong and synthetic that it will hit the eye and imagination of all or almost all intelligent readers . . . Try to live the war pictorially, studying it in all its marvellous mechanical forms (military trains, fortifications, wounded men, ambulances, hospitals, parades etc).'

F.T. Marinetti, letter to Severini, 20 November 1914.

The war of course changed everything – for Europe, Italy and the Futurists. Old orders, both social and cultural, were certainly broken, but it was not, for Italy or for France, the revolution for which generations of romantics had yearned. It could be argued that the cultural climate created by intellectuals in these years actually contributed to the build-up of war, just as surely as the failure of intellectuals to resist the rise of Fascism a generation later. As heirs to the romantic tradition, the Futurists themselves substituted war for revolution in the fervour of their Interventionist manifestations. Patriotism got the upper hand of anarchy and the message of the 'Founding Manifesto' way back in 1909: 'We wish to glorify war – sole hygiene of the world', had become, by the time the last issue of *Lacerba* appeared: 'From this moment on we are one thing only: Italians.'

Interventionist manifestations were not restricted to the pages of *Lacerba*. For Marinetti's Milanese group, expanded by new adherents but without the presence of Carrà, Severini and Balla, the initial excitement of early days was now augmented by real external events. To the growing atmosphere of tension in Italy the Futurists contributed their own riots. On 15 September 1914 Marinetti, Boccioni, Russolo, Mazza and others interrupted a gala evening of Puccini at the Teatro dal Verme in Milan with the ceremonial burning of an Austrian flag, while Marinetti brandished the Italian flag. The next day eleven Futurists were arrested during a similar demonstration in the Milan Galleria and held for three days in the San Vittore prison. They were far from being martyrs, as a letter from Boccioni to his mother (of 19 September) shows: 'I've been in prison in Milan for three days with Marinetti, two painters, two actors and two lawyers. . . . I'm in a paying cell and lunch brought in from outside is excellent. . . . Eating, drinking, sleeping and reading. This rest came at a good time, but it will only last a few days.'

To some extent the Interventionist period, even with the absence of some of the founder members, masked the growing lack of cohesion within the group. The old rivalry between the concept of Futurism as upheld by the Florentine group round Papini and Soffici and the 'Marinettism' of the artists of Milan had again emerged through the pages of *Lacerba*. An article of 14 February 1915, written by Papini, Palazzeschi and Soffici and entitled 'Futurism and Marinettism', outlined the

145 Carrà *Interventionist Manifesto* 1914

Lacerba position which the authors held to be 'true' Futurism as practised by themselves, Carrà, Severini and Tavolato. On the other, 'Marinettist', side were Boccioni, Balla, Pratella and Russolo.

It is, of course, in the nature of groups that they will sooner or later disintegrate when individual needs or external events become more urgent than the initial shared needs and feelings. Marinetti was to struggle to sustain the fervour of Futurism throughout subsequent decades, but, like Dada or Russian Constructivism, or any of the pioneering twentieth-century movements, its powerful and productive years were limited. Even the most exuberant members of a group, and particularly artists, will start to feel a conflict between communal and personal activity once the novelty and stimulation of group energy, discussion, disruption, cabaret or street theatre has worn off.

The Futurist painters were no exception. The development of private and individual tendencies became quite pronounced after 1913, the year of hectic production, and thus preceded the Interventionist period. It was most perceptible in the work of Boccioni and Carrà, both of whom, in different ways, were to embark on a quite un-Futurist return to order. Differences were apparent not only in terms of style and content, but in basic principles of art. On top of this there were rifts not only between the major Florentine and Milanese groups, but among the artists themselves, the most bitter rivalry being between Boccioni and Carrà, as their correspondence of the time shows. They shared a distaste for the way in which Marinetti had thrown open the movement to newcomers, some of whom were certainly inferior as artists. It should not be forgotten that both painters were keen to gain critical recognition not just as Futurists but as individual painters of excellence, while Marinetti's interest was now essentially in the transformation of a cultural group into a populist movement. The dual complications of being forced into a decision by the imminence of war, and the dilemma of allegiance to a group that had become watered down in quality through Marinetti's need for quantity, are clear in Boccioni's letters of these years. Writing to his family just after his release from prison on 22 September 1914, he described his split loyalties: 'I want to work, but the anxiety that grips everyone prevents me . . . I should retreat to the country but . . . the war?' And then, in a letter of 16 June 1916 to Pratella, the soldier lamented the artist's dilemma: 'The burden of having to elaborate in oneself a century of painting is terrible. So much more so when one sees the new arrivals to Futurism grasping the ideas, mounting them and galloping off at breakneck speed.'

The last truly Futurist group action was the departure to war as volunteers of the kernel of the Milan group. Marinetti, Boccioni, Russolo, Sant'Elia, Erba, Funi, Piatti and Sironi enrolled with the speediest division — the Lombard Volunteer Cyclist Battalion — in July 1915, and were then transferred to the Alpine regiment for active service in the Trentino. Marinetti quickly had an operation for a hernia in order to qualify where others would have been only too glad of an excuse for exemption. Like D'Annunzio, Marinetti was in his element in the war, even receiving the ultimate tribute of red roses from his old rival when he was injured. For both men this was a chance to continue and elaborate the roles they had already selected and which they were to pursue into the Fascism of the post-war period. But for the painters and other Futurists the

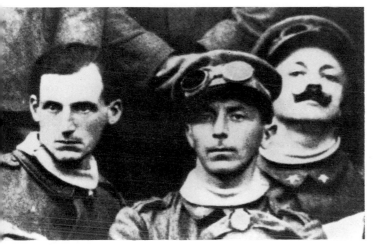

146 Sant'Elia, Boccioni
and Marinetti in uniform

reality of the trenches had little to do with the 'mathematical and aesthetic intoxication' they had expected. They paid for it dearly: according to Marinetti thirteen Futurists were killed during the war, among them Boccioni, Sant'Elia, Ugo Tommei, Athos Casarini and Carlo Erba. Forty-one were injured, including Marinetti himself, Russolo, Piatti, Soffici, Rosai and Dessy.

But the Interventionist and war years were not completely unproductive for the Futurist painters. All of them turned to the theme of war in one way or another. These are inevitably the most Futurist works they were able to produce, while at the same time each was working independently on his own direction. For some, of course, these were to be their last works, while others were to turn to different interests and allegiances.

In April 1914 Boccioni's book, *Futurist Painting and Sculpture*, had been printed, an extensive and detailed, but far from objective, study in which Boccioni implied that he was the greatest talent among the Futurists and the driving force of their researches. After this, with the exception of his last piece of sculpture, the delightful and sophisticated *Horse + Rider + Houses*, he, like Carrà, concentrated on painting, and on a close study and adaptation of the synthetic Cubism of Picasso and Braque. Themes, with the exception of the *Pavers*, shared the Cubist remoteness of still-lifes and heads. The influence of Picasso's use of the Negro head was evident, but the dominant interest, becoming stronger in 1915, and dominant in 1916, was Boccioni's rediscovery of Cézanne in his effort to find a lost classical strength in painting.

Boccioni contributed just one work to the theme of war: *The Charge of the Lancers*. This, like Carrà's *Interventionist Manifesto*, was essentially a collage, and a rare departure for Boccioni. It was reproduced almost immediately in *Grande Illustrazione* in January 1915, and included a newspaper report of 4 January recording progress on the front in Alsace and the taking of a German strategic point. Over this news item the cavalry charges, an almost monochromatic horde, the horse Boccioni had previously used to symbolize work now representing war, an anachron-

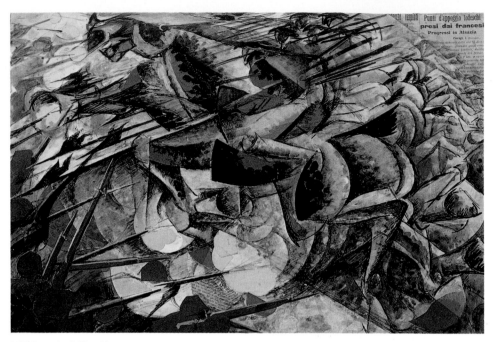

147 Boccioni *The Charge of the Lancers* 1915

istically chivalrous retort to the gleaming German bayonets.

The war diary that Boccioni kept from August to November 1915 records a cryptic mixture of fear, excitement and youthful patriotism. At the end of September he wrote to Balla: 'We'll do great things if we survive. You're preparing it with your tremendous Futurist courage. My mother showed her great bravery, she followed us in a carriage shouting 'Long live the Futurists, long live Italy, long live the volunteers!'

At times he was sure of dying, at others he was proud to be fighting for Italy. Marinetti and Sant'Elia move in and out of the staccato entries as in a Futurist manifestation, and Boccioni's style is enthusiastically Words-in-freedom: '19 October: Some confusion commands in low voice countercommands. Captain

Ateneo in spite of order to retreat remembering Buzzi says to Marinetti and me "You advance" we go. Zuiii Zuiii Tan Tan. Bullets all around. Volunteers calm on the ground shoot Pan Pan. Crack shot Sergeant Massai on his feet shoots, first shrapnel explodes. We arrive hearing a shout we throw ourselves to the ground: shrapnel explodes twenty steps away and I shout: At last.'

This was Boccioni's thirty-third birthday. War for him was still 'a wonderful, marvellous, terrible thing. And in the mountains it seems like a battle with the infinite. Grandiose, immense, life and death. I am Happy.'

In December 1915 the battalion was disbanded, and during his period of leave Boccioni threw his energies into writing for the paper *Gli Avvenimenti*, lecturing and painting a series of canvases that were

to be his last: 'I am working a great deal and in many different directions' was his comment. He was staying with his friend the composer Ferruccio Busoni on Lake Maggiore, and the influence of Cézanne in his portraits of Busoni and his wife as well as in two landscapes is so strong that it extends to a homage-like inclusion of an echo of Mont Sainte-Victoire in the Italian

148 Boccioni on horseback 1916

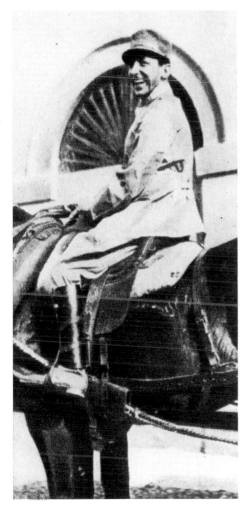

lakeside scenery. For Boccioni this search through Cézanne for a more solid form of expression seems to have been a preliminary step towards what he felt sure was to be a major breakthrough. When he was called back for service in early June, the excitement of art had cooled his fervour for war. He was stationed five kilometres outside Verona with an artillery brigade. It was from there that he wrote his last words: 'I shall leave this existence with a contempt for all that is not art. There is nothing more terrible than art. Everything I see now is on the levels of games compared to a good brushstroke, a harmonious verse or a sound musical chord. By comparison everything else is a matter of mechanics, habit, patience of memory. Only art exists.'

On 17 August Boccioni died, fatally injured when falling from a horse.

Carrà's isolated position both before and during the war demonstrates most clearly how eroded the group spirit of the early years had become. It is true that a change of direction had been discernible in his painting from the time of his involvement with Cubism in 1912. With the exception of a few works, notably the *Interpenetration of Planes* and the *Red Horseman* of 1913, his interest had been less in movement and dynamism than in the painterly analysis of objects and figures. After a year of active contribution to *Lacerba* in 1913, Carrà returned to Paris in 1914, together with Soffici and Papini. His contacts there were with Apollinaire, Picasso, Archipenko, and Amedeo Modigliani, and these were the influences that filtered through into his work. During the same period he saw the painting of Georges Rouault, and visited the studios of Henri Matisse and Maurice de Vlaminck.

A letter of 3 March 1914 to Severini shows how deep the rift with Marinetti and

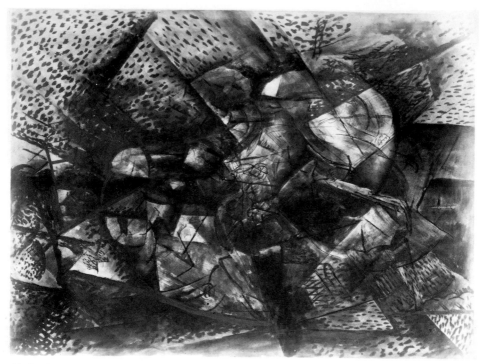

149 Carrà *Interpenetration of Planes* 1913

Boccioni had become, and to what extent Carrà's hopes were now pinned on Paris: 'I'm deeply sorry to hear that you too find yourself in the same financial condition as me . . . I have noticed that we are more and more peripheral . . . forgotten. We really must hold an exhibition as soon as possible with new and more daring works. We should also stay here as long as possible, and transfer our tents to this capital of the world. I have seen Picasso in these days and had long conversations with him that have clarified many things and cleared up ambiguities. He would almost be on our side if it were not for the fact that he hates the various Ciacellis, Giannattasios and other fools who by calling themselves Futurists are bringing

all of us disastrous publicity. I must repeat that the tactics of Marinetti and Boccioni are no good at all. . . . Mediocrity is always damaging, above all in *avant-garde* developments. We must stand firm on this if we do not want to be dragged into a dungheap of social-humanitarian sentimentality which will sweep us out of art and cut off financial help.'

But it was not only the throwing open of Futurism to new arrivals that upset Carrà. In Paris he had received Boccioni's book *Futurist Painting and Sculpture*, and been deeply hurt by Boccioni's dismissal of his, Carrà's, contribution to Futurism in a couple of pages (pp. 318–21). In the same letter to Severini Carrà continued: 'I know what Boccioni's ideas about painting were

150 Carrà *Still-life: Noises of a Night Café* 1914

at the beginning of our friendship. In fact I can say that he owes a fair part of his ideas on art to me. I remind you of just two significant facts: four years ago he preferred Klimt to Renoir, he loved the Pre-Raphaelites and understood nothing of the great Impressionists or the Post-Impressionists, or Matisse and Picasso. He fervently believed that Rodin was much greater than Rosso. Russolo could tell you about the struggles I had with Boccioni to make him admit the greatness of these artists.'

Collage was Carrà's preferred medium in 1914, and during the months January to September he carried out a dozen or so small-scale works which again owe more to the Cubist analysis of still-life than to the Futurist philosophy of experimentation with materials. At the same time he was turning to the past, to the Italian tradition

and the work of Giotto and Paolo Uccello. In his autobiography he described 'a need that had matured in me for something different and more measured . . . a strong desire to identify my painting with history, and particularly with Italian art history. It matters little if this aspiration was understood by few people and if my new needs were interpreted as the result of tiredness. They were mistaken who saw in me a hurried reconciliation between tradition and revolution.'

Just before the outbreak of war Carrà returned to Italy, and the excitement of the Interventionist period seems to have interrupted both the steady course of his personal return to order, and his feeling of isolation from the rest of the Milanese group. In the autobiography he described his feelings about war, patriotism and the Interventionist position as follows: 'Pat-

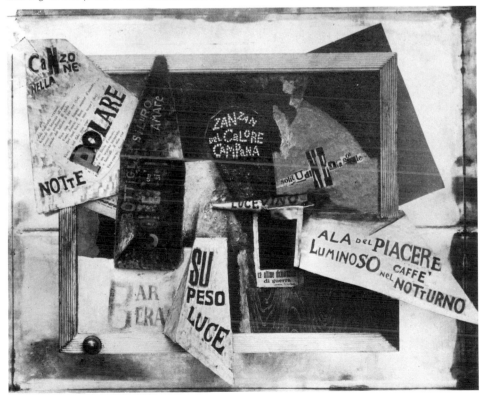

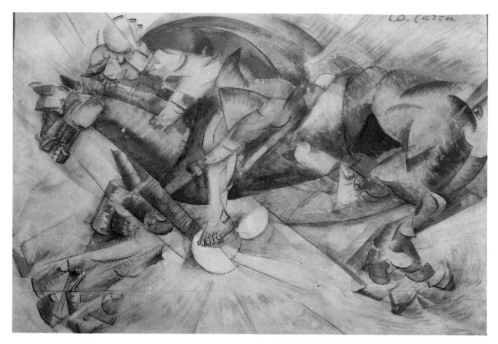

151 Carrà *Red Horseman* 1913

riotic feeling predominated above all others, and determined each person's position. For me love of the fatherland was a moral entity and could not be considered as an abstraction but as a spiritual force. Honour, pride and independence constituted the concept of fatherland which I saw as an "extention of the ego" . . . a glorification of individual life.' Such thinking led Carrà, like many of his fellow anarchists, to throw in his lot with the Interventionists, though he did not go to the front until called up in 1917.

Drawings of 1914: Naval War in the Adriatic and *Aerial Reconnaissance—Sea—Moon + 2 Machine Guns + North-east Wind* combine Carrà's familiar composition based on a spiral form with snatches of patriotic slogans, numbers and

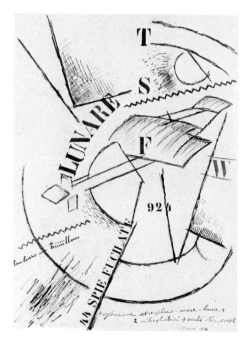

152 Carrà *Aerial Reconnaissance—Sea—Moon+2 Machine Guns+ North-east Wind* 1914

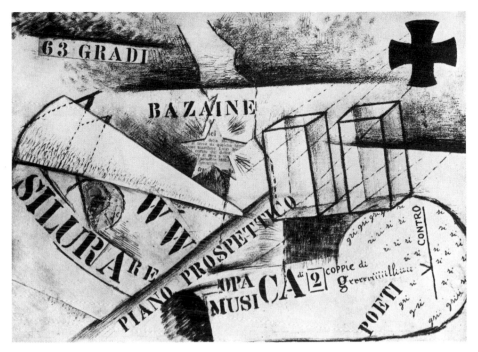

153 Carrà *Penetrating Angle of Joffre over Marne against 2 German Cubes* 1915

154 Carrà *Atmospheric Envelope – Exploding Shell* 1914

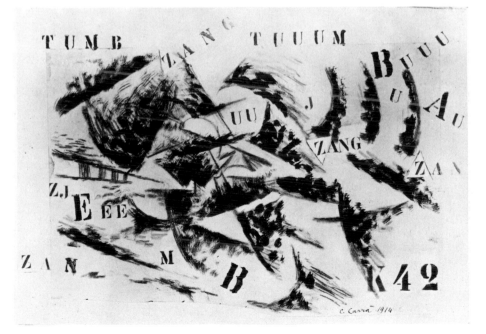

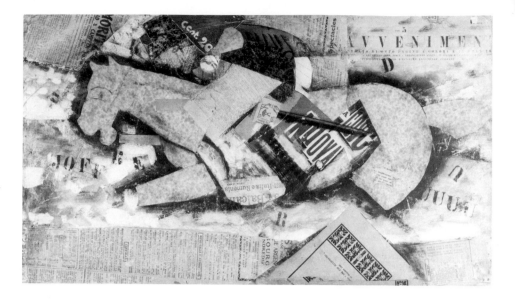

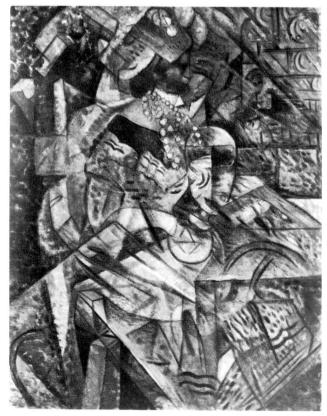

155 Carrà
Pursuit 1914

156 Carrà
Woman and Absinthe 1911

157 Carrà
Futurist Synthesis of War 1914

hints of the moon, 'the way of the infinite', and the burning question of Trieste simplified to an even more radical extent in the sparse blasts of numbers and words in *Atmospheric Envelope — Exploding Shell* of the same year. Two other works: *Pursuit* and *Penetrating Angle of Joffre over Marne against 2 German Cubes*, pick up the theme of the Battle of the Marne and show the variety of Carrà's range at this time. The first is the familiar image of the horseman as used by both Carrà and Boccioni, the other a truly remarkable foretaste of Dada and El Lissitzky's revolutionary geometric tale of how the Red wedge beat the Whites. In August 1914 his most exuberant collage appeared: the *Interventionist Manifesto* [145]. This small work (38·5 × 30 cm) is one of the most delightful images of Futurism, as well as being a highly accomplished virtuoso exercise in the new medium of collage. It departs from Cubist practice and has more in common with Apollinaire's *Ideograms*

or the imaginative Dadaist use of collage a few years later. Curiously, while sharing with *Woman and Absinthe* of 1911 the compositional device of spiralling-out from a centre, this collage comes closer to illustrating Futurist principles than any work since *The Funeral of the Anarchist Galli* [36], also of 1911. Carrà described it in a letter to Severini, who was also experimenting with collage, as an attempt to render 'the plastic abstraction of civil tumult', and the effect is that of a visual counterpart to Russolo's *Spirals of Intoned Noises*. Place of honour at the centre of the collage is reserved for Italy and her aviators; then it spirals out to shouts of 'e viva', shot across with lines of force that have a dual function: compositional interruption of the spiral and quoted tributes to his friends: *Zang Tumb Tuum* for Marinetti, *La Rosa* for Apollinaire, nothing of course for Boccioni.

A month later, in September, Carrà produced the 'Futurist Synthesis of War',

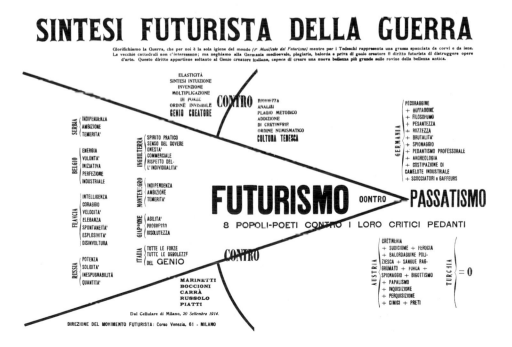

signed together with Marinetti, Boccioni, Russolo and Piatti. This was a patriotic and witty line-up of the eight 'poet-peoples' against their pedantic critics, the Austrians and Germans. All the enemy can offer is brutality, heaviness, the constipation of industrial cheapjacks, bigotry, papalism and spying — no match for Italy with 'all the strength and all the weakness of genius', or England and her 'practical spirit, sense of duty, commercial honesty and respect of the individual.'

To all intents and purposes Carrà's last contribution to Futurism was *Guerrapittura (Warpainting)*, published in Milan in March 1915 and signed with an extra aggressive R to his name Carrrà. This little book was perhaps intended as a counter-blast to Boccioni's *Futurist Painting and Sculpture*. It contained a collection of writings on art under the banner of Delacroix's untranslatable condemnation of flabby painting, '*La peinture lâche est la peinture d'un lâche*'; reprints of Carrà's earlier *Lacerba* essays, repetitions of Futurist preferences and dislikes in art; typographic arrangements and Words-in-freedom on the theme of war echoing Carrà's own *Futurist Synthesis of War*, and a number of illustrations including *Pursuit*. Apart from various thoughts on art there were also some extraordinary statements

158 Carrà
Drunken Gentleman 1916

159 Carrà
Antigrazioso 1916

about the behaviour of the bourgeoisie in the war. Here Carrà made it quite clear that in life as in art he had moved away from the anarchist beliefs that had seemed so deep-rooted in his youth: 'Today the bourgeois favourable to the war is certainly more revolutionary than the so-called revolutionary with his neutralism. The former takes risks and acts, therefore he is a revolutionary, while the other, the so-called anarchist, is harmful to life and progress because in reality he sacrifices nothing to them.'

While the Milanese Futurists went to war, Carrà spent much of 1915–16 in Florence, once more with the *La Voce* group. Paintings like the *Drunken Gentleman* and the *Antigrazioso* continue his attempt to identify with a simplified art of the past: 'If I had stayed with the Futurists I would have been a hypocrite,' he wrote in his memoirs, attributing to Boccioni at the same time the ideal of achieving a classical form. In 1917 Carrà was at last called to arms, but found unfit for the front and sent first to hospital and then to mental hospital at Pieve di Cento between Bologna and Ferrara. One of the reasons for this was apparently the impression that Carrà's *Guerrapittura* made on a medical officer, who was sure that this could only be the work of a madman.

Then, still connected to the XXVIIth infantry regiment, Carrà was transferred to the Ferrara military hospital where he met Giorgio de Chirico, and subsequently two other painters, De Chirico's brother Alberto Savinio, Filippo de Pisis, and the poet Corrado Govoni. This is where a new chapter of Italian art begins, for it was from this wartime grouping, drawing its strength from the irritable imagination of De Chirico, that Metaphysical Painting was to emerge. The dispute as to who started it was to be a sore point with both Carrà and De Chirico for years after. Here it is enough to say that the direction taken by De Chirico confirmed Carrà's quest for a painting that would express the mysterious life of 'ordinary things', and the Italian tradition.

At the end of 1917 Carrà, according to De Chirico, hurried off to Milan and held an exhibition of twenty-nine examples of the new Metaphysical Painting at the Galleria Chini, thus robbing the true father of the paternity of the movement.

When Carrà was demobbed in 1919 he wrote a book on the subject, *Metaphysical Painting*, and once more contributed to *Valori Plastici*. His painting continued to show the return to order, tradition, simplicity and deliberate naïvety that makes it identifiable as part of the Fascist era. For Carrà himself it was a time of personal and financial crisis, during which he was helped by the faithful Medardo Rosso. In 1922 he became art critic of the Milanese *L'Ambrosiano*. During the Fascist period his works were shown extensively abroad in shows financed by the regime, though in 1942, a year after he took the Chair of Painting at the Brera Academy, a fresco for the Palace of Justice met with official disapproval and was covered over.

Curiously enough the painter who came closest to being the Futurist artist of war that Marinetti would have liked was the peaceful, retiring and frequently sick Severini, whose cafés and dancer themes had until then been the furthest removed from Futurist turmoil. He was in Italy when war broke out, and unlike his patriotic companions returned to Paris as soon as he could in the autumn, though the journey took nine days. By now his tubercular state and his daughter's poor health forced him to move out of Paris with the financial help of French friends and probably Picasso. It was an unlikely place from which to paint images of war as strong as the *Armoured Train*, and the two versions of the *Red Cross Train*, though here the influence of the war poetry of his father-in-law, Paul Fort, certainly played a part. The stragetic railway running by the house provided the inspiration, as he recorded in his autobiography: 'By our little house trains passed by day and night loaded with military equipment, soldiers and wounded men. I did a number of paintings, so-called war paintings, though they were inspired by the real things that passed in front of my eyes. My approach became increasingly synthetic and symbolic, until by the end of the next winter they were true "symbols of war".' On returning to Paris Severini deliberately sought out a flat near the Denfert-Rochereau station 'so that I could still see these military trains and continue my war paintings'.

In this way Severini was able to come closest to the kind of painting Marinetti had hoped for, and which he described to Severini in a letter of 20 November 1914: 'What we need is not only direct collaboration in the splendour of this conflagration but also the plastic expression of this Futurist hour. I mean a more ample expression that is not limited to a small circle of experts, an expression so strong

160 Severini
Red Cross Train 1915

and synthetic that it will hit the imagination and the eye of all or almost all intelligent readers. I don't see in this a prostitution of plastic dynamism but believe that the Great War, intensely lived by Futurist painters, can produce true convulsions in their imaginations, pushing them to a brutal simplification of radiantly clear lines. . . . Paintings or sketches will probably become less abstract, perhaps a bit too realistic, perhaps in a way a more advanced form of Post-Impressionism. Boccioni and Carrà agree with me and believe that immense artistic novelties may be possible. We urge you to interest yourself pictorially in the war and its repercussions in Paris. Try to live the war pictorially, studying it in all its marvellous mechanical forms (military trains, fortifications, wounded men, ambulances, hospitals, parades, etc.)'

Severini explained his series *Guerre* as an attempt 'to experience the idea of War by a plastic ensemble composed of these realities: cannon, factory, flag, mobilization order, aeroplane, anchor, since these realities are symbols of general ideas'.

With paintings like *War, Armoured Train* and the two versions of *Red Cross Train*, he was able to concentrate on the hard and shiny metallic facts of modern warfare, with something of the same fascination that Léger found at this time in the metallic forms of battle. As he wrote: 'A few objects, or a few forms that related to a certain reality, perceived in their "essential state" as "pure notion", provided me with a highly condensed and extremely modern idea-image of war.'

The excitement of these paintings apart, Severini's preoccupation was also with the desert that Paris had become, his health, and the disappearance of the art market. In January 1916 he was glad to show his war paintings together with some of his early work as the first Futurist Exhibition of the Plastic Art of War at the small Galerie Boutet de Monvel. He gave a lecture to accompany the show which resulted in two articles for the *Mercure de France*, a welcome chance for the least prolific theorist among the Futurist painters to voice some of his ideas, since Marinetti had still not published his manifesto 'The Plastic Analogies of Dynamism'. The exhibition brought him once more into contact with Ozenfant, Lipchitz and Lhôte, as well as Jean Cocteau who was recommending a return to order quite different from those on which Boccioni and Carrà

161 Balla *Mercury Passing the Sun as Seen Through a Telescope* 1914

162 Severini *Armoured Train* 1915

had embarked. Severini's turn away from Futurism towards an art in which intelligence was once more reinstated along with sensibility ('for in my opinion intelligence is in the process of losing even its limited share'), also took in the Catholic past in which he perceived a tendency towards universality shared by 'our modern art'. Contemporary scientific interest too could be related back to the Italian past: 'None of us should forget the notions which science puts at our disposal so as to intensify our sense of the real. . . . This sympathy for science also existed at the time of Paolo Uccello, Andrea del Castagno, Domenico Veneziano, Luca Signorelli, Leonardo, etc., who were

Realist painters in the largest sense of the word, as we are.'

From such thinking emerged the Severini of post-Futurist years, heralded by the austere *Quaker Oats* of 1917, and the Picassoesque *Harlequin* of 1918, then making way for the figure paintings that form a strange parallel with Carrà's later work.

Balla spent the war years in Rome. Boccioni's letter to him, written at the end of September 1915, suggested that Balla was preparing a Futurist future with his 'tremendous' courage while the others were off at the front. In fact, Balla's wartime activities were, true to type, of a playful nature that bordered on the frivo-

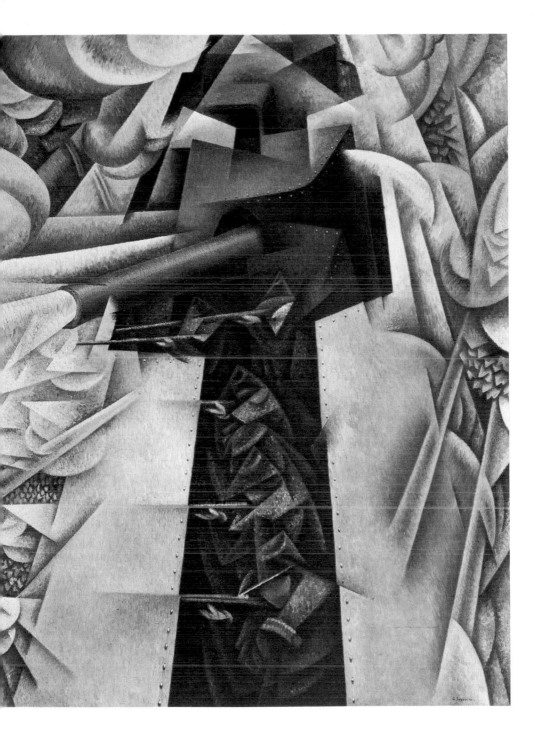

G. Severini.

IL VESTITO ANTINEUTRALE

Manifesto futurista

Glorifichiamo la guerra,
sola igiene del mondo.
MARINETTI.
(1° Manifesto del Futurismo – 20 Febbraio 1909)

Viva Asinari di Bernezzo!
MARINETTI.
(1° Serata futurista – Teatro Lirico, Milano, Febbraio 1910)

L'umanità si vestì sempre di **quiete**, di **paura**, di **cautela** o d'**indecisione**, portò sempre il lutto, o il piviale, o il mantello. Il corpo dell'uomo fu sempre diminuito da sfumature e da tinte **neutre**, avvilito dal nero, soffocato da cinture, imprigionato da panneggiamenti.

Fino ad oggi gli uomini usarono abiti di colori e forme statiche, cioè drappeggiati, solenni, gravi, incomodi e sacerdotali. Erano espressioni di timidezza, di malinconia e di **schiavitù**, negazione della vita muscolare, che soffocava in un passatismo anti-igienico di stoffe troppo pesanti e di mezze tinte tediose, effeminate o decadenti. Tonalità e ritmi di **pace desolante**, funeraria e deprimente.

OGGI vogliamo abolire:

1. — Tutte le tinte **neutre**, « carine », sbiadite, **fantasia**, semioscure e umilianti.

2. — Tutte le tinte e le foggie pedanti, professorali e teutoniche. I disegni a righe, a quadretti, a **puntini diplomatici.**

3. — I vestiti da lutto, nemmeno adatti per i becchini. Le morti eroiche non devono essere compiante, ma ricordate con vestiti rossi.

4. — L'equilibrio **mediocrista**, il cosidetto buon gusto e la cosidetta armonia di tinte e di forme, che frenano gli entusiasmi e rallentano il passo.

5. — La simmetria nel taglio, le linee **statiche**, che stancano, deprimono, contristano, legano i muscoli, l'uniformità di goffi risvolti e tutte le ciucciabindoli. I bottoni inutili. I colletti e i polsini inamidati.

Noi futuristi vogliamo liberare la nostra razza da ogni **neutralità**, dall'indecisione paurosa e quietista, dal pessimismo negatore e dall'inerzia

Vestito bianco - rosso - verde
del parolibero futurista Marinetti. (Mattino)

163 Balla *Anti-Neutral Clothes* 1914

lous, a mixture of Interventionist manifestations, manifesto writing, painting and enjoyable theatrical enterprises. Constructions and manifestos of this period typify the dispersive inventiveness of Balla's outlook, and confirm the impression that he would have been more in his element in Dadaist circles. The half-joking, half-serious tone of his manifestos and his experimental attitude to materials certainly predate the spirit of Zurich Dada, and had his attitude carried more solemnity he might even have been seriously considered as a precursor of Russian Constructivist principles of the transparency of planes and Gabo's concept of 'universal vibration' of 1920.

Balla's first Interventionist prank was the manifesto printed by the Direction of the Futurist Movement on 11 September 1914: 'Anti-Neutral Clothes'. In fact this is less an attack on the neutralist position

than a playful onslaught on the boring 'niceness' of contemporary conformist dress, pre-Dada in its advocacy of clothes that are joyful, short-lived, and asymmetrical, recognizably Futurist in its demands. Shoes for instance were to be 'dynamic, each foot different in shape and colour, ready to deliver merry kicks to all neutralists'. Only the last part of the leaflet, illustrated with Balla's own designs, makes direct reference to the war: 'Italian youth will recognize the radiant Futurist flags we wear for our great war, necessary, URGENT. If the government does not shake off its passéist garb of fear and indecision we will double, multiply by a hundred, the red of the tricolour we wear.'

Meanwhile, of course, Balla continued to paint and make constructions. In November 1914 the excitement of a partial eclipse which he watched through a telescope inspired *Mercury Passing the Sun as Seen Through a Telescope*, the continuation of his search for abstract and dynamic interaction of transparent planes that he had investigated through the *Flights of Swifts*, and which he was to pursue further in 1916 with the spiralling *Noise Forms of a Motorcycle*, and the sketches of the same year for abstract line sculpture which recorded only the line of movement.

In January 1915 Marinetti's Interventionist theatre started its disruptive activities, followed shortly by the first of three Interventionist demonstrations in Rome in which Balla took part. The first activity/event was the realization of the anti-neutral clothes, launched at a 'conference' in the University of Rome. Balla's clothes were worn by Cangiullo and provoked violent fights among pro- and anti-Interventionist professors and students. The event was accompanied by the copious distribution of Balla's 'Anti-

164 Depero *Plastic Complex: Motorumorist Pianoforte* 1915

Neutral Clothes' manifesto. During the third such manifestation Balla was arrested, together with Marinetti, Settimelli, and Mussolini who had just resigned from the editorship of the Socialist newspaper *L'Avanti* to lead the Interventionist movement.

It was during these rumbustious months, which Balla seems to have thoroughly enjoyed, that 'The Futurist Reconstruction of the Universe' appeared. This was written by Balla with the younger Fortunato Depero, and illustrated by ingenious constructions by both of them. The manifesto itself had less to do with the war in hand than with playful and disrespectful inventiveness. The reconstructed universe was to be run according to the principles of the Futurist toy that would protect both children and adults from dull conformism through laughter, agility, imagination, sharpened senses,

and, with a nod to the war: 'physical courage for fighting and for WAR (by means of huge outdoor toys, dangerous and aggressive)'. This Futurist Universe would feature an Artificial Landscape to replace boring Nature, and be populated with Metallic Animals, millions of them, which would, under the direction of Balla and Depero, bring about 'the greatest war (a conflict between all the creative forces of Europe, Asia, Africa and America) which will undoubtedly follow the current marvellous little human conflagration'.

The constructions that illustrated the manifesto, Plastic Complexes as both artists called them, deserve perhaps more attention than the whimsical text. For Balla they continued the experimental interest in the transparent play of coloured lines that was already apparent in his painting. Depero's delightful little *Motorumorist Coloured Plastic Complexes* go a stage

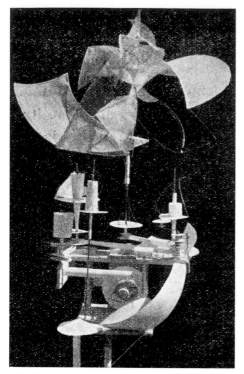

165 Depero *Motorumorist Coloured Plastic Complex* 1914–15

further on the way to the art of movement that is recommended in the manifesto. Here all manners of metals, tissues, coloured glass and celluloids were to be used with liquids, springs and noise-making devices to produce sculpture that would rotate and decompose. Balla had already toyed with such inventions, following the lead of Marinetti's hanging stick-figure *Self Portrait*, exhibited and sold at the Doré Gallery in London in 1914. In 1915 Balla constructed his affectionate wood and cardboard portrait of the Marchesa Casati. In this novel form of portraiture the black mica eyes were placed on a pivot linked to a 'line of speed in volume' which indicated the heart. This heart, when turned by the

spectator, made the eyes blink while the colours behind a row of punched holes changed [132].

In the same year, 1915, Balla made his only contributions to the theme of war in painting. *Flags on the Altar of the Fatherland* and *Patriotic Hymn* both commemorate Interventionist manifestations, the first held in front of the monstrous Vittorio Emanuele monument and the other in the open arena of Piazza di Siena in the Borghese Gardens. In both the setting has been fused with the rising shouts of the crowd into great solid swirls of colour shooting off from the red, white and green of the Italian flag. The harsh sharpness of the forms and the ponderous use of the once dynamic Lines of Force typify a predominant tendency in the Futurism of the post-war period and show the beginnings of Fascist heavy-handedness in art. The aggressive clenched-fist tension of the *Flags on the Altar of the Fatherland* owes something to

166 Marinetti *Self-portrait* 1914

167 Balla *Patriotic Hymn* 1915

Boccioni's Fist, Balla's sculpture of 1915 in which lines of force are frozen into three dimensions and which Marinetti adopted as the symbol of the movement [65].

One more painting of 1915–18 completes the patriotic triangle of Balla's wartime subjects. *Aeroplanes* shows two Caproni biplanes abstracted to the extent that they begin to look like a clumsy equivalent of Malevich's 'Suprematism'. Against a rigidly divided sky of pale and darker blue fly the planes, and in their wake are diagonal air waves of red, white and green. The painting was used as a postage stamp in 1961 to commemorate Italy's First World War ace pilot, Francesco Baracca.

Balla's light-heartedness found an exuberant outlet in 1917 in the stage sets for Stravinsky's *Fireworks* [102]. Here coloured abstract forms made of cloth and transparent paper, transformed by variously coloured changing lights, took the place of living dancers and interpreted the rhythms of the music. This was an elaboration of some of the ideas of the Futurist Synthetic Theatre, and a new and living role for the young art of abstraction. A battery of lights, manipulated by Balla when the work was performed at the Teatro Costanzi in 1917, produced seventy-six different combinations of lights. Though it was not generally well received in Rome, Stravinsky was said to have approved, and Balla received his applause dressed in a Futurist suit complete with purple straw hat and a square-cut walking stick.

After this Balla's imagination and involvement became progressively weaker and more peripheral. By 1920 he was turning his abstraction towards subjects

197

like *Tennis* and *Landscape*, and the endless series of decorative furnishing and facetious flowers that make a sad epilogue to two decades of invention.

By then Second Futurism was under way. This was Marinetti's attempt to keep his movement alive after the death and desertion of many of his most talented followers. Second Futurism lasted until the Second World War. It certainly attracted many artists, as a list of 109 'aeropainters' drawn up in 1970 by Franco Passoni shows. Carrà and Boccioni had been alarmed by the way Marinetti was throwing the movement open to new adherents, and indeed much of the later work that goes under the term Futurist was derivative or second rate. The most talented participants, apart from Balla and Depero, were Enrico Prampolini (1894–1956) the architect, designer and painter, who had already made the sets for Bragaglia's film *Thais* in 1917 (see p. 144), and two painters, Gerardo Dottori (b. 1884) and Tullio Crali (b. 1910).

The most challenging characteristic of Second Futurism was its appeal to what Marinetti called the 'new senses', and the good ideas that did emerge amidst a plethora of bad paintings relate to the search for cultural innovations that could match or even develop the sensory excitement of modern phenomena like radio and air travel. The most interesting experiments of these years, apart from amusing attempts to shock the tastebuds with Futurist cookery and cocktails, were Marinetti's Tactilism, Futurist Radiophonic Theatre, and the Aeropainting (*Aeropittura*) and Aerosculpture (*Aeroscultura*) which became Marinetti's new label for Futurist art after 1931.

Marinetti claimed that he came on the idea of Tactilism in a dugout in Gorizia in 1917, when, fumbling in the dark, his fingers encountered the different sensations of bayonets, mess tins and the heads of sleeping soldiers. But in his manifesto 'Tactilism', read at the Théâtre de l'Oeuvre in Paris in 1921, he recognized Boccioni's *Fusion of Head and Window* of 1912 [73], with its startling assortment of materials—iron, porcelain and human hair — as perhaps the first example of tactile art.

Marinetti's own 'tactile pictures' were first made in 1920, using a wide range of materials designed to re-educate the atrophied senses and develop new ones. 'Human beings', he wrote in the 1921 manifesto, 'speak to each other with their mouths and eyes, but cannot reach a point of true sincerity because of the insensitivity of their skin which is still a mediocre conductor of thought'. There were different categories for different kinds of sensation, and different materials to conjure them up. Sandpaper and metal foil meant cold abstraction, velvet and wool were warm and nostalgic, and so on. Scenes and places could be evoked too: the sea was metallic and fresh with foil; for Paris the 'tactile values' were soft, delicate, caressable, at one and the same time warm and cool (silk, velvet and feathers).

The tactile pictures could be extended into environments too, rooms, streets and theatres. Balla felt tactile art could be used to recall past life through sense of touch. A second-generation Futurist, Maga, saw it as a new portrait means—elephant skin for the hard cynic, velvet and rose petals for the seducer. He proposed new sensory rosaries too, with beads of marble, iron, coral, pasta and tobacco replacing the beads of Rome. All in all, Marinetti felt that Tactilism was 'most suitable for young poets, pianists, typists and all refined, erotic and powerful temperaments'. 'These tactile pictures', he wrote, 'are destined to replace the stultifying game of chess.' To

give the experiment scientific respectability, he announced in his 1921 manifesto that later that year, at the First Futurist Congress in Milan, Charles Henry of the Laboratory of Physiology of Sensations at the Sorbonne would discuss new researches into the sense of touch.

The 'Manifesto of Futurist Aeropainting' was written on 22 September 1929, and signed by nine 'Futurists': Balla, Marinetti's wife Benedetta, Depero, Dottori, Fillia, Marinetti, Prampolini, Somenzi and Tato. But, as Marinetti wrote, 'Aeropainting started at the beginning of the Futurist movement with the first Futurists who were anxious to leave the earth with poetry, painting and sculpture and achieve a first, albeit vague aesthetic of flight and of aerial life.' In 1919 Fedele Azari had written the 'Manifesto of Futurist Aerial Theatre', proposing the mass spectacular of aerial entertainment, with daredevil pilots recognized as artists, and in the same year Balilla Pratella composed his musical homage, the *Aviator Dro*. But it was the first Italian Atlantic flight, by Italo Balbo, that really inspired the Futurist painters to become Aeropainters. In 1929 Gerardo Dottori painted a mural featuring a synthesized swirl of propellers and wings for the Ostia Airport, and eleven painters prepared over fifty works glorifying flight and trying to put into practice Marinetti's recommendation that sketches made from first-hand experience should all go into the creation of works of art that faithfully render the 'optical and psychic sensations of flight' — 'the overcoming of trite and imbecilic everyday life', as Dottori called it. Such works, with their hard solid flat shapes and clumsy colours, were in the huge shows that the Aeropainters prepared for successive Venice Biennales during the 1930s, while the term 'Futurist' took a back seat.

Futurist Radiophonic Theatre was the last major insight into the potential of technology for the extension of art forms. The manifesto 'The Radio' (*La Radia*) of 1933 again emphasized the new sensibility that Marinetti felt was inherent in modern experience. Sound waves, creatively used, could offer a 'universal cosmic human art'. This was a world without 'time, space, yesterday or tomorrow'. Futurist radio art would utilize the characteristics of the medium: interference, static and 'the geometry of silence' could play a part in the general Futurist overturning of conventional values. So radio, too, became a continuation of the movement. Russolo's Art of Noises was extended into 'the psychic and spiritual world of sounds, voices and silence', and radio sound waves became the vehicle for Marinetti's Words-in-freedom.

Futurism and Fascism: Marinetti and Mussolini

'This unheard-of, outrageous, colossal thing happened, divulgation of which threatens to wipe out all the prestige and credit of the Communist International: in Moscow, during his speech to the Italian delegation — a speech given in the most correct Italian, mind you, so doubts about misinterpretation must be discarded a priori — Comrade Lunacharsky (Minister of Culture) stated that in Italy there is only one intellectual revolutionary and that he is Filippo Tommaso Marinetti. The philistines of the workers' movement are completely scandalized, and it's clear that to the old list of insults: 'Bergsonian, voluntarist, pragmatist, spiritualist', will be added a new and bloodier one: Futurist! Marinettist!'

Antonio Gramsci, co-founder and theorist of the Italian Communist Party, in an article in *Ordine Nuovo*, 5 January 1921.

The relationship between Futurism and Fascism has caused embarrassment to generations of historians. For formalist art historians it has been an excuse to pass over the political side and concentrate on Futurism as simply an art movement, a poor and provincial second-cousin of Cubism, concluding perhaps with a description of a prematurely cretinized Marinetti suddenly compromising on his early anti-academic stance by accepting a position in Mussolini's Academy of Italy. Other critics, taking their lead from the passage by Walter Benjamin quoted on p. 17, have presented an equally distorted picture, refusing to fill in the grey areas in a black-and-white 1930s description of 'bad' Fascist art aestheticizing politics, and 'good' Communist art politicizing art. The result has been a refusal to examine the context or complexities of a time when, in culture as in politics, the boundaries between 'good' and 'bad', left and right, progressive and reactionary, revolutionary and repressive, were not so clearly perceptible. Shielded by the comfortable knowledge that Futurism shared at least three characteristics with Fascism — romantic and uninformed glorification of the machine (technology) in society, the use of physical violence against opponents, and infatuation with youth — generations of writers who should have known better have left it at that. Statements in favour of Futurism by men of the left like Gramsci demonstrate that the truth was more complex, but have been ignored along with awkward comparisons like Lenin's slogan: 'Electricity + Socialism = the Soviet', or the Russian UNOVIS formulation 'We are young — in us the answer to the eternal youth of the world is found'. Silly oversimplifications have by now become irresponsible untruths. Recent articles have included statements such as 'Marinetti later became Mussolini's Minister of Culture', and 'Futurism was the official art of Fascism', both of which are far from true. The same process goes on in history too. In a television lecture given as this manuscript was being completed the eminent English historian A. J. P. Taylor talked for half an hour on Mussolini, referring to him constantly as 'the blacksmith's son' and omitting all mention of the fact that he had two degrees, was trilingual, edited the

Socialist paper *L'Avanti*, and moved from anarcho-syndicalism through Socialism to Fascism. The course of Futurism ran in much the same way as Mussolini's career. To avoid the issue and stifle the facts because they are inconvenient is to perpetuate the view of Fascism as a club of bone-headed buffoons, and gets us no closer to recognizing the origins and symptoms of totalitarianism in politics or in culture, then or now.

Gramsci wrote his article (p. 200) three years after Mussolini had founded the Fascist Party, two years after Marinetti had been presented as one of its first (unsuccessful) parliamentary candidates, and one year after the publication of Marinetti's article 'Beyond Communism', in which he attacked the Marxist class struggle as outdated. This makes Gramsci's attitude all the more remarkable, though he was obviously shielded somewhat by Lunacharsky's 'outrageous' statement. The title of the article was 'Marinetti the Revolutionary?', and it was certainly the most generous tribute he ever received.

Gramsci could entertain the idea of Marinetti as a revolutionary because he, more than anyone, had attempted to destroy bourgeois culture, which Gramsci equated with bourgeois civilization (*civiltà*). This destruction, for Gramsci, was the first stage of revolution, since only then could the true creativity of the proletariat emerge: 'What else must be done? Nothing less than the destruction of the present form of civilization. In this field "destroy" does not have the same meaning as in the field of economics: destroy does not mean to deprive humanity of material products necessary to their survival and development, it means the destruction of spiritual hierarchies, prejudices, idols, traditions that have become rigid. It means to be unafraid of what is new and daring, not to be scared of monsters, not to believe that the world will collapse if a worker makes a grammatical slip, if a poem limps, if a painting looks like a banner, if youth snubs its nose at academic senility. The Futurists . . . destroyed, destroyed, destroyed without worrying whether their new creations were all in all superior to those they destroyed . . . they had a precise and clear conception that our era, the era of big industry, of the great workers' cities, of intense and tumultuous life, had to have new forms of art, philosophy, customs, language; this was their clearly revolutionary concept, and an absolutely Marxist one, when the Socialists were not even remotely concerned with such things, when the Socialists certainly had nothing like so precise a concept of politics or economics, when the Socialists would have been frightened (and still are) at the thought that the bourgeois machine of power had to be smashed in the state and in the factories.

'The Futurists in their field, the field of culture, are revolutionaries; in this field, in terms of creativity, it is unlikely that the working class will be able to do more than the Futurists for a long time. When they supported the Futurists the groups of workers demonstrated that they were not afraid of destruction, that, sure of power, these workers could create poetry, art and drama like the Futurists: these workers were reinforcing the historical possibility of a proletarian culture created by the workers themselves.'

The admiration expressed by Gramsci was reciprocated. In his critical article a year before, 'Beyond Communism', Marinetti, while beating his own drum, had paid tribute to the culture of the Bolshevik revolution: 'I am delighted to learn that the Russian Futurists are all Bolsheviks and that for a while Futurism was the

official Russian art. . . . All the Futurisms of the world are children of Italian Futurism, created by us in Milan twelve years ago. All Futurist movements are nevertheless autonomous.'

The leader of Fascism and the leader of Futurism were completely dissimilar in background and remarkably similar in character. Both believed in the Nietzschean idea of the Man of Destiny, and were pragmatic enough to manipulate events to achieve this destiny. Both compromised on their revolutionary ideals, Mussolini because he had power, Marinetti because he had not. Marinetti, privileged and wealthy, started from the aristocratically anarchic position. Mussolini's first political lessons were in the Anarcho-syndicalism of his father the blacksmith. By the early years of the century Marinetti's easily won degrees were matched by Mussolini's, and so was his linguistic virtuosity. Both had delved into the history of anarchism, Marinetti through the Anarcho-syndicalism of Paris, and Mussolini through the labour of translating Sorel and Kropotkin into Italian. In 1910, a year after Marinetti launched the destructive message of Futurism in praise of 'the strong arm of the anarchist', Mussolini wrote an article on an encounter between anarchists and police in London, the siege of Sidney Street, in which he described the protagonists as 'anarchists in the classical sense of the word. Haters of work, they had the courage to proclaim it once and for all, because physical work brutalizes and degrades man, haters of property which seals the difference between one individual and another . . . but above all, haters, negators, destroyers of society.'

By 1912, when the Italian Socialist Party split between revolutionaries and reformists, and Mussolini became editor of the revolutionary Socialist newspaper L'Avanti, he was still writing of the individual as the only 'human reality': 'We shall support all that gives him greater freedom, greater well-being, greater latitude of life. We shall fight all that depresses and mortifies the individual.' When he eventually joined the Interventionist camp – that oddly united front of 'the Right, nationalists, Futurists, republicans, Mazzinians, democrats and Freemasons' whose case for intervention on the side of 'modern' France and England had been strengthened by Marinetti's campaigning – he was careful to dissociate himself from 'those who see in war the sole hygiene of the world'. Marinetti's attacks on 'cowardly Socialism' had been reciprocated in 1913 by Mussolini's gleeful spite in a letter of 1913: 'Have you read the last issue of La Voce? Futurism is down and out. It's finished. Marinetti has killed it. The moonlight is coming back.'

But as the campaign hotted up and gained popular support, Mussolini's reservations were swept aside, and the two men spoke at the same meetings. Marinetti's ferocious patriotism was now rivalled by Mussolini's: 'It is time for the diplomats to stop their intrigues and let the bayonets speak, with which we shall affirm our ideals of patriotism and humanity.' Mussolini's rhetoric owes much to Futurism, and among his contradictory statements about Marinetti he admitted his debt to 'the innovator poet who gave me the feeling for the ocean and the machine', and whose language is there in Mussolini's rhapsodic reaction to his first flight in 1918; 'I feel in my veins the truly dionysian intoxication at the conquest of the azure.'

Mussolini's letters and his quotations show how assiduously he had studied Futurism, but his relationship with Marinetti was always a mixture of love and

168 Mussolini in flying suit beside plane
c. 1918

hate, tinged perhaps with envy and certainly with opportunism. When he needed Marinetti's panache and his energetic ability to stir crowds, he used it. When Marinetti's radicalism became inconvenient and embarrassing, he discarded him. Marinetti too fell in and out of love with Mussolini, always on the issue of the politician's pragmatism, compromise and strategy versus the poet's intransigent demands for all or nothing. The Mussolini Marinetti loved was fused in his mind with his own appalling creation, Mafarka the Futurist: 'Mussolini has an exuberant, overwhelming, swift temperament. . . . Square champing jaws; prominent scornful lips which spit arrogantly on everything that is slow, pedantic and petty. . . . Massive rocklike head, but eyes that move ultradynamically, race as fast as automobiles on the plain of Lombardy or Italian seaplanes in the skies over the ocean, their whites flashing like those of a wolf. . . . Rash but sure because his elastic good sense has accurately judged the distance. Without cruelty because his vibrant fresh lyric childlike sensibility laughs. I remember how he smiled like a happy infant as he counted off twenty shots from his enormous revolver into the policeman's kiosk on the Via Paolo da Canobbia. . . . Lyric child with a marvellous intuition . . . a Futurist temperament. . . .'

Marinetti's romantic vision of the dictator was based on the years 1915–19 when they were closest. Marinetti took part in Mussolini's Fascio d'Azione Rivoluzionario, founded in late 1914 and appeared with him at one of the meetings of this ominously named force for intervention in March 1915. The war provided platforms for both men to pursue their chosen roles: Marinetti as the man of action and Mussolini (who was on active service at the front for only thirty-eight days) as speech-maker. Even before the war ended Marinetti had founded the Futurist Political Party, with its manifesto published in *Italia futurista* in February 1918. This elaborated points made ten years before in the 'First Political Manifesto' and the 'Futurist Political Programme' of 1913. The demands were anarchistic, socialistic and utopian: abolition of the monarchy, expulsion of the Papacy along with madonnas, candles and bells, socialization of the land, of the property of the Church, of mineral resources and water. There was to be heavy taxation of inherited wealth, an eight-hour working day, equal pay for women, free legal aid, protection of the consumer, easy divorce and gradual devaluation of matrimony as preparation for free love and state children. Freedom of the press was demanded, together with abolition of political parties and the removal of the

authority of the state army to intervene in civil strife. Most concrete among the proposals was that if even a reformed parliamentary government failed to work, it would be replaced by twenty administrative 'technicians' elected by universal suffrage, accompanied by regional decentralization. The Futurist Party was to work on short-term practical policies as distinct from the artistic Futurist movement which would continue with the long-term vanguard work of renewal. In the troubled climate at the end of the war as men were demobilized and disillusion grew, this programme was vague enough to attract a fair cross-section of supporters. The most influential and sinister of these were to be men like Bolzon and Bottai, who were to rise quickly to positions of power in the Fascist movement, or the writer Mario Carli and sculptor Ferruccio Vecchi, who drew into the Futurist Party the *Arditi*, the renowned volunteer shock troops who rushed into battle stripped to the waist, a grenade in each hand and a dagger between the teeth. The *Arditi* ('daredevils') became the *Fasci Futuristi*, the attack gang who transferred to Mussolini's Fascist Party when it was formed on 23 March 1919 in the Circolo Industriale e Commerciale in Piazza San Sepolcro in Milan. They were certainly responsible for the violence with which the movement established itself, the attacks on Socialists, and the burning in April 1919 of the Socialist *L'Avanti*, of which Mussolini had formerly been editor. For Mussolini, Marinetti was still a worthwhile ally. He was elected to the central committee of the Fascist movement, and Mussolini's new official newspaper *Il Popolo d'Italia* gave a great deal of coverage to a rather tired Futurist Exhibition that March. In July, Mussolini wrote: 'Fascism is an unprecedented movement. It has not disdained

to make contact with groups which have been ignored or condemned by the philistine stupidity of the *bien-pensants*. Mediocrities have always pretended not to take Futurism seriously, and now, in spite of such people, the head of the Futurists, Marinetti, is a member of the Central Committee of the Fasci di Combattimento.'

When the Fascist Party presented its first parliamentary candidates for election in November 1919, Marinetti was one of them, and Mussolini instructed one of his journalists to write a 'robust profile to show these Italian parrots that Marinetti is one of our most powerful political brains'. Marinetti was still useful: it was his rhetoric that persuaded the conductor Arturo Toscanini to stand for election too. Of these initial twenty, only Bolzon was to go to the front ranks of Fascism. Toscanini later withdrew from the Party, refused to conduct the Fascist anthem, was outspoken in his criticism, and was beaten up by Fascist thugs. It was some measure of the degree of political confusion of those years that even those who had grave doubts about the movement could be swept along in patriotic fervour, at least for a time. In this 1919 election the Fascists were soundly defeated by the Socialists, who had Mussolini, Marinetti, Bolzon, Vecchi and fifteen *Arditi* arrested and imprisoned in San Vittore for twenty-one days on charges of menacing state security and forming armed bands. This was, quite literally, the closest Marinetti ever came to Mussolini.

For Mussolini it was important at this stage that his movement be seen to have the support of prominent cultural figures. D'Annunzio was his next darling, and the poet's occupation of the town of Fiume made him a popular hero. Fiume (Rijeka) had been claimed by Italy from the Austro-Hungarian monarchy, but in 1919 was

being held by the new state of Yugoslavia. D'Annunzio, with the help of the erstwhile *Arditi*, took the matter into his own hands and seized it, holding it for a year, and creating one of the legends of early Fascism. But even the popular appeal of this exploit could not hide the fact that the Fascist Party had been ignominiously defeated in the election, and that the extravagance of some of its wilder members, not least Marinetti, was frightening off wider support.

While Mussolini was working towards the compromises of 1920, Marinetti was indeed becoming more extravagant in his demands. An article in 1919, 'Futurist Democracy', was even more outspokenly aggressive than earlier writings towards the triad of monarch, pope and bureaucracy. In Futurist Democracy traditional morality would make way for the 'Morality of danger: elastic liberty with neither prisons nor Carabinieri. Prisons are infamous traps presupposing a bestial Cat-force treating the most charming and ingenuous temperaments like mice. . . . Well, it really is time that the prisons and penal settlements, these relics of the Middle Ages, were destroyed and razed to the ground.' Less than ten years later, of course, 'cat-forces' and imprisonment had become Mussolini's own expedient for stifling opposition. So much for Marinetti's 'elastic liberty'.

A year later Marinetti published 'Beyond Communism', an article dedicated 'To the French, English, Spanish, Russian, Romanian, Hungarian and Japanese Futurists', which saluted the Bolshevik revolution and the part played in it by 'Russian Futurist' artists as quoted before (p. 15), while distinguishing between revolution based on a class struggle and the one envisaged by Marinetti for Italy. Once again this is an extraordinary mixture of ideas that with hindsight we can call either 'progressive' or 'reactionary', 'left' or 'right'. Few would take exception to his disgust with bureaucracy and barracks, with 'conservative traditionalism, material egotism, misogyny, the fear of responsibility and plagiarist provincialism'. Some would agree that a revolution based on class struggle and the rule of the proletariat is less than total revolution in that it still preserves the idea of class. But Marinetti is inconsistent, here as elsewhere, in his commitment to universal revolution. Nationalism leads him to dismiss as 'plagiarist provincialism' the willingness of Italian Communists to follow the lead of 'the Russian Lenin, disciple of the German Marx'. His isolationist interpretation of the principle 'to each people its own revolution' represents a sad reversal of his earlier cultural internationalism.

On the other hand, Marinetti was politically shrewd enough to see that the Bolshevik revolution was already in danger of being swamped by what he called 'the bureaucratic cancer — a German disease'. Never for a moment recanting his anarchistic individualism, he equated this with 'the fixed, restful uniformity promised by Communism' There then follows a classic Marinetti passage, a mixture of the inspired and the absurd, in which his strength and weaknesses show clearly for perhaps the last time: 'They want life without surprises, the earth as smooth as a billiard ball.

'But the pressures of space have not yet levelled the mountains of the earth, and the life that is Art is made up (like every work of art) of peaks and contrasts. . . .

'The life of insects demonstrates that everything is reduced to reproduction at any cost and to purposeless destruction.

'Humanity vainly dreams of escaping these two laws that alternately excite and

exhaust it. Humanity dreams of stabilizing peace by means of a single type of world man, who should then be immediately castrated lest his aggressive virility declare new wars.

'A single human type should live on a perfectly smooth earth. Every mountain defies every Napoleon and Lenin. Every leaf curses the wind's warlike will. . . .'

'Communism may be realized in cemeteries. But, considering that many people are buried alive, that a man's total death cannot be guaranteed, that sensibilities survive to die later, cemeteries doubtless contain . . . furious gatherings, rebels in jail, and ambitions that will out. There will be many attempts at Communism, counter-revolutions that wage war and revolutions that defend themselves with war.

'Relative peace can be nothing but the exhaustion of the final war or the final revolution. If I were a Communist, I would concern myself with the next war between homosexuals and lesbians, who will then unite against normal men.'

'Beyond Communism' finds Marinetti remembering his early inventions, the characters in *Re Baldoria* (*King Riot*), who now sound almost like self-parody: 'the artistic innovative dynamism of the Poet-Idiot ridiculed by the mob fuses with the insurrectional dynamism of the libertarian Famone [Big Hunger], to propose to humanity the only solution of the universal problem: All power to Art and the Artists. Yes! Power to the Artists! The vast proletariat of gifted men will govern.' To encourage the growth of this 'proletariat of gifted men' there would be a People's Cultural Palace in each city, a permanent 'free exhibition of creative talent' open to all citizens in which works of art of any kind would be performed, poetry and scientific writings read, including those normally judged 'absurd, foolish, mad and immoral'. 'Thanks to us', Marinetti concluded, 'the time will come when life will no longer be a simple matter of bread and labour, not a life of idleness either, but *a work of art*.'

There was to be no room for such dreams in the tidy house-keeping of the Fascist State. Marinetti had seen 'the Fatherland' as an extension of the individual, but the Fascist Fatherland of Mussolini, like that of Stalin, stifled the 'proletariat of the gifted' by delegating both its creativity and its responsibility to those who would maintain the status quo. But in 1920 Marinetti was not alone in his romantic belief that revolution was just over the horizon. The equally romantic tradition of D'Annunzio lingered on, with dreams of 'transmuting the Bolshevik thistle into the Italian rose'. In his Fascist review *Testa di Ferro* (*Ironhead*), Mario Carli had written an article on 'Our Bolshevism', and had envisaged much the same union of strange bedfellows as had occurred in the interventionist period: 'Futurists, *Arditi*, Fascists, combatants, etc. and the so-called parties of the *avant-garde*, official Socialists, reformists, Syndicalists, Republicans.'

Mussolini's way of bringing together enough votes to get him in power was totally different. With hard-headed political pragmatism he compromised. At the second National Fascist Congress in Milan in May 1920 his message to the Monarchists and the Church was conciliatory. As he said, 'the Vatican represents four hundred million people scattered throughout the world'. This was the 'colossal force' he now wanted behind him, so the Vatican was now instated in Fascist vocabulary as a 'spiritual sovereignty' beyond attack. In his efforts to curry favour with the industrial and landed bourgeoisie, Mussolini was prepared to make the final shift to the

169 Marinetti seated in front of a painting of himself, his wife and three children c. 1933

right, disowning the intransigent and embarrassing Marinetti as 'this extravagant buffoon who wants to play politics', though this was not put quite so personally in Congress. The message, however, was clear enough. Marinetti stormed out of the meeting, shouting that there was obviously no place for him among this 'flock of passéists'. He was not alone. Many founder members left too, including Socialists, Anarchists, Syndicalists and Republicans, and it was from them that the most vocal opposition was later to come. But Mussolini got the support he wanted. In 1923, after his March on Rome, he assumed the premiership.

By that time Marinetti had been put out in the cold long enough, trying unsuccessfully to force a left-wing position on a Party that was too strong to change. Realizing that his movement, now in its *Aeropittura* stage, though with none of its old élan, was being steadily pushed aside, he rejoined the Fascists and at the Futurist Congress in 1924 sent the following last-ditch message to Mussolini; '. . . free yourself of parliamentarianism . . . restore to Fascism and Italy the marvellous spirit of '19 . . . imitate the great Mussolini of '19'.

It was too late. The last thing Mussolini wanted was the rash and rebellious involvement of the Futurists. Fascism now presented itself as the force of order and harmony. The art that matched this image

was the romantic or archaizing realism that asked no questions and posed no problems. With hindsight we can see that this was as close to the Socialist realism of Stalin's Russia as Marinetti had fancied the Russian art of the Bolshevik revolution had been to Futurism. Once again D'Annunzio's vision of Rome reborn through art was closer to Mussolini's desire for a clockwork classical state. It was D'Annunzio's world of Italy's millennial tradition, Latin and Mediterranean, as Roman as the revived idea of the *fasces*, repressive symbol of order and discipline, that gave the form to the official art and architecture of Fascism, the neoclassical style restored to favour with the 'Exhibition of the Fascist Revolution', and the neo-Roman plans for Mussolini's EUR (Esposizione Universale Romana) city outside the capital of his empire. It was either that or the new classicism, exemplified by Giuseppe Terragni's Casa dei Fasci in Como and Ivo Pannaggi's Casa Zampini at Esanatolia (1925–26): the disciplined language of architectural order usually associated in retrospect with the leftist 'International Style'. Futurist dynamism and extravagance fitted neither bill. The architectural dreams of Sant'Elia went unrealized, with the exception of the war memorial at Como carried out to one of his designs, but on a scale so reduced as to make ill-proportioned nonsense of the original concept. Unrealized, too, were the designs of later Futurist architects like Virgilio Marchi and Enrico Prampolini, for whom commissions were largely restricted to exhibition stands. When they were represented, as at the First Exhibition of Futurist Architecture under the patronage of Mussolini in 1928, they were treated as a historical movement, part of the romantic spirit of early Fascism, and irrelevant to the *Real politik* of the expansionist state.

Even to retain this gallingly passéist marginal position for his movement, Marinetti had to compromise. In 1929 he swallowed his anti-academic pride and became a member of Mussolini's prized Accademia d'Italia, and secretary of the Union of Fascist Writers. He was still writing *Aeropoesia* and promoting the *Aeropittura* of his second generation of painters, Balla being the sole stalwart of the early days. Marinetti's concepts for the creative use of radio in the 1930s were probably the only revolutionary artifacts of the Fascist era (see pp. 108, 199); but even they received scant attention. The front page of the magazine *Futurismo* of July 1932 still attempted to cajole the party into believing that: 'Fascists, you are the Futurists in Art', but the 'political function of art' it sought to promote fell on deaf ears. Marinetti still insisted that 'Art is an alcohol, not a balm', but, under dictatorship, a balm it had to be.

Yet Marinetti, disillusioned as he must have been, stayed loyal both to Fascism and to Mussolini the man. When Mussolini invaded Ethiopia, Marinetti, stirred by youthful memories of the Libyan campaign into believing that heroic days were back again, joined up as a sixty-year-old volunteer, and later, in 1942, hurried off to accompany the disastrous Italian campaign in Russia on the Don.

As Fascism receded further and further from the last vestiges of anything that could be confused with revolutionary thought, Marinetti followed, relinquishing the position of opposition that might at least have vindicated him in the eyes of history. He shared the final squalor of the Republic of Salò, the last-ditch puppet regime of die-hard Fascists set up by the Germans before the final collapse. His last text, 'Quarter of an hour of poetry of the X Mas' sang the praise of the most vicious of

the Black Brigades. In the impotent isolation of Salò, Mussolini returned to the inflammatory language of his youth, and in the powerless leader's railing against monarchy and Vatican Marinetti found some illusion of comfort. He died under this illusion on 2 December 1944 at Bellagio, last refuge of the Fascist hierarchy. His funeral on a cold, foggy day in Milan was one of the last ceremonies of the collapsing Republic.

In 1909 Marinetti had given his movement ten years of life before 'younger and stronger men will throw us in the wastepaper basket like useless manuscripts — we want it to happen'. It was part of his tragedy that it did not. What defeated the positive side of Marinetti's vision, hampered as it was by fatally naive ideology, was not the violent symbolic death at the hands of a yet more revolutionary generation envisaged in the 'Founding and Manifesto', but a process of gradual atrophy. 'At last they'll find us,' he had written, 'one winter's night — in open country, beneath a sad roof drummed by a monotonous rain.' Marinetti ultimately had no weapon to deal with the 'monotonous rain' of Fascism, to counter the process of erosion that absorbed the crudest of his messages and swept aside the rest. 'The sad roof' was of his own making, a shelter from within the walls of which it seemed the world could be changed so fast. It was a temple for the new religion too, and a trap, a trap that still lies open.

Sources and further reading

Acknowledgments

For their help and patience, thanks to Brian Petrie, Giuseppe Sprovieri, Ian Barker and the McDowell family.

History and background

This is a brief listing of sources that the authors have found useful. The most exhaustive survey of Futurist painting and sculpture is still that by Martin (1968).

Aeropittura futurista, Milan 1970. (Exhibition catalogue.)
Apollinaire, Guillaume, *Apollinaire on Art,* London and New York 1972.
Banham, Peter Rayner, *Theory and Design in the First Machine Age,* London and New York 1960.
Bellonzoni, Fortunato, *Il divisionismo nella pittura italiana,* Milan 1967 (Mensili d'arte Fabbri).
Benjamin, Walter, 'The Work of Art in the Age of Mechanical Reproduction', in *Illuminations: Essays and Reflections,* New York 1968, London 1970.
Bergson, Henri, *Matter and Memory,* London and New York 1911; *Creative Evolution,* London 1911.
Cork, Richard, *Vorticism and Abstract Art in the First Machine Age,* London 1976.
Crispolti, Enrico, *Il mito della macchina e altri temi del futurismo,* Trapani 1969.
Croce, Benedetto, 'Estetica', in *Filosofia come scienza dello spirito,* 1908: *Aesthetics,* London 1922.
De Felice, Renzo, *Mussolini il Fascista: la conquista del potere, 1921–25.* Turin 1966.
De Grada, Raffaele, *I macchiaioli,* Milan 1967 (Mensili d'arte Fabbri).
Discoteca alta fedeltà, January–February 1971. (For later Futurist music.)
Golding, John, *Cubism, a History and an Analysis, 1907–14.* London and New York 1959.
Gramsci, Antonio, *Quaderni dal*

carcere, Turin 1955; *Prison Notebooks,* London 1975.
Gray, Camilla, *The Russian Experiment in Art, 1863–1922,* London and New York 1971.
Hamilton, Alastair, *The Appeal of Fascism,* London 1971.
Joll, James, *Intellectuals in Politics: Blum, Rathenau, Marinetti,* London 1960, New York 1961.
Martin, Marianne W., *Futurist Art and Theory, 1909–15,* Oxford 1968.
Nietzsche, Friedrich, *Thus Spoke Zarathustra,* Harmondsworth and Baltimore 1961.
Rye, Jane, *Futurism,* London and New York 1972.
Sipario, Numero doppio dedicato al Teatro Futurista Italiano, Autumn 1967.
Verhaeren, Emile, *Villes tentaculaires,* Brussels 1895.
Woodcock, George, *Anarchism,* London and New York 1963.

Futurist texts

There is no complete edition or even bibliography of the manifestos. Drudi Gambillo and Fiori (1958–62) supply a useful if incomplete documentation of both texts and works of visual art. A compact selection is provided by Apollonio (1973)

Apollonio, Umbro, ed. *Futurist Manifestos,* London and New York 1973.
Carrà, Massimo, and Giorgio de Marghis, ed., *Lacerba,* Milan 1970. (Complete reprint.)
Carrieri, Raffaele, *Il Futurismo,* Milan 1961. (The English edition, *Futurism,* Milan 1963, lacks bibliography.)
Drudi Gambillo, Maria and Teresa Fiori, *Archivi del futurismo,* Rome 1958–62.
Futurismo 1909–1919, Newcastle, Edinburgh and London 1972–73 (Exhibition catalogue.)
Kirby, Michael, *Futurist Performance,* New York 1971.

Marinetti, Filippo Tommaso, ed., *I manifesti del futurismo lanciati da Marinetti, Boccioni, Carrà, Russolo, Balla, Severini, Pratella, Mme de Saint-Point, Apollinaire, Palazzeschi.* Florence 1914.

Studies of individual artists

Balla: Fagiolo dell'Arco, Maurizio, *Balla: ricostruzione futurista dell'universo,* Rome 1968.
Boccioni: Ballo, Guido, *Boccioni, la vita e l'opera,* Milan 1964. Boccioni, Umberto, *Gli scritti editi ed inediti,* Milan 1970; *Altri inediti e apparati critici,* Milan 1972.
Bragaglia: Bragaglia, Antonella, *Fotodinamismo,* Florence 1971.
Carrà: Carrà, Carlo, *Guerrapittura, futurismo politico, dinamismo plastico,* Milan 1915; *La mia vita,* Rome 1943, Milan 1945. Carrà, Massimo, and Piero Bigongiari, *L'opera completa di Carrà,* Milan 1970 (Classici dell'arte).
Chiattone: Veronesi, Giulia, *L'Opera di Mario Chiattone,* Pisa 1965. (Exhibition catalogue.)
Depero: Passamani, B., *Depero,* Bassano del Grappa 1970. (Exhibition catalogue.)
Ginna: Ginanni Corradini, Arnaldo (Arnaldo Ginna), *Cinema e letteratura del futurismo,* Rome 1968.
Marinetti: Marinetti, Filippo Tommaso, *Opere,* Verona, especially vol. 3, 1968; *Selected Writings,* New York and London 1971, 1972. *Distruzione,* Milan 1911.
Palazzeschi: See preface to Marinetti, *Opere,* vol. III.
Papini: See Carrà and De Marghis, ('Futurist texts', above).
Rosso: Soffici, Ardengo, *Medardo Rosso,* Florence 1929. Barr, Margaret Scolari, *Medardo Rosso,* New York 1963.
Sant'Elia: See *Controspazio* (Milan), April–May 1971.
Soffici: *Ardengo Soffici e il cubofuturismo,* Florence 1967. (Exhibition catalogue.)

List of illustrations

(33·4 × 23·9). Civico Gabinetto dei Disegni, Castello Sforzesco, Milan.
75 Boccioni working on *Head + House + Light* 1912.
76 *Development of a Bottle in Space* 1912–13. Bronze h. 15 (38). The Museum of Modern Art, New York, Aristide Maillol Fund.
77 *Synthesis of Human Dynamism* 1912 (destroyed; exh. 1913). Sculpture.
79 *Speeding Muscles* 1913 (destroyed; exh. 1913). Sculpture.
80 *Spiral Expansion of Speeding Muscles* 1913 (destroyed; exh. 1913). Sculpture.
81 *Dynamism of a Cyclist* 1913. $27\frac{1}{2} \times 37\frac{3}{8}$ (70 × 95). Collection Mattioli, Milan.
82 *Unique Forms of Continuity in Space* 1913. Bronze h. $43\frac{1}{2}$ (109·2). The Museum of Modern Art, New York. Acquired through the Lillie P. Bliss Bequest.
84 *Horse + Rider + Houses* 1914. Wood, paper and metal 26 × 48 (66 × 122). Collection Peggy Guggenheim, Venice.
85 *The Pavers* 1914. $39\frac{3}{8} \times 39\frac{3}{8}$ (100 × 100). Collection Mrs Barnett Malbin.
86 *Study for a Head of Signora Busoni* 1916. $15 \times 18\frac{1}{4}$ (38 × 46·5). Civica Galleria d'Arte Moderna, Milan.
87 *Maestro Busoni* 1916. $69\frac{1}{4} \times 47\frac{1}{4}$ (176 × 120). Galleria Nazionale d'Arte Moderna, Rome.
90 *Caricature of a Futurist Evening* 1911 (lost). Ink.
103 *Cover for Pratella's 'Musica Futurista'* 1912. Printed. Collection Pratella, Ravenna.
133 Boccioni in his studio with his mother and Balla 1913.
146 See SANT'ELIA.
147 *The Charge of the Lancers* 1915. Tempera and collage $12\frac{5}{8} \times 19\frac{3}{4}$ (32 × 50). Collection Riccardo Jucker.
148 Boccioni on horseback 1916.

BRAGAGLIA, Anton Giulio (1890–1960)
119 *The Slap* 1913. Photograph.
120 *Image in Motion* 1913. Photograph.
121 *Carpenter Sawing* 1913. Photograph.
122 *The Typist* 1912. Photograph.
123 *Balla in front of 'Leash in Motion'* [155] 1912. Photograph.
124–26 *Thais* 1916: Thais Galitzky. Frames of film. Photos National Film Archive.

BUZZI, Paolo
142 *Spiral and Helix.* Free-word poems in *Lacerba.*

CANGIULLO, Francesco (1888–)
98 *Free-word Painting* 1915. Pen on paper $14\frac{1}{2} \times 9\frac{5}{8}$ (37 × 24·5). Private Collection, Rome.
99 See BALLA.

CARRA, Carlo (1881–1966)
17 *Portrait of the Poet Marinetti* 1911. $39\frac{3}{8} \times 32\frac{1}{4}$ (100 × 82). Private Collection, Turin.
21 See RUSSOLO.
33 *Leaving the Theatre* 1910–11. $27\frac{1}{8} \times 35\frac{7}{8}$ (69 × 91). Collection Mr and Mrs Eric Estorick.
34 *Women Swimmers* 1910. $43\frac{1}{4} \times 63$ (110 × 160). Museum of Art, Carnegie Institute, Pittsburgh, Pa. Gift of G. David Thompson.
36 *The Funeral of the Anarchist Galli* 1911. $78 \times 100\frac{3}{4}$ (198 × 266). The Museum of Modern Art, New York.
37 *Milan Station* 1911. $19\frac{7}{8} \times 21\frac{1}{2}$ (50·5 × 54). Staatsgalerie, Stuttgart.
50 *The Galleria in Milan* 1912. $35\frac{7}{8} \times 20\frac{1}{4}$ (91 × 51·5). Collection Mattioli, Milan.
137 *Words-in-freedom* 1914. Printed in *Lacerba.*
145 *Interventionist Manifesto* 1914. Collage on card $15 \times 11\frac{3}{4}$ (38 × 30). Collection Mattioli, Milan.
149 *Interpenetration of Planes* 1913 (lost). $23\frac{5}{8} \times 31\frac{1}{2}$ (60 × 80).
150 *Still-life: Noises of a Night Café* 1914. $11\frac{5}{8} \times 15\frac{3}{4}$ (30 × 40). Former Collection F. T. Marinetti.
151 *Red Horseman* 1913. Tempera and ink $10\frac{1}{4} \times 14$ (26 × 36). Collection Riccardo Jucker.
152 *Aerial Reconnaissance–Sea–Moon + 2 Machine Guns + Northeast Wind* 1914. Ink and collage $14\frac{1}{2} \times 10\frac{5}{8}$ (37 × 27). Galleria Annunciata, Milan.
153 *Penetrating Angle of Joffre over Marne against 2 German Cubes* 1915. Ink and collage $10\frac{5}{8} \times 14\frac{1}{2}$ (27 × 37). Galleria Annunciata, Milan.
154 *Atmospheric Envelope– Exploding Shell* 1914. Ink and collage $10\frac{5}{8} \times 14\frac{1}{2}$ (27 × 37). Galleria Annunciata, Milan.
155 *Pursuit* 1914. Collage on card $13\frac{3}{8} \times 26\frac{3}{4}$ (34 × 68). Collection Mattioli, Milan.
156 *Woman and Absinthe* 1911. $26\frac{3}{8} \times 20\frac{1}{2}$ (67 × 52). Private Collection, Naples.
157 *Futurist Synthesis of War* 1914. Manifesto.
158 *Drunken Gentleman* 1916. $23\frac{5}{8} \times 17\frac{3}{4}$ (60 × 45). Collection Frua, Milan.
159 *Antigrazioso* 1916. $26\frac{3}{8} \times 20\frac{1}{2}$

(67 × 52). Private Collection, Milan.

CHIATTONE, Mario (1891–1965)
116 *Construction for a Modern Metropolis* 1914. Indian ink $41\frac{3}{4} \times 37\frac{3}{8}$ (106 × 95). Istituto di Storia dell'Arte, University of Pisa.
117 *Platform and Study of Volumes* 1914. Indian ink $25\frac{1}{2} \times 18\frac{5}{8}$ (65 × 47·5). Istituto di Storia dell'Arte, University of Pisa.

CHITI, Remo
127 See GINNA.

DELAUNAY, Robert (1885–1941)
38 *Eiffel Tower* 1911. $79\frac{1}{2} \times 54\frac{1}{4}$ (201·9 × 138·5). Solomon R. Guggenheim Museum, New York.
59 *Window* 1912. Musée National d'Art Moderne, Paris. Photo Musées Nationaux.

DEPERO, Fortunato (1892–1960)
164 *Plastic Complex: Motorumorist Pianoforte* 1915. Drawing. Galleria Museo Depero, Provereto.
165 *Motorumorist Coloured Plastic Complex* 1914–15. Sculpture. Galleria Museo Depero, Provereto.

DUCHAMP, Marcel (1887–1968)
46 *Nude Descending a Staircase* 1911. Oil on card $38\frac{5}{8} \times 23\frac{3}{4}$ (96·7 × 60·5). Philadelphia Museum of Art, Louise and Walter Arensberg Collection.

FATTORI, Giovanni (1825–1908)
10 *Stormy Sea.* Galleria d'Arte Moderna, Florence.

FIGARO, Le
1 Front page, 20 February 1909.

GALLI, Riccardo
56 *Vibrations* from *Novissima* 1904.

GINNA, Arnaldo (Arnaldo Ginanni-Corradini, 1890–)
127 *Vita futurista* 1916: Remo Chiti. Frame of film.
128 *Vita futurista* 1916: Balla. Frame of film.
129 *Vita futurista* 1916: dance sequence. Frames of film.
130 *Vita futurista* 1916: Marinetti's fisticuffs. Frame of film.

GOVONI, Corrado
97 *The Sea* 1915. Words-in-freedom poem from *Lacerba.*

Index